Beyond Rosie the

CultureAmerica

Erika Doss
Philip J. Deloria
Series Editors

Karal Ann Marling
Editor Emerita

Beyond Rosie the Riveter

Women of World War II
in American Popular
Graphic Art

Donna B. Knaff

 UNIVERSITY PRESS OF KANSAS

Lyrics in Chapter 3: "They're Either Too Young or Too Old," words by Frank Loesser, music by Arthur Schwartz. Copyright © 1943 (Renewed) WB Music Corp. All Rights Reserved, used by permission.

Published by the University Press of Kansas (Lawrence, Kansas 66045), which was organized by the Kansas Board of Regents and is operated and funded by Emporia State University, Fort Hays State University, Kansas State University, Pittsburg State University, the University of Kansas, and Wichita State University

Library of Congress Cataloging-in-Publication Data

Knaff, Donna B.
 Beyond Rosie the Riveter : Women of World War II in American popular graphic art / Donna B. Knaff.
 pages cm — (CultureAmerica)
 Includes bibliographical references and index.
 ISBN 978-0-7006-1966-5 (pbk : alk. paper) 1. Women in art. 2. Women in popular culture—United States—History—20th century. 3. World War, 1939–1945—Women—United States. 4. Women—United States—Social conditions—20th century. I. Title.
 NE962.W65K55 2012
 704.9´424097309044—dc23
 2012007156

British Library Cataloguing-in-Publication Data is available.

Printed in the United States of America

10 9 8 7 6 5 4 3 2 1

CONTENTS

ACKNOWLEDGMENTS

Writing a book in many ways is like a journey, and I would like to thank all who have helped me along the way.

First—always first—I thank my parents, Rhoda Knaff and P. Robert Knaff, who, with love and a few other emotions, indelibly imprinted curiosity and respect for education on all of their daughters. My sisters and I have sought out schooling by different means and modes, but that desire simply to *figure out* is present in all of us. My mother, who continues to glean items of interest from the *Washington Post* and send them to me, showed me the value of cartoons and comics—the attitudes they reveal, how subtly they impart their messages, and what a worthwhile cultural resource they present.

The book and I have been the beneficiaries of an outpouring of kindness. Beth Bailey opened large windows in her jammed schedule to contribute her invaluable expertise and to help me produce a publishable work. Kathy Freise judiciously read nearly every word of the manuscript, and her eagerness for meticulously reading every revision and re-revision, with dinner or without, is the hallmark of her generosity, encouragement, and friendship. Simona Fojtova helped me hammer out the important concepts underpinning the work and talked me through the more theoretical bits. Natasha Moulton gave me feedback when I wanted it, a lovely place to stay when I was conducting research, and support *all* the time, even when we were on different continents. Kara Vuic stepped in at critical times to give astute (and calming) advice and help draw it all together. These wonderful women were unstinting in their willingness to engage in the many conversations I had to have in order to write and fully think. Such conversations are part of what makes intellectual work so deeply rewarding.

Cynthia Brenner did much of the museum-based research with me and also contributed photographs, notably the picture she and her sister Cathleen Brenner kindly gave me permission to use of their mother, the late Virginia (Johnson) Brenner. In all of my thinking on artistic depictions of women, Virginia's photo was a good reminder that the women in those

images represented *actual* women—and that their World War II service influenced their daughters and granddaughters. My thanks to Virginia for her service, for a more personal connection to World War II, and for her two bright and remarkable daughters.

The book would not be anything without its images. My research began at the University of New Mexico's Zimmerman Library, and I thank the helpful and humorous librarians there, especially the always-smiling Carroll Botts. I spent many a happy hour sitting in the stacks at Zimmerman, and the wonderful librarians could always point me to productive places. I thank the Jay N. "Ding" Darling Wilderness Society, which gave permission to use two of his wonderful drawings, and Sidney Huttner and Kathryn Hodson, Special Collections librarians at the University of Iowa, for their help in finding and procuring the images. The United States Army Women's Museum at Fort Lee, Virginia, provided a rich store of images and the history behind them. Mary Margaret Schisler Salm gave me the benefit of both her wartime experiences and of access to her collection of papers and images, now housed at the Institute on World War and the Human Experience at Florida State University and the Southern Historical Collection at the University of North Carolina. Margaret passed away in December 2009, much to the sadness of the Minerva e-list community. Colonel Patricia "Pat" Jernigan, USA (Ret.), has been a source of incisive analysis of historical events for me for several years. Her penetrating intellect and vast knowledge of military women's history are matched by her gracious nature—she not only shared her knowledge with me but also invited me to WAC luncheons. The collection of her Vietnam experiences and artifacts is currently at the Vietnam Veterans Memorial State Park in Angel Fire, New Mexico, and the collection (and the Visitors Center there) is worth the trip.

Ranjit Arab, Kelly Chrisman Jacques, and Susan Schott at University Press of Kansas and copy editor Kathy Streckfus gave their professionalism and enthusiasm in making this book ready for publication. With stories of publishers running over authors' wishes ringing in my ears, I found it deeply reassuring that they considered me indispensable to the process of production.

In the midst of the writing, I met my favorite veteran, SGT B., who did me the honor of calling me her "Battle Buddy" and showing me her rich interpretation of the term. As I introduced her to the world of her military forebears, she explained how military women still carry on their traditions.

She continues to show me what grace under fire—all kinds of fire—looks like. You're still a high-speed soldier, SGT B. Hooah.

And last, but certainly not least, I want to thank my sisters, Constance and Jennifer. I've said it before, and I'll say it again: When things are wonderful or terrible, yours are the voices I want to hear. I love you.

"A Queer Mixture of Feelings"

Conflicting Messages to Women during the War

"My Dear Daughter," reads a handwritten "letter" from a "father" in a 1943 recruiting advertisement for the Women's Army Auxiliary Corps. "You ask how I feel about your joining the WAAC. The idea gives me a queer mixture of feelings."[1] The feelings laid out in this fictional letter were conflicted indeed: The father was torn between pride in his daughter and concern about her. The ad's deep ambivalence was perhaps the most striking thing about it.

To modern-day eyes, what may stand out most is the word "queer." "Queer" in this advertisement obviously meant "odd"; only a peculiar woman, went the logic, would join such an organization.[2] During the war, the country needed women to be unconventional, to take on new functions and responsibilities, even to enter previously all-male fields and do work formerly restricted to men. Women's departure from traditional roles was portrayed as a patriotic duty, as support for the men who had left those positions and responsibilities to fight overseas. And yet, the use of the word "queer" in the ad (instead of "odd," for example) suggested an unspoken layer in the father's "mixture of feelings."

Indeed, "queer" at that moment carried the hint of a second meaning: It was already, by the beginning of World War II, a way to talk about sexuality and sexual identity.[3] In this advertisement, the dual meaning of the term

mattered. Working as a welder or farm laborer, and more particularly, joining the military, required women to take on characteristics or attributes generally associated with men: their clothing (especially uniforms), behavior, and language, in addition to the formerly male work itself. Here, the word "queer" moved toward the sexually charged meaning it was beginning to acquire in a society that tended to equate mannishness with lesbianism (and vice versa). The ad captured some of the profound concerns about women's changing roles in the wartime world, including changes that were not restricted to women themselves but were also fraught with consequences for men, children, and the culture. These concerns were reflected in other images of the times as well, such as those popping up in newspaper cartoons. Women's expanding roles raised the specter not only of cigar-smoking women with facial hair, but also of feminized men wearing aprons, doing the washing, and minding the babies. To many, it seemed that women were taking over men's rightful place in society.[4]

The fears associated with women's gender roles, gender expression, and possible queerness often troubled an American public struggling with the upheavals of worldwide conflict. Even as the state and private industry worked hard to recruit women into traditionally male fields, Americans worried about the short- and long-term personal and social effects of doing so. Though the problem of maintaining proper gender roles paled in comparison to the deaths of millions, the turmoil of war intensified concerns about matters at home (or *in* the home). Many worried that the social order would be so disrupted by the war that America might never be able to unscramble it.

Though evidence of American anxiety about gender was everywhere, it appeared perhaps most powerfully in the popular graphic art created during World War II. From government-created propaganda to material produced by companies intent on inspiring their workers to greater productivity to advertisements capitalizing (literally) on wartime gender-role changes, graphic art vigorously relayed its ostensible messages while betraying ambivalence about women and their societal roles in wartime America. These portrayals of female "masculinity" and gender-role upheaval during World War II are the subject of this book. I argue that popular graphic art did significant cultural work during those years, providing a platform both to voice and to ease societal fears.

Even as women were being encouraged into formerly male spheres, posters, cartoons, and advertisements approached discussions of gender strategically. There was no doubt that the American public had to be "sold" on

the notion of women's movement into male arenas, and the WAAC ad was designed for this purpose—at least to the limited extent of selling young women on the notion of joining the WAAC. The ad's "father" writes, "Your right to decide for yourself is one of the things we're fighting for," thus reframing the unstable gender situation to make women's advances part of a larger structure of war aims (however surprising to Allied commanders that aim might have been). The ad draws parallels with men's wartime service as the letter continues, "When your brother Bill went into the Army I was mighty proud. The men of our family have always put on uniforms when their country called." The father does acknowledge obvious differences between his son's participation in the war effort and his daughter's. "Frankly," he writes, addressing her femaleness, "in your case other feelings are involved." Moreover, he explains, "you were our first born." Although "it's no secret I wanted you to be a boy," the fictional father writes, he has "never been" sorry that the boy he had desired turned out to be a girl—and he wants her not only to know this, but to understand his inherent hesitations about her wartime plans.

"You know I like *womanly* women—your mother's kind," he tells her. "And watching you grow up in that pattern has been a delight to me." In joining the army, he tells her, she must not sacrifice her femininity and womanliness to a masculine world. Here, the father's voice speaks to the anxieties of a great many fathers and husbands during the war who watched their daughters and wives take on "masculine" work. He wants her to know that, although his approval of women has previously rested on their status as conventionally feminine, he is willing to accept her wartime masculinity as necessary when the "country call[s]." This ad redefines femininity within the wartime context: "I am firm in the belief," he writes, "that whatever your decision is, it won't make you any *less* of a woman—just a wiser, steadier, stronger one." The "father"—and behind him, the writers of the ad—makes no attempt to define his emphasized term "*womanly*," assuming the "daughter"—the readers of the ad—will know what he means: femininity as expressed by "homey" occupations and women's accepted, expected behaviors and emotional characteristics, such as tenderness, gentleness, love of family and tradition, and, of course, heterosexuality—no queerness at all.

He does not mention sexuality directly, but it is strongly implied; lesbianism was often coded as "manliness," because entering male spheres, to this way of thinking, might also imply assuming a manly sexual role in regard to other women. The amorphous nature of terms such as "womanly," "feminine,"

"queer," and "sexuality" is one of the modern challenges to understanding World War II–era conceptions of gender and gender roles. If the term "queer" was often pejoratively used, oddly, female masculinity was not necessarily perceived as disqualifying for a WAAC (or later, WAC [Women's Army Corps]) enlistee.[5] The military specifically needed women who could perform traditionally male work, and military examiners were sometimes counseled that "women showing a masculine manner may be perfectly normal sexually and excellent military material."[6] Thus, masculine women, if not specifically lesbian ones, were actively sought for military service. Ads such as this one were specifically directed at broaching, and then tempering, anxieties revolving around gender expression and women's roles.

In some sense, the recruitment of women into previously all-male spheres allowed them to agree to, and become comfortable with, their own masculinity. It entailed new kinds of occupations, behavior, clothing, and language and gave women permission to walk a line between the old and new ways. Both women and men often responded to this novel masculinity with ambivalence or even hostility. But the conflict boiled down to social anxieties versus practical need for at least temporary change as gender shifted in multiple ways for multiple purposes. Here I attempt to understand these changes as they were understood then, using, by necessity, modern concepts of sexuality and gender expression to understand and reframe World War II images of sex, sexuality, and gender.

"Women's Work"

To make sense of the anxieties aired and managed in popular graphic art, it is necessary to understand the actual scope of change in wartime America. "The extent to which World War II altered women's lives and social norms," wrote women's historian Susan Hartmann, "can be fully understood only with reference to the Depression decade." By almost every gauge, and contrary to the popular notion that World War II marked the first time women had entered the workforce, she reported, women's participation in work outside the home increased during the 1930s. By 1930, women's labor-force participation had increased from their first mass entry in the 1890s, rising from 22 to 25 percent, while the percentage of all adult women who were in the workforce rose from roughly 24 percent to over 25 percent.[7] These changes were generally consistent with, if faster than, trends that had been evident since the turn of the century.[8] This was because the workforce was sexually stratified. Sex-linked occupations meant men and women did not usually compete for the same jobs; because they were not

in direct competition with men for jobs, women were able to maintain their relative position in the world of work. Women were also pushed into the labor market during the Depression as the customary breadwinners, the men, suffered unemployment, which reduced family income.[9] Clearly, working women were not an unusual phenomenon by the start of World War II.

This did not mean that working women met with unalloyed success. As historian Elaine Tyler May observed, "although female unemployment was a severe problem, and many families depended on the earnings of both spouses, federal policies supported unemployed male breadwinners but discouraged married women from seeking jobs." Thus, married persons were the first discharged if their spouses were government employees; as a result, 1,600 married women were dismissed from their federal jobs, as were many of those who worked for state and local governments. In addition to losing these kinds of jobs, women in the 1930s suffered the loss of others, including professional opportunities hard won by middle- and upper-class feminists in the 1920s.[10]

The overall result of the employment trends, however, was positive for women, and by 1940, nearly a third of all women were employed. Most of these women worked in low-paying occupations such as light manufacturing, service, and clerical work (this was the "sexual stratification" to which Hartmann referred). Despite the contraction of professional prospects, May noted, and "given the need for women's earnings, the widespread employment of women might have been one of the most important legacies of the depression era."[11]

Men's gender roles were of course also affected by the Great Depression, and this provoked the same kinds of anxieties that were again raised during World War II. In her work on citizenship and sexuality, Margot Canaday observed that, "most troubling of all [about the Depression] was what unemployment seemed to do to American men. Psychologists and social workers believed that unemployment created neurosis among men. Laid-off workers were compared to the shell shock patients of the Great War.... For a while, many workers remained optimistic.... But protracted failure eventually broke them. 'I guess we'll all be wearing skirts pretty soon,' [said] one unemployed man."[12]

Many Americans believed that it was essential for men to provide for their families, equating wage earning with masculinity. Consequently, losing a job deprived the Depression-era male not only of employment but also of masculinity itself, and wage-earning women were the ones who seemed to be taking both. In effect, the loss of nearly 13 million jobs at the height of

the Depression took an enormous toll on the masculine self-image and the self-esteem of men generally.[13] "A trip to the relief office," Canaday related, "meant a total surrender of manhood.... The degradation of male unemployment was complete when husbands began to assume feminine responsibilities around the house."[14] The Depression years spawned a number of anxieties over gender roles, but most focused on challenges to men's masculinity. This was the context in which calls for women's increased participation during the war crisis took place.

Women experienced material deprivation, economic discrimination, and psychological discouragement during the Depression, which made World War II all the more important in improving their lives and status. The war rescued the American economy and sent unemployment rates plummeting. Without enough civilian men to supply labor to produce goods and provide services, the nation turned to its women. With the coming of war, the media, in Hartmann's words, "continuously made women aware of their importance, not alone as mothers, wives and homemakers, but also as workers, citizens, and even as soldiers." Women found benefits in their new roles. As their value increased in the public consciousness, they profited from fresh opportunities to earn income. They entered new fields of employment and performed in a wide variety of areas that had hitherto been reserved for men.[15]

Therefore, World War II was not necessarily notable for the fact that women suddenly went to work, but as part of a perhaps predictable progression: Women worked before the Depression, took low-paid, unskilled work during the Depression (along with more home-centered, unpaid work), and surged out of the home during the war to take higher-paid, nondomestic jobs. This sequence was then reversed after the war, when various social factors, including the return of millions of servicemen to America, (re)moved them from the higher-paid workforce (sometimes by choice and sometimes not), and they ebbed back into more domestic roles.

During the war, more women worked than before in every occupational field except domestic service. Their numbers rose the most in the defense industries, where their representation increased by 460 percent compared to the prewar years. Women replaced men most visibly in factories making aircraft, ordnance, and ships, but they also appeared more frequently in jobs as diverse as musician, airplane pilot, scientist, athlete, and college professor, with their greatest economic gains in formerly male fields like manufacturing. Women's earnings also climbed in traditionally "pink-collar" jobs (that is, jobs that traditionally had been filled by women already). Of most

importance were the opportunities to work in historically higher-paying positions. Women worked longer hours during the war and gained advantages from government and union equal pay policies, which, although never systematically applied, did help to raise women's income.[16] This increased their independence, social status, and parity with men, further increasing their visibility in the world of work.

Much of that visibility, though, was "spun" to reflect the desired image. When the war labor force was in full swing, the "predominant media portrayal of women war workers was that they were young, white, and middle-class; furthermore, that they entered the labor force out of patriotic motives and eagerly left to start families and resume full-time homemaking," wrote World War II historian Maureen Honey. But "this image," Honey said, "is almost completely false." She cited a 1944 Women's Bureau survey finding that only 25 percent of the women working at that time had less than two years' work experience. Nearly half had been in the labor force for at least five years, and almost 30 percent for at least ten years.[17] Hartmann, who noted that during the war the number of women in the labor force grew by more than 50 percent, jumping from nearly 12 million in 1940 to more than 18.6 million in 1945, pointed out that although women worked before the war, the war added to their work experience. Before the war, only 27.6 percent of all American women were employed; by war's end, that proportion had risen to 37 percent. By 1945 working women formed 36.1 percent of the civilian labor force.[18]

While the majority of women did nonessential (nondefense) labor and a significant but smaller number did essential (defense) work, perhaps the biggest change was the swelling number of women in the U.S. military. During World War II, women entered the military in large numbers for the first time. They had served in earlier conflicts in small numbers, though not in any official capacity until the Army Nurse Corps and Navy Nurse Corps were established around the turn of the twentieth century (1901 and 1908, respectively). In previous wars they had been contract and volunteer nurses, cooks, and laundresses; on occasion they had even served in disguise as soldiers.[19] When a few hundred women entered the armed forces in World War I, it marked the first time in American history that regular army and navy military nurses served overseas—although it was without rank—and the first time that non-nurse women were allowed to enlist in the U.S. Navy and U.S. Marine Corps (a handful also served in the U.S. Coast Guard). The army only allowed women as contract employees and civilian volunteers in World War I, but according to the Women In Military Service For

America Memorial Foundation, "when the call came for service in World War II, women's successful participation in World War I was an important precedent for expanding roles of American women in the military and for developing the military establishment's acceptance of women's service in the U.S. Armed Forces."[20]

At the suggestion of Congresswoman Edith Nourse Rogers, and amid much debate, Congress created women's branches for each of the services, and roughly 350,000 women served in the military by the end of World War II. This number included 1,074 Women Airforce Service Pilots (WASPs); 150,000 in the WAAC/WAC;[21] almost 90,000 in the Navy's Women Accepted for Volunteer Emergency Service (WAVES);[22] 10,000 in the Coast Guard's women's branch (SPARS, based on the Coast Guard motto, Semper Paratus);[23] and 20,000 in the Marine Corps Women's Reserve (WR).[24] The number of Army Nurse Corps (ANC) members totaled 59,000; the Navy Nurse Corps (NNC) numbered about 11,000.[25] A large number of women also entered the Cadet Nurse Corps, which trained nurses on the condition that they would join the ANC or NNC after graduation. Suddenly, women had numerous opportunities to serve their country by entering this masculine domain.

And though women in the U.S. military were restricted to noncombat roles, that did not mean they were at a safe remove from war. Even nurses, who served in traditionally feminine, care-giving roles, came under fire in the European, Southwest Pacific, and China-Burma-India theaters, as well as anywhere that troop movements on land or sea carried them into enemy range. Seventy-seven army and navy nurses were captured on Corregidor and held in prison camps for three years.[26] More than half of the 59,000 ANC nurses volunteered to serve overseas in frontline hospitals in war zones; sixteen American nurses were killed as a result of enemy action. Approximately 1,600 army nurses won awards and decorations, including the Distinguished Service Medal, the Legion of Merit, the Silver Star, the Bronze Star, and the Purple Heart; more than 200 died while in military service.[27] Navy nurses were similarly highly decorated and were at stations and on hospital ships that were attacked all over the world, including Guam, the Philippines, and Pearl Harbor on December 7, 1941, where the navy nurses were awarded a Unit Commendation for their bravery and efficiency.[28] A "feminine" job was no guarantee of safety.

The combination of aversion to women's entry into this essentially male milieu and fear for their well-being meant that when women were integrated into the military in World War II, it was not without debate or

conflict. "Because it was considered unnatural for a woman to join the military, she was often considered a deviate of some sort," wrote women's military historian Jeanne Holm.[29] And historian Leisa Meyer noted that "fears of the kind of woman who might flourish in a martial environment . . . threatened the legitimacy of all female soldiers."[30] The societal concerns, as indicated by the ad that included the father's letter, reflected a conflict between the need for women's military service and the difficulties that their service entailed in practice. "The process by which women were integrated into the armed forces revealed the power of war to refashion sex roles," Hartmann wrote, "but also demonstrated the tenacity of conventional beliefs, as military leaders and public officials sought to meet exigencies with the least disruption of the prewar sexual order."[31] The crux of the conflict often came down to the soldiers, sailors, and Marines themselves. Although many men grew to accept and even welcome military women, "collectively," Holm observed, "the attitudes of male peers were rife with an antagonism that took its toll on the morale of the women and was soon communicated to the public at large. . . . Dirty jokes, snide remarks, obscenities and cartoons became commonplace."[32]

Meyer's *Creating G.I. Jane: Sexuality and Power in the Women's Army Corps during World War II* uses a small number of those cartoons to provide insight into the cultural clashes between perceptions of "feminine" and "military" women. Meyer argued that "analyzing military and civilian attempts to create a place for women without disrupting contemporary definitions of 'masculinity' and 'femininity' is crucial to understanding the impact of World War II on gender and sexual ideology and the struggles around gender and sexual identity taking place in American society." The majority of her work is thus devoted to the examination of "the 'women's army' as a means through which to evaluate the discussions and debates over men's and women's 'proper' roles during wartime."[33] This exploration is particularly valuable because military women arguably made the greatest shift in gender-role behaviors and were therefore subject to the most overt, cynical, and sometimes cruel public evaluations of their wartime contributions.

My work builds on Meyer's to explore how, during World War II, the new masculinity was implicitly part of women's wartime changes, and these changes prompted the old Depression-era fears to resurface. As historian Karen Anderson explains, "American women received conflicting signals during the war. They were urged to demonstrate physical strength, mechanical competence, and resourcefulness for eight [or more] hours a day, while being told to be 'feminine' and attractive, weak and dependent on

men during their free time." As much as women were exhorted to go to work as a patriotic duty, they were sternly cautioned against taking a paycheck and a set of welding leathers as license to have traditionally "manly" freedoms. A *Seattle Times* article warned women not to "go berserk over the new opportunities for masculine clothing and mannish actions"; as Anderson observed, "wartime changes did not signal any radical revision of conventional ideas regarding women's proper economic and social roles."[34] Women were expected to maintain whatever made them quintessentially "feminine," both physically and socially, despite the need for masculinity in their new wartime roles.

In fact, with U.S. entry into the war, the ego-wounds of the Depression had little healed, and public reaction to women's ingress into all-male spheres thus often had a predictably negative reaction. Characterizations of women as "mannish" carried an uncomfortable bitterness for both men and women. Many women who were in the military or the production labor workforce during the war, in fact, still resent their characterization as lesbian because of their wartime masculinity, a description as negative as calling women prostitutes or camp followers, in their view.

Popular Graphic Art

In the years before America's entry into World War II, popular culture in all its forms had huge influence in society. Radio shows filled the airways, and families gathered around their radios to hear them. Magazines and newspapers enjoyed enormous readership. Many of the stories and advertisements promoted the growing technologies of the day, while emphasizing traditional values, with a tone that to us would seem to reflect an astonished innocence. Advertisements urged people to buy "Dr. West's toothbrushes" in "thrilling nylon," instead of conventional boar-bristle, and a model in a highly prefeminist Kleenex ad confided that using paper tissues to cover a public phone mouthpiece "helps me avoid catching germs while I'm catching my man!"[35] According to ads in *Life* magazine, Goodyear "Pliofilm" plastic wrap was "amazing," and in most magazines, every Ford, Pontiac, Packard, and Hudson was touted as bigger and more opulent than the last. Heterosexual love and the wonders of technology were foremost in the pages of popular publications as the nation attempted to pull itself out of the Depression and gear up for an uncertain future.

Against this prewar cultural backdrop of idealized gender roles and American consumerism, the Japanese attacked Pearl Harbor in December 1941. Suddenly, in the pages of American magazines, people focused not

only on love but also on fear—of separation from family members, of loved ones being sent overseas, dying or being maimed or humiliated, in combat or otherwise. Ads for thrilling nylon toothbrushes and Kleenex all but disappeared as all manner of factories underwent "conversion" to make military vehicles and war materiel. Plastic, nylon, and paper were among the hundreds of items that were rationed, recycled, or deferred to concentrate resources on the war effort. Love stories usually featured soldiers or sailors; by the end of the war, approximately 16 million Americans had served in the military, many overseas and most away from home, and nearly every popular song, movie, drawing, piece of clothing, menu item, or household article had *something* to do with the war. War and its conditions governed all, whether someone wanted rationed meat for dinner, sugar-rationed cookies for dessert, rationed-rubber soles for shoes, or rationed-fabric pleats in a skirt. With blackouts imposed against the threat of enemy attack, one could not even turn on a light or open one's curtains at night in some areas of the country. There was no escape, and everyone was involved, whether they liked it or not. As President Franklin D. Roosevelt put it in a radio talk on December 9, 1941, "every single man, woman and child is a partner in the most tremendous undertaking in our American history."[36]

The wealth of images that arose out of such unanimous endeavor provided its own visual culture. We will examine three key forms of popular visual culture: cartoons and comics, advertisements, and war posters. As World War historian Paul Fussell noted, "television had not yet appropriated the popular imagery business,"[37] and thus photographs and graphic art carried even greater impact than they might today. Art was produced by the government, by companies engaged in war production, and by various periodicals. These all used artists commissioned by the Office of War Information (OWI), known as "dollar-a-year men," who essentially donated their talents for the war effort, and publications' own contracted cartoonists (sometimes the same artists), who were usually paid by the piece. I have used cartoons obtained from OWI and published collections, thus drawing from a fairly wide range of images taken from popular publications; I also extensively use cartoons and advertisements from magazines, a rich source of cultural information of the time.[38]

"During the 1940s," wrote Maureen Honey, "magazines were one of the major forms of mass entertainment, and they enjoyed circulation figures high enough to make them important carriers of cultural values." The OWI publication *Magazine War Guide*, for instance, contained several new free OWI cartoons for periodicals to publish each week; it was sent to four

hundred to six hundred magazines with a combined readership of 140 million people. Those four hundred to six hundred magazines were directed to a wide range of interest groups and social classes, and their art, via both subject matter and style, reflected both the editors' and audiences' attitudes toward women. And, as many have noted, an audience's class or ethnic status affects portrayals of women. In wartime, especially, media images of female experience are greatly influenced by the socioeconomic levels of the groups at which they are aimed.[39]

Two magazines I have used heavily for this analysis because of their popularity and influence at the time are *The New Yorker* and *Collier's*. Both routinely printed some of the highest number of cartoons per issue of periodicals of the day, but they were directed to different audiences and reflected different images of female experience. *The New Yorker*, which by the end of the war had a readership of 300,000, and which Fussell has characterized as "sophisticated," was generally directed toward a higher socioeconomic audience, and its cartoons rubbed shoulders with book reviews and poetry.[40] In fact, the cartoons themselves "were always called 'drawings,'" an indicator of both editorial attitudes and perceptions of the educational and income levels of the audience.[41] The bound volume of *The New Yorker* containing the issues dated from August 21 to October 30, 1943, for example, contains advertisements directed at those with an income far exceeding the $2,000 per year of the average American of the time. Ads for Charles of the Ritz (an expensive clothier) run near Elizabeth Arden (a fashionable women's beauty salon). Bergdorf-Goodman advertises dresses at $80 (a small fortune for the working woman, for whom this might be two weeks' pay or more). Tiffany and Co. advertises a diamond and sapphire brooch at $2,050, and Gunther mink coats are marketed from $4,750 to $7,950.[42] The perceived income matched the urbane audience.

Collier's, on the other hand, was, as Fussell put it, "busy promulgating the local values of cheerful efficiency and success." This publication was somewhat more middlebrow (and middle-class) than *The New Yorker*, with romantic fiction filling its pages.[43] Its circulation reached about 2.5 million copies during the war and even higher numbers in 1946.[44] The magazine was inclined to emphasize traditional values, and the fiction tended to be fairly purple and rather provincial. The magazine did not shy away from uncomfortable stereotypes, which were often racially based. One piece, entitled "The Queen of Tijuana," begins, "The cure of a romantic, like that of a drunk, is not always pleasant. But think of the fun they have had." It renders the dialogue between two characters in this manner: "'And so I am dead,'

said El Chino, with conviction. 'Noots,' scoffed the Queen of Tijuana, with a tinkling laugh. 'Noots, Gregorio.'"[45]

Not surprisingly, cartoons from these two magazines tended to differ in style and subtlety. More significantly, both dealt frequently with themes of the (re)negotiation of gender roles across the demographics of their readerships.[46]

Significant themes, in fact, were rarely dealt with realistically in the graphic art of the time (for example, photographs of American dead were released only strategically). Popular graphic art was kept to a lighter tone, particularly cartoons and comics, which were much more prevalent then than now.[47] As modern cartoonist Bill Watterson has noted, cartoons and comics were "visual, easy to understand, funny, boisterous, and lowbrow by design and hence immediately popular." Newspapers ran them because they dramatically increased readership. Omnipresent in American culture during the first half of the twentieth century, the comics pages of the newspaper were just that: pages and pages of story-lines with beautiful and powerful artwork, with a single Sunday comic strip often filling an entire newspaper page.[48]

World War II was the height of the "Golden Age" of comics. Comics and cartoons surged in popularity between the mid-1930s and the Comics Code of the mid-1950s, which sought to regulate production and sale of comic books, which were thought to corrupt children and promote vice.[49] The archetype of the superhero was created during this Golden Age; most were male, but not all. Wonder Woman, created just before American entry into the war, became an icon for girls and women, embodying qualities of strength, intelligence, autonomy, and power.

Comic strips were among the most popular sources of cultural heroes and heroines during the war. Seventy million Americans read the daily comics in newspapers, and sales of comic books grew from 12 million copies each month in 1942 to more than 60 million in 1946. And these productions provided an unparalleled means to alter public opinion concerning women's wartime activities and roles. More than 80 percent of boys and girls aged six to seventeen read comic books regularly during the war. Both daily strips and comic books were quick to reflect the new situations created by World War II, and thus young people also saw favorite characters assuming wartime functions.[50]

World War II also changed how cartoons and cartoonists were received. In the early days of comics, cartoonists (political or otherwise) had few, or perhaps erroneous, ideas about the artistic and cultural significance of their

work.[51] Cartoonists such as Bill Mauldin, who won his first Pulitzer Prize when he was attached to the 45th Division, altered perceptions, both for the public and for other artists, of what a wartime cartoonist could do. The satirical sketch style of cartoons was used, much as it had been for political cartoons, to convey not only humor but also deadly serious ideas, information, and emotions. When he first began, Mauldin noted, "the gag man's conception of the army was one of mean ole sergeants and jeeps which jump over mountains." Despite his wartime experiences, often close to the front lines, he still felt too young to judge the war's failures and successes, but he did understand the schism between perceptions about cartooning and its reality. "Since I'm a cartoonist, maybe I can be funny after the war," he mused, "but nobody who has seen this war can be cute about it while it's going on." Mauldin's first Pulitzer Prize–winning cartoon had a decidedly uncute tone. It shows a worn American soldier, eyes downcast, rifle shouldered and turned upside down against a driving rain, walking beside German prisoners of war along a European street. Some of the Germans are wounded, but they and the Americans look equally miserable. The caption reads, "'Fresh, spirited American troops, flushed with victory, are bringing in thousands of hungry, ragged, battle-weary prisoners.' . . . (News item)."[52] The gap between rhetoric and reality loomed large. As historian George Roeder has noted, Mauldin's cartoon "visually measured the gap between this experience and official reports of it."[53]

There weren't only "official reports" of events: Cartoons were also produced and collected by amateurs. Letters from soldiers were decorated with cartoons depicting life overseas, drawings of other servicemen in combat, or other situations. In the enormous quantity of letters and "V-mail" ("Victory" mail, letters reduced to microfilm to save space in wartime air transport overseas, then reproduced for military personnel) produced during World War II, people on the home front wove cartoons throughout text and embellished missives to their loved ones with descriptions of life at home.[54] Cartoon panels were often gathered, sent to servicemen and women, and pasted in scrapbooks. If wartime photographs were rationed, censored, and timed for greatest effect, cartoons had a homey, friendly ubiquity to them. Some amateur cartoons were better than others, but almost anyone could draw them, and they could be tailored to reflect very personal situations. Home collections also spoke to private perceptions of public circumstances. The State Historical Society of Wisconsin, for instance, houses a collection whose amateur editor had painstakingly cut out every single panel from

a selected feature for multiple cartoon features, producing something not unlike the modern cartoon collection books. The resulting albums (made of the panels pasted onto poor-quality recycled World War II paper) are clearly some of the first "collected" volumes of single cartoon features, however informal, and they fill dozens of scrapbooks.

These "vernacular" cartoons show how widespread the audience was for cartoon and comic images. A number are stored in the Veterans' History Project at the Library of Congress. One sample has a collection of perhaps eighty envelopes covered with cartoons depicting life in the Solomon Islands for a group of servicemen. One of the men had had an artist friend of his decorate each of his letters home to his wife with caricatures of everyday happenings and people. A piece of V-mail shows an officer's wife's attempt to construct a "newspaper" about the family for her husband. She decorated it with cartoons that cover the page and fill the margins. The notion that comics and cartoons were produced exclusively for or read only by children is patently disproven by the thousands of images consumed by adults during the war.

These cartoons meant so much, even to adults, because they provided a way for readers to assimilate all of the frightening and unfamiliar situations in which war had placed them. They helped people cope because they "poked unabashed fun at the home-front chaos of shortages, spy scares and rationing," according to one account.[55] Another writer commented, "When a war comes, the folks at home get pretty funny, and the cartoonists have a field day. All they have to do is put down what they see." What most (civilian) cartoonists saw in World War II was "stayhomers running around in crazy little circles...wearing uniforms, helmets, armbands, welders' hoods and slacks...blowing air raid whistles, collecting old pots and pans, planting asparagus, painting their legs [nylon for stockings was rationed, so women made do with "trompe l'oeille"]...thinking up slogans, designing posters and criticizing each other." "Most of this ado," he continued, "is just home-front hysterics—a nervous mass effort to compensate for the essential inability of folks at home to do anything really important about a war."[56]

In fact, cartoons of all sorts did essential work in the World War II era: They broached subjects that were unfamiliar, painful, or awkward; they made those subjects accessible or agreeable by their friendly, informal style of image and text; and they conveyed information that both official and unofficial sources considered important. Even non-OWI cartoons carried valuable messages. Cartoons swayed the public to the nation's wartime

goals—production, recruitment, rationing, recycling—and "lightened the loss" that went along with worldwide cataclysm.[57]

They also provided a way to explore how female power and autonomy related to women's new masculinity, how that female masculinity might feminize men, how it might mean that women were sexually threatening, and how it might be linked with lesbianism. Although that might seem a tall order for a cartoon, many popular cartoon heroes and heroines neverthe-less enlisted in the war effort, providing lessons in coping with home-front problems, such as women working and joining the military, and encourag-ing their readers to conserve goods, buy war bonds, and reach for other OWI-stated goals. Other wartime comic strips—Wonder Woman, for in-stance—showed women as more than wife, worker, and mother and gave women a starring role in defeating the Axis powers. Of all sources of graphic images of women, comics pushed the envelope of acceptable female behav-ior the most.[58]

In fact, in a circular dynamic, by modeling ways in which women could assume masculinity, cartoon and comic characters became behavioral icons for women's new roles. By offering a site for negotiation of social anxiet-ies about women and their new roles, cartoons and comics gave women a wider range of acceptable power and freed the way for them to exhibit masculinity.

Another form of popular graphic art that experienced a tremendous up-surge during World War II was the war poster. Although posters had been used to recruit servicemen for World War I and to publicize the Civilian Conservation Corps (CCC), the Works Progress Administration (WPA), and other government-sponsored programs during the Great Depression, World War II took posters to new heights. As World War II art histori-ans William Bird and Harry Rubenstein have explained, inexpensive, ac-cessible, and ever-present World War II posters, deriving their appearance from the fine and commercial arts, helped to mobilize the nation. Because they were ideal for promoting Allied aims as the personal mission of every citizen, government agencies, businesses, and private organizations issued a large array of posters linking military and home-front goals.[59]

An enormous number of posters were created by and for OWI, but plant managers, company artists, paper manufacturers, and others also seized upon the poster as a tool to increase production and "sell the idea that the factory and the home were also arenas of war." In posters, according to wartime advertisers, the "average working woman . . . was idealized as a fashion model in denim," helping to recruit women into the workforce.

"This carefully glamorized image was intended to convince women that they would not have to sacrifice their femininity or attractiveness for war work."[60]

Theory of Female Masculinity

Because the notions of "femininity" and "masculinity" occur so frequently in wartime popular culture, how they relate to the study of World War II deserves discussion. What this work describes as "female masculinity" is based on a modern theoretical concept. Judith Halberstam's 1998 work *Female Masculinity* articulates the idea that masculinity is not produced solely by males and in fact "becomes legible as masculinity where and when it leaves the white male middle-class body." Halberstam has different goals in her attempt to disrupt the gender binary, but her notion of masculinity attached to the female body is a useful lens with which to approach mid-twentieth-century America. Her work is an attempt to see what is so ingrained in our culture that it is often unseen; she attempts to bring female masculinity "into view," and this is a functional practice looking backward into the war years as well.[61]

I have used the theoretical concept of female masculinity in part because of the link that people saw during the World War II era between gender, masculinity, and sexuality. Needless to say, not all women who bucked rivets, welded steel plates, or machined parts while wearing pants and boots were lesbian; likewise, not all lesbians bucked rivets and wore pants. Because gender and sexuality are so nuanced in their expression and varied in their reception, what is important for this study is not only who exhibits masculinity, but how much, with what (un)conscious purposes, and what these things mean to those who witness them. These issues are particularly important when examining wartime graphic art, which was especially apt at both reflecting and affecting popular attitudes, and which could be read so differently by different audiences, opening up possibilities as much as shutting them down. The war occurred during an era when understandings of sexuality, sexual identity, and gender expression were considerably less shaded than they are today. This limited understanding was juxtaposed against the need, and hence some social acceptance, of women's wartime masculinity. What matters is not so much whether women had sexual relationships with other women but how, at the time, masculinity and lesbianism were connected.

There are concerns, of course, about using modern theoretical notions as a foundation on which to base examinations of a society at war nearly

seventy years earlier. There is a strong danger of presentism, ignoring the historical context of the war and wartime American culture to explain and interpret notions of gender and sexuality from the past in the terms of the present. But one need not choose between applying present perspectives inappropriately and not applying them at all: I prefer the option proposed by Halberstam, who, for her own work, chose "a *perversely* presentist model of historical analysis . . . that avoids the trap of simply projecting contemporary understandings back in time, but . . . can apply insights from the present to conundrums of the past" (emphasis mine).[62] This approach also seems appropriate for my study, and I have thus attempted to avoid anachronisms in discussing queerness and lesbianism in the early 1940s, when these notions were little expressed and fearfully regarded, while keeping in mind insights gained from the women's studies of our time. It is highly difficult to look back seven decades and try to assess whether a woman's wartime military service led to deep emotional and/or sexual relationships with other women, whether she integrated those relationships into her life, and if so, how. Even now, women who came of age during that era may have lives intricately interwoven with other women, sharing living space, finances, and bedrooms, but resisting a lesbian identity.

From a larger perspective, popular culture sources also generally explore women's wartime *progress* rather than the racial or gender discrimination they faced; scholars of World War II, however, do investigate women's subsequent postwar reverses and the long-term effects of those advances. As John W. Jeffries has noted, "The identification of World War II as the Good War is essentially a postwar phenomenon, a product to an important degree of nostalgia and selective memory, of movies and the media, and of changing times and lengthening perspectives." The war was still a time of "Jim Crow discrimination and segregation for African-Americans, of limited opportunities for women, of the incarceration of Japanese Americans," and even American anti-Semitism, societal features that are hardly sources for nostalgia.[63] Ultimately, it seems that popular and scholarly views of World War II are widely contrary, with the picture of Rosie the Riveter flexing her muscles on tote bags and action figures at odds with the women struggling against sexist attitudes so often recorded by researchers.

If, as Jeffries noted, our view of the war has been shaped by two widely accepted perspectives—that it was a "Good War" of "national unity, virtue, and success," and that it was "a 'watershed' or turning point in the nation's history, marking fundamental change," what continues to be at stake for all research of women in World War II is the significance of the era to

women's ultimate role in American social structure, in integral positions in the workforce as well as the family.[64] Scholarly claims that war accelerated the movement of women into the labor force over the long term are counterbalanced by those asserting that war had no permanent impact on women's participation rate. And although most scholars agree that the war was a lynchpin in making women's combination of home roles and paid employment acceptable, others are split as to the strength of the war's progressive impact in regard to its basis for the emergence of Second Wave feminism.[65] The war was unquestionably a time of enormous advances for women, but questions remain about whether those advances were lasting. Were women's progress and social status consistent over time, or was the war an irregularity? In other words, were the advances women made in wartime the catalyst for long-lasting changes, or simply short-lived departures from the status quo?

To examine the evolution of women's roles, I have used forms of popular culture that enjoyed extremely high circulation during the war. Popular graphic art of that time is unique in part because its depictions of women flew under the radar of feminist scrutiny as we now know it. Frequently seen through Rosie-colored glasses in revisionist history, women's gains were not whole-heartedly embraced in their time. Cartoon and comic images also tended to be discounted either as humor ("It's just a joke; it has no real meaning") or, in the case of cartoons and comic books, as productions of questionable worth aimed mostly at children.[66] Yet it is critical to understand the power of images to influence behavior, goals, and social acceptance in an era when all was in upheaval.[67] As George Roeder observed, "the war gave a focus and intensity to American visual experience not matched for any sustained period before or since."[68] The visual rhetoric of the time provides a crucial resource of implicit and explicit attitudes toward women's expansion of gender expression that was not replicated in any other production of the World War II era. Graphic art's mass appeal, its ubiquity in the 1940s, and its unique revelations about women, gender, and social place in American customs during that time reveal it as a precious mine of cultural information. This work seeks, in the best sense, to exploit that mine.

One might well ask why this work concentrates to such a great extent on other images when Rosie the Riveter is so clearly the most famous one from World War II. As I began my research several years ago, I started to see that Rosie was representative not only of working women in World War II, but also of the thousands of images that *showed* women working during that

time. At every turn, I saw representations of wartime women, in cartoons, comics, and advertisements, and I became aware of how vast this trove of imagery truly was. Rosie the Riveter was not, by any means, alone; she was the tip of the iceberg. I aimed to dig past the tip of that iceberg and show the richness of the source material at hand.

Chapter One lays the groundwork by showing that the images produced through the Office of War Information were used as visual propaganda to recruit women into the workforce and the military. These images were often the site of negotiation for the changes in gender roles the U.S. government required to meet its war-production needs. These representations of newly masculine women were also used to help Americans deal with social anxieties about those changes.

Building on this analysis of OWI's uses of visual propaganda, Chapter Two further explores definitions of femininity and masculinity, using cartoons and war posters to investigate how images of women at civilian work and in the military defined the culturally understood boundaries (as demonstrated in the WAAC ad) of "womanliness" and "manliness." Although some depictions reinforced traditional gender roles, others played with the anxiety that women's masculinization might have unforeseen negative consequences. These images implicitly argued that women should maintain femininity despite adopting masculinity "for the duration" of the war. Still other images dealt with the fear that masculinized women might feminize men, pushing the boundaries of femininity and masculinity to even more uncomfortable frontiers.

Chapter Three goes into perhaps the most uncomfortable of these frontiers: images of women's sexuality. Arguably the most sensitive area of women's masculinization, depictions of women's sexuality in popular graphic art demonstrate the line that women walked: A woman was both encouraged to express her "feminine" sexuality and to restrict it, so that she might be perceived as accessible but neither promiscuous nor lesbian. The military was an especially problematic organization. While ostensibly promoting women's self-regulation, it acted *in loco parentis* for women, regulating a possible public-relations nightmare and protecting women's virtue under the guise of providing discipline. It sent very different messages about sexuality to male soldiers, however, especially concerning "sex hygiene," and this provides an interesting contrast to its treatment of women. Finally, images of women's sexuality portray that sexuality not as liberal, individual, private expression but as threat both to men and to prewar definitions of femininity.

Chapter Four examines the most threatening of women, those who were physically or authoritatively powerful. A strong woman, in these images, could be seen as "mannish" or lesbian, but she could also show strength in acceptable ways, especially if she was "managed" in some manner. The images showed women controlled or supervised by men, thus lessening their emasculating qualities. Central to this chapter is an exploration of a comic-book storyline featuring Wonder Woman, whose rise in popularity was based on her wartime appearance.

Finally, Chapter Five presents images of American society's, and women's, "reconversion" at war's end, revealing that not only the economy but also gender roles changed back to constructed ideas of prewar standards. In order to keep peace with millions of returning male veterans, many women, graphic art shows, surrendered their masculinity as the war drew to a close.

The Epilogue deals with the life these World War II images have maintained after the war. Some of the images and female characters became icons of Second Wave Feminism, having been recast as symbols of female power, autonomy, and freedom. As such, these World War II–era representations became emblems of women's strength and cohesion. Although the wartime images of female masculinity are often taken as charming mementoes of a long-past time, they are now humorously recast as hopelessly outdated tokens of women's subordinate status. They also have a certain "queerness," as having encouraged a "butch" quality in women, revealing or perhaps pushing them toward lesbianism.

Coming from a time when women still did not commonly wear trousers, these mementoes from the past signal the dramatic changes World War II brought to women and the mixed feelings with which those changes were received. Through this analysis, we can begin to understand why, for instance, in a cartoon from *The Saturday Evening Post*, an elderly man, who is watching women try on slacks in a department store, would growl, "Ask me how I like them . . . go on, ask me . . . just ask me once!"[69] What is most important for this writing, however, is not just the changes wrought during the war but also the work done, not only *by* women, but also *for* and *to* women, by popular graphic art, and what that work later meant for women seeking liberation from tradition. During the war, female masculinity provided for an expansion of people's ideas of what women should be and how they might behave. It thus provided a canon of images to inform future versions of feminism.

1

From Bathing Suits to Parachutes, or, "Don't Call Me Mac!"

OWI, Ambivalence, and "Women's" Work

During World War II, there was an exciting and dangerous tingle in the air when the subject of women and their new freedoms came up. One cartoon showed that people already understood that something new was afoot. Entitled "Letting the Genie Out of the Bottle," it depicted a tiny, balding man in spectacles looking up at a "genie"—his wife—who is ten or fifteen times his size. The "bottle" out of which she has erupted, in a cloud of smoke, is their home. The husband is wearing an apron; the wife is wearing a hat, coveralls, and gloves. He is holding a frying pan and a broom; she is carrying a large hammer and a lunchbox. Into her back pocket are stuffed several additional tools, and significantly, a package marked "$" and "HER OWN MAN'S SIZE PAY ENVELOPE." The tiny husband waggles his finger up at his gigantic wife: "But remember[,] you gotta come right back as soon as the war is over!" The enormous woman smirks, as she heads toward a skyline of smoky factories, "OH, YEAH?" (see Figure 1–1).[1]

The chilling implication of the cartoon—that a woman with a pay envelope could enthusiastically flout convention, leaving the home and striking out on her own—was just the beginning of the story. The woman's gigantic size suggested society's gigantic fears that women would never go back into the "bottle"—and American society could never go back to the way it had been before the war. The cartoon symbolized the fears Americans felt about

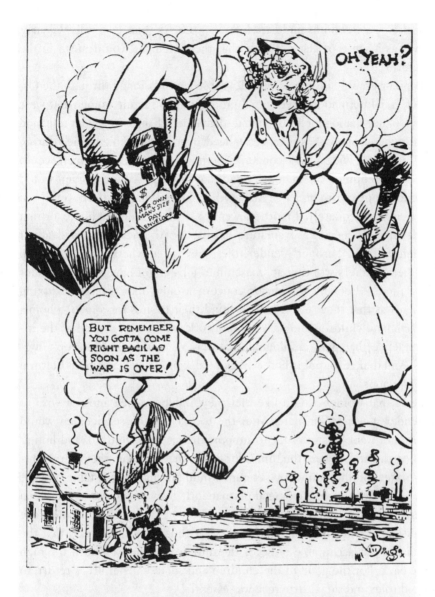

LETTING THE GENIE OUT OF THE BOTTLE

The Des Moines Register & Tribune, 1943

Figure 1–1: Postwar fears: great big masculinized women; teeny tiny feminized men. Source: *Jay N. ("Ding") Darling*, Des Moines Register and Tribune, *1943. In Monika Franzen and Nancy Ethiel*, Make Way! 200 Years of American Women in Cartoons *(Chicago: Chicago Review Press, 1988), 131, and* Ding's Half Century, *by Jay N. Darling, edited by John M. Henry (New York: Duell, Sloan & Pearce, 1962). (Courtesy of the Jay N. "Ding" Darling Wildlife Society. Used by permission.)*

women's new freedoms and the shifts in women's roles generally. Clearly, there was a sense of alarm about what these changes would mean in the long term.

Popular graphic images, especially those commissioned through the Office of War Information, used visual propaganda to recruit women and were the site of negotiation for both the state-demanded changes in gender roles and social anxieties about those changes. Indeed, images of working women during the war reveal widespread concerns. Some suggested that women would become unfeminine or "mannish," and that these masculine women would somehow replace or challenge men. Others hinted that children would not be cared for adequately if mothers went to work outside the home, or that children might become premature adults. As Americans worried about women violating "proper" gender roles, they asked whether children who saw their mothers working at "masculine" jobs might have skewed gender orientations. Probably the major concern around masculinized working women was that they would leave behind their desires for a man, a home, a hearth, and children and actually *like* work and its pay, as well as the independence that paid employment conferred, as the genie cartoon suggests. And that, most published work agreed, would have enormous cultural repercussions.

Fears that women would like their new independence and not wish to surrender it were legitimate. After the war, 16 million servicemen would return and want jobs in order to support their wives, children, and homes and hearths, which were the things for which they believed they were fighting.[2] Sixteen million unhappy veterans would not make for a stable postwar America; if gender roles changed permanently for women, the whole social order would have to change with them. Those who worked to promote the expansion of women's roles during the war thus also emphasized that the expansion was acceptable only for the duration of the war, until the men came back. For the good of the children and society generally, a return to the old roles and social structure was essential.

Though many American women had worked during the Depression, World War II provided an unmatched opportunity for women to work in untried male spheres in large numbers. Although the undesirable circumstance of war was the impetus for them, the new defense factory jobs and opportunities for military service were seen by many women as a chance to prove what women could do.[3] Women's historian Karen Anderson has called the "liberative potential" of wartime changes "undeniable," noting that the cultural changes of a wartime society can cause people to challenge

traditional assumptions and practices. Men leave the home front to become part of the war machine just when demands for production are greatest, and conventional distinctions between "women's" work and "men's" work are put under great stress.[4] The "liberative potential" of World War II was not missed by millions of American women (and men). The very limits of gender behavior and expression were challenged.

During the Depression, even "Mrs. Franklin D. Roosevelt" struggled with the challenges to "normal social patterns." In the Foreword to her book *It's Up to the Women*, Eleanor Roosevelt cited examples from history and fiction to show what nations have expected of women during times of crisis.[5] Her understanding of women's roles was fairly traditional. She wrote, for example, that, "it seems to me perfectly obvious that if a woman falls in love and marries, of course her first interest and her first duty is to her home." Nonetheless, she noted that the woman's "duty to her home does not of necessity preclude her having another occupation," thus acknowledging not only the possible necessity but also the potential desire of a woman to work. She never suggested that a woman might desire that occupation in place of, rather than in addition to, her household duties, which fell with little question into the lap of "the mother of a family." Roosevelt, though, made clear that she "never like[d] to think of this subject of a woman's career and a woman's home as being a controversy."[6]

Eleanor Roosevelt set a bold and public example of what women could do, substituting for polio-impaired FDR in places difficult for him to access. A well-known cartoon of the time shows miners at the bottom of a dark coal shaft. One of the miners shines his headlamp down a shadowy passage and exclaims, "For gosh sakes, here comes Mrs. Roosevelt!"[7] Her analysis of the Depression would as much describe World War II: "In this present crisis it is going to be the women who will tip the scales and bring us safely out of it."[8] She encouraged other women to take up work—not by claiming that women were necessarily substituting new behaviors for old ones, but by making the case that women could do all kinds of work because they had always done so in times of crisis.

Ultimately, women working during the war *were* a major factor in the Allied victory. Women's assumption of formerly male jobs, often out of sheer necessity, prompted women to take on the mantle of masculinity and pushed the boundaries of acceptable conduct. Unquestionably, the blurring of gender-norm lines during the war was highly disruptive to traditional notions of what constituted "appropriate" female behavior. But, like the necessity of breadwinning during the Depression, which also made

working outside the home a woman's duty, the necessities of war demanded it. Though today we might view the expedience of wartime gender-role changes cynically, at the time they were cast as permissibly liberating. They resulted from performing a duty, and that duty took precedence over the maintenance of gender norms. State-sponsored encouragement for women to work equated, essentially, to state-sponsored permission to take up a new masculinity. Even the military, formerly an all-male bastion, now actively recruited women into its ranks. Women who joined the WAC often saw it as a unique opportunity to gain freedom and independence enough to see the world.[9] They were able to do this, though, under the aegis of "Free[ing] a Man to Fight," whereby their service freed a man for combat or overseas duty. Women's masculinity was thus not only a consequence of wartime duties but also an expression of patriotism.

Patriotic wartime duties, however, did not preclude anxiety over the adjustments in women's roles; indeed, their replacement of men was the lynchpin of anxiety concerning gender-role change. And the anxiety was especially pronounced when women entered the military. The thought that one is replaceable—especially by a woman, and especially for combat soldiers—gains uncomfortable reality during wartime.[10] As the blue stars on window banners (signifying family members in military service) were replaced with gold stars (for family members killed in service to the country), families across America were all too aware of the dangers of the war for the men who served. So, if a woman appeared to be replacing a man by "being masculine" (entering the masculine military), the response could be vitriolic in both military and civilian circles. Women in the WAC, for instance, were subject to an ugly smear campaign that impugned the character of women who served. The smear campaign was ultimately attributed to male soldiers.[11] The smearers often implied or stated outright that Wacs were prostitutes; an equally damning accusation was that they were lesbians, or "mannish." The slanders had a menacing tone that indicated that women had crossed the line of acceptable wartime female behavior in a shocking, scandalous, and unsanctioned way by "replacing" a man sexually.

Worries over whether or how women could replace men in the workplace, and the consequences of that replacement, were widely cited in cartoon panels and series. The images often portrayed a civilian workforce that cheerfully welcomed women, when, in reality, men in factories were frequently "profoundly prejudiced" against women workers, hissing and whistling at them as they entered formerly all-male space.[12] A newspaper cartoon from the OWI files, entitled "Beware of Tank Traps," expressed

the pitfalls awaiting the armament-bristling tank of "U.S. WAR PRODUCTION." Various spikes, labeled "Labor Discrimination," "Ignoring Safety Rules," "Absenteeism," and the like, are pointing toward the tank, posing hazards that might cripple it. In the forefront of these traps, prominently labeled, is "Prejudice against Women Workers." The OWI was attempting to create in reality what it had already created in images, encouraging women to enter the workforce. We *have* to take women workers, was the message; the women stand between us and defeat.

Both men and women worried about women's entry into the workforce. Men's objections and resentment stemmed from their fear that women were taking away their jobs, that men "wouldn't be able to undress in the shop and work half nude like they did before," as some workers complained, or that women would otherwise interfere with their work and distract them.[13] One cartoon attempted to treat this situation humorously: It shows a male welder commenting to a masked counterpart, "You know, Bud, I'm glad there are no danged women working on this job!"—not noticing that "Bud" is wearing high-heeled pumps below "his" coveralls.[14] The image of "Bud" in heels is full of irony: Not only has the male welder not noticed his co-worker's footwear, but apparently her job performance is not recognizably different from a man's.

Women also worried that their replacement of men in formerly male jobs could make them masculine. Since social standards weighed heavily against masculine women, some women fiercely guarded against their "gentrification." "Bud," for instance, is wearing all-male work gear, except for the feminine shoes. A *New Yorker* cartoon has a woman worker addressing a male worker while on a lunch break. The man, chewing his sandwich, is looking anxiously at the woman; in headscarf and overalls, she is tartly ending a reprimand, saying, " . . . and don't call me Mac!" (see Figure 1–2).[15]

The fact that men and women could now be seen as competing in the same worlds was received with great ambivalence. The unease with role reversals and redefinitions caused confusion and discomfort. One civilian cartoon has a Wac and a sailor, both with luggage, saying goodbye at a crowded train station. "Let's get this straight," the Wac is saying to the sailor, "—who's going to wait for whom?"[16] This scenario reflected real life, even in situations where the woman was in a traditionally female occupation: One history, recalling how an army nurse deployed for European service before her army-officer husband, noted, "It was ironic that Claudine was leaving for the front before Frank. . . . Both remarked on how strange it seemed for a husband to be saying good-bye to his wife, who was

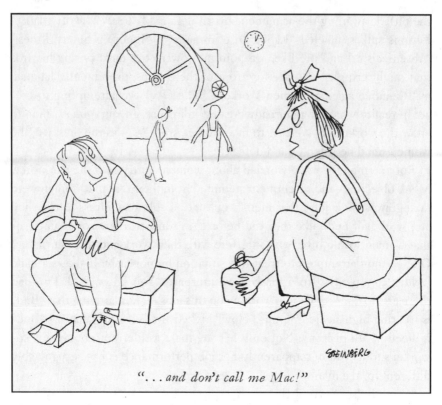

Figure 1–2: Guarding against "gentrification": consequences of being accepted as "one of the boys." Source: *[Saul] Steinberg,* New Yorker, *December 4, 1943, 30. (© Saul Steinberg, The New Yorker Collection. Used by permission.)*

being shipped to a combat zone."[17] As far as the military was concerned, in the "line services" (not the Nurse Corps), marriage neither disqualified a woman to serve nor resulted in her discharge. The Army Nurse Corps allowed marriage but did not permit couples to be assigned to the same station.[18] (The military appears not to have kept records of how many women deployed before their husbands.)

The task of helping American society adapt to the strangeness and uncertainty of the wartime gender situation fell to the OWI, which was established in the Office of Emergency Management by executive order in June 1942.[19] The Domestic Branch of OWI served, in the words of an official memo, "1. To keep people better informed on war news, and 2. To provide and supervise the operation of Information Programs" supplied by the government to "tell people the *what* and *why* of public cooperation needed

to sustain the nation's war effort." This would theoretically counteract the confusion and indifference government organizations (such as military recruiting commands and the War Manpower Commission) believed that "Joe and Jane America" would feel at the huge influx of information coming their way from multiple war agencies.[20] To be sure, the vast number of governmental urgings directed at the public could easily have caused bewilderment and apathy. The directives concerned many different things. The OWI encouraged the public to do the following, for example:

Stop food waste
Produce more food
Observe rationing
Refrain from spending
Conserve clothes
Get a war job
Refrain from traveling
Use less fuel
Stop careless talk
Winterize the home
Save household fats
Salvage scrap metals
Salvage tin cans
Salvage waste paper
Join the Crop Corps
Join the WACS
Join the WAVES
Join the SPARS
Join the Marines
Get an essential civilian job
Get proper nutrition
Prevent sabotage[21]

And there were many other similar directives. Considering this daunting list, it is not surprising that OWI sought ways to convey these messages in palatable, understandable, and even amusing formats.

Of the Office of War Information's many roles, one of the most important was to recruit women to enter civilian work or military service. This was critical because, unlike their British sisters, who were conscripted, American women worked and enlisted on a purely voluntary basis. The issue of

women's work was being addressed over the radio, as "millions of women who *could* work [were] still unmoved by feelings of personal responsibility in the war effort," one OWI document noted.[22] OWI radio spots like this one, directed toward women, played regularly:

ANNOUNCER:
Ladies! Are you accepting the full responsibility of being an American woman living in 1944? Your country needs your full energies *now* more than at any period of its history. This is a tough year. And it's going to be increasingly tough. Men and still more men must be landed overseas every week to replace those who are wounded, captured or killed. Meanwhile, warplants at home must run full speed ahead to supply those men with weapons. . . . Essential civilian services must be carried on. . . . Men inducted into the Army, Navy and Marines must be replaced on the jobs they are leaving. Right here in __ (city) ____, there are ____ (no[.]) ___ jobs for which women are needed. No one of them is as dramatic as the dropping of a bomb on Berlin, but it is just as much a part of the war. Will *you* take one of these jobs? Look in the Help Wanted column of your newspaper, then visit the United States Employment Service office of the War Manpower Commission *today*. Get in step with America at war! The need is urgent—and the time is *now*.[23]

That message and others like it took up the problem of reticent women, but men still also needed to be convinced. In another radio ad:

ANNOUNCER:
Now—an urgent appeal to the men of ____ (city) _____. Is there a woman in your home with extra time on her hands?. . . . *Please don't insist that she stay home.* She is desperately needed in a war job . . . and there are several she can do, even if she's never worked before. She can put her pay—and it's *good* pay—into war bonds. She'll experience an immense satisfaction in contributing her bit to the war effort. Every woman at work helps speed the end of the war, and the safe return of *more* American boys. So be understanding—lend a hand with the housework—tell her you'll be *proud* if she takes a job. Turn right now to the help wanted column of your newspaper, and discuss with her a warplant or essential civilian job right here in __ (city) ____ that she might do. Then send her today to the Office of the U.S. Employment Service of the War Manpower Commission at __ (address) ____. The

more women at war—the sooner we'll win—and *your woman is needed.* (Emphasis mine; ellipses in original)[24]

These highly gendered messages promoted both women's working (to female *and* male listeners) and men's compliance with social and nationalistic needs. Women were encouraged to view taking a job as a patriotic demonstration of their citizenship; by "get[ting] in step with America at war," they could vicariously exhibit the equivalent of "dropping a bomb on Berlin"—which was far more exciting than recycling kitchen fats. The ad made an emotional appeal to women, reminding them that they would replace the "men and still more men" who were "wounded, captured or killed." The ad uses vivid words and phrases: "Your country needs," "full speed ahead," "dramatic," and "women are needed."

The ad directed at men, however, seems slightly less vital and more conciliatory. Men should not "insist" that women should stay home. They needed to understand that "their" women were desirable for war work—although clearly housework was still considered women's domain, with men only "lending a hand" as a concession to wartime deprivations. A woman could make "good pay," but (in accordance with other OWI campaigns) she could put that pay into war bonds. If the ad had said the money women earned could be used to help support the household, or to gain independence, it might have detracted from the ad's appeal to men. The woman would experience "satisfaction" at her work, not a dramatic realization that she was replacing wounded or killed men.

Women had to recognize that they were now a valuable commodity, despite the fact that many still apparently required permission from the men in their homes to take jobs that the country needed them to take. Many images and advertisements showed that women's societal value increased dramatically in a nation at war. Appeals for them to enter the workplace, especially, were a sign of women's worth and importance in a culture that had to a great extent rated their desirability only in terms of their faces and figures.[25]

Those who were charged with persuading the American public to support the war effort in these tangible ways gradually came to understand the importance of visual images. An internal report from the Bureau of Publications and Graphics written in 1942 bemoaned the lack of such images: "A taxi ride through the City of Washington reveals practically no graphic evidence of the greatest struggle in history," the report lamented. "It is something of a disgrace that a country whose graphic resources are greater

and more advanced than the rest of the world combined has not, after nine months of war, posted stirring messages on every available vertical space." "Needless to say," the account continued, "government posters cannot continue to be conspicuous by their absence." The report noted that "private printing concerns and commercial groups" had already started to market their own "Victory Line[s] of war posters," then determined that the "most satisfactory way" for the government to control and direct production was "for [it] to do such an outstanding job that commercial enterprises will begin to rotate automatically around it." "Only then," the summary commented, "will the overall information pattern begin to take on full shape of the powerful weapon it is."[26]

To this end, OWI officials set as their goal "posters on fences, on the walls of buildings, on village greens, on boards in front of the City Hall and the Post Office, in hotel lobbies, in the windows of vacant stores — not limited to the present neat conventional frames which make them look like advertising, but shouting at people from unexpected places with all the urgency which this war demands."[27] Various duties were outlined for sections of the Graphics Unit, all of which added up to planning, requisitioning, and contracting for graphic art for topical and instructional posters, cartoons, pamphlets, and all other manner of productions, and negotiating its smooth publication in all of these forums. Ultimately, until funding cutbacks curtailed their distribution, OWI sent four cartoons on war-related subjects to approximately eight hundred newspapers each week and offered advice and proposed designs to others involved in production of advertisements, posters, and pictorial publications.[28]

Using all these elements, OWI negotiated social anxieties about wartime changes in gender roles by using graphic art that directly addressed the issue. Two of its main tools were the publications *The Graphic Artists' Newsletter* and *News Copy from OWI* (later called *Copy from OWI*). *The Graphic Artists' Newsletter* provided ideas for the artists to illustrate — they were to "clothe [these ideas] with flesh and blood and give them human interest."[29] *[News] Copy from OWI* provided some of those realized ideas (mostly cartoons from the Graphics Division) to newspapers, magazines, and other publications across the United States. Many of the cartoons are not dated, although some are datable from their appearance in these OWI publications, and there are no specifics about where they might have appeared. A 1943 OWI memo points out, however, that "in some form or other [the cartoons produced for the letter] reach practically every newspaper and magazine reader in the country. Not only are the cartoons . . . still being shown around the country

as traveling exhibits, they have been reproduced by countless publications and will reappear, probably, as long as the war lasts."[30]

Every week, a *Graphic Artists' Newsletter*, labeled "Restricted: For Your Information Only—Not For Publication," was distributed to encourage art production on any of a number of topics. After a brief summary of an issue—say, Victory Gardens or variations on the theme "Food Fights for Freedom"—the newsletter would suggest a number of "Graphic Possibilities" related to the topic. For example, a piece on the 1943 U.S. potato harvest ("the largest crop of white potatoes in its history—460 million bushels, or 89 million bushels more than last year") included the following suggestions for artists to use to "advertise" potatoes: "A peck to a purchaser—call up the reserves on the Home Food Front.... Turn your cellar—back porch—spare closet—garage into a billet for a fighting food."[31] One cartoon created in response to these recommendations showed a sergeant-type character holding a banner reading "Food Fights for Freedom!" in front of a rank of potato-headed soldiers. The soldiers are watching a voluptuous onion-headed woman in a short skirt cross their path as the sergeant yells, "EYES FRONT!"[32] Another panel plays on the stereotype of the silly woman, who presumably would be unfamiliar with the toil of food production. Two women stand in a field helpfully marked "POTATOES." "Just think, Maizie," one woman says to the other, "when we didn't know what went into mashed potatoes!"[33] The entertaining images that artists came up with when they set out to "clothe" the ideas "with flesh and blood" (or potato) allowed readers to relate to the subject at hand in a more familiar, friendly, and accessible way than they would have if they had been reading a traditional informational brochure.

A majority of OWI cartoons directed at women focused on tensions around gender; in commissioning and distributing these images, OWI relied heavily on what it discovered in a survey on women's concerns about going to work. The survey revealed worries about pay, social status, and women's ability to do war work, and the OWI cartoons addressed these apprehensions, but at the same time they deftly focused on tensions around femininity versus masculinity. The survey seems not to have survived, so we do not know precisely who created or administered it, when, for what purpose, or to whom. Its mention in a 1943 *Graphic Artists' Newsletter*, however, shows how much OWI depended on it in proposing topics for graphic artists to address. We can see, even in indirect references to the poll in the newsletter, the close relationship that the topics proposed over the following months had to the poll's findings. "A survey of reasons given by women

for not tackling unfamiliar wartime occupations shows that the following are among the most common," the newsletter reported. "In some places [employed] women are said to be leaving their work for no very logical or satisfactory reasons. . . . It has been estimated that between now [September 15, 1943] and July 1944 one million women must be recruited from among those not working at present to fill the various labor needs of the coming months."[34] The newsletter then analyzed the survey in its effort to get artists to create logical, understandable, and goal-oriented artwork to counteract the problems.

The cartoons produced in later *News Copy from OWI* pieces are obviously in response to the survey; many tried to recast clichéd female behavior as now being desirable wartime conduct. One *Copy* piece, in an artistic effort to counter the issue of women quitting their jobs, shows a frazzled-looking male factory boss interviewing a woman in his office. She is wearing heavy makeup and a short skirt and has one hand on her hip as she leans suggestively on his desk. He is saying, "You have the—er—personality, Miss Ferguson, but—darn it—you must have a certificate of availability!"[35] The largest print on the cartoon is not its caption, however; it is an outsized placard on the wall behind the boss's head, which reads, "STAY ON THE JOB!!" in bold letters. Another drawing has a hen perched precariously on top of a heap of eggs she has laid in her nest. On the wall of the chicken coop is a sign reading, "STAY ON THE JOB."[36] A third image has another male boss in his office, cigars sticking out of his vest pocket, with a heavily made-up woman worker in overalls sitting on his lap, applying lipstick while she looks into a compact mirror. The boss is saying into his telephone, "But, dear, I've promised to stay on the job!" On the wall behind them is yet one more bold notice ordering, "STAY ON THE JOB!"[37] All of these OWI Graphics Unit images portray women at their most stereotypically "female"—as sex objects tempting a middle-aged boss, or as (literal) egg-producers—"feminine" women staying on their wartime jobs.

Although women had many concerns regarding employment, the survey, as analyzed by the newsletter, addressed only three reasons for leaving or not taking employment: that war work didn't necessarily pay very well; that one might lose social standing in taking employment; and that the work might be too difficult. The first concern was answered in this way: "Many jobs vital to civilian life must be filled out of patriotism rather than from the profit motive."[38] It is impossible to ascertain whether this approach would have worked for men, or in peacetime, or both; however, the stance of most

employers, unions, and government officials was that women would be hired only during the war, "for the duration," and then would leave, voluntarily or otherwise, at its end, as an expression of loyalty to the country.[39] In the meantime, cartoonists reading the *Graphic Artists' Newsletter* were advised that cartoons soliciting women to work "should be keyed chiefly to simple patriotism," and that the female audience for these images were "not the 'glamor girls' of war plants or military service," but the "folks who live next door or across the street."[40]

Though many images did focus on women's patriotism—by using American flags, for instance, in the back- or foreground—cartoonists tended to emphasize women's glamour once they took war jobs. This tactic sidestepped the issue of poor pay and assumed that glamour would be an acceptable substitute for other kinds of benefits. The glamorization of war work, which cast working women as fashion plates, was an attempt to ease the transition from apron-clad housewife to worker in pants.[41] Glamour worked best as a graphic "solution" when it was used to imply that doing "men's" work did not make women masculine, but rather, more feminine. Cartoons, advertisements, and other images often appealed to women's vanity. One OWI cartoon, for example, shows two women employees having coffee in a factory cafeteria. "I'm glad I went into war work," one tells the other. "I lost twenty pounds and the men are whistling at me again."[42] The cartoon neatly takes a woman's fear of entering a previously all-male field (and being called "Mac") and converts it into a desirable feminine goal.

In fact, popular images stressed the idea that, as they assumed new masculinity, women retained or increased their femininity—by retaining all their original duties, as well as taking on paid work. A "Cole of California" advertisement summed up women's responsibilities this way:

> She'll work on Christmas day,
> if her war job demands it.
> She's been giving every day of the year,
> America's war worker, spending
> eight hours at the machine, six days a week,
> and her hours afterward for home and children.
> She chose to give all her time and energy,
> and to this she adds:

| *War Bonds Weekly* | *Rationing Board Work* |
| *Blood Donations* | *Saved Kitchen Fats* |

> *Buying only what she and her family need*
> *Exchanging stamps for all rationed goods*
>
> *She has given all she can*
>
> *Have you?*
>
> *... Uncle Sam Needs Millions More Women In War Jobs*
> (Emphasis in original)[43]

The addition of "men's" work in addition to women's traditional tasks was recast as hard, and noble—but not necessarily as masculine. Women worked a forty-eight-hour workweek, but that was the workweek that was *paid*; they were still responsible for home and children.

Other images countered the concern about work not necessarily paying well by emphasizing the theme of the working woman having gained, rather than lost, femininity. One drawing shows a sailor, a soldier, and a pilot winking and gesturing at a poster behind them showing a female "War Worker" wearing a headscarf.[44] The picture is entitled "Their Real Pin-Up Girl" (a reference to Betty Grable, Rita Hayworth, and the stars of other pin-up posters distributed to servicemen during the war).[45] Here, the cartoon assures women that servicemen would find this new role for women—their production labor—sexy and worthy of admiration. A similar image, in a panel entitled "LADY OF FASHION—Spring 1943," shows a woman in work-clothes, carrying a lunchbox and gloves, who is striding energetically in front of a factory. Beside her is the legend, "WOMEN NEEDED! To replace men in our essential war industries."[46] A third image is in two parts. Part One, labeled "Deb 1940," shows a woman blasting along in a large, expensive car. Part Two labeled, "Deb 1943," shows the same woman in overalls, puttering around a farm on a tractor.[47] If women had to take up "men's" work, clearly the only thing to do was to redefine that work as now a woman's rightful place, practical but stylish, reflective of the inner beauty that caused her to value her country enough to help it win the war. A woman who worked was now her country's patriotic sweetheart.

The second concern voiced by women in the survey was, "If I take this job, my social standing will suffer." This worry was peculiar to women, as a man's job *was* his social standing and reflected as much. A bank manager had more social standing than a blue-collar laborer in a man's world, while a woman's standing was often based on her husband's. In other words, her status was higher if she did not need to work at all. The newsletter's solution was to draw a direct connection between women's and men's status, saying,

essentially, that any individual, male or female, who rose to the occasion of the wartime situation made personal status gains: "Thousands of 'socialites' have forgotten about social standing, just as thousands of young men from socially prominent families are serving as privates."[48]

A 1944 pamphlet entitled *The More Women at War the Sooner We'll Win* broached this topic in "Questions Often Asked," relating social standing at least abstractly to age. It showcased questions such as, "I'm over 45. Is that too old to take a war job?" and "I don't need the money. What will my friends think?"[49] The *Graphics Artists' Newsletter* quoted the War Manpower Commission as saying, "Not only have older women been accepted in trade and service to replace men . . . but in many labor shortage areas women of 50, 60, and in some cases even 70 years of age, are operating machines . . . assembling, inspecting, and performing other similar jobs."[50] The "Graphic Possibilities" section of the letter pointed out, "We have had hundreds of 'pix,' cartoons, and magazine covers showing our stalwart and personable young womanhood matching skill and strength with male fellow workers. Let's take off our hats to the patience, steadiness, and mature judgment of the older women some of them grandmothers—who have come from *the sheltered quiet of their homes* to take their places on busy assembly lines" (emphasis mine).[51] The war disrupted class codes as well as gender codes, and though the former had a lesser role, it still showed up in the published images.

Although it's not clear how many, if any, rich dowagers who had never needed to work traded in their evening gowns for defense-factory coveralls, cartoonists drew (literally) upon humorously exaggerated notions of the most sheltered women possible taking this momentous step to create cartoons encouraging women to work.[52] One OWI panel depicted an upper-class woman who had exchanged her mature, comfortable life for a busy factory production scene. The stout older lady, holding a large metal rasp, is regarding with puzzlement the moisture she has wiped from her forehead. Nearby, a young woman worker addresses her, saying: "That's perspiration, Mrs. Van Butterworth."[53] In her essay on advertising images in World War II, Maureen Honey noted that "blue-collar work was elevated in stature throughout the media." People who worked with their hands and bodies were placed center stage and given heroic qualities in all manner of popular culture productions. The symbols of their work, such as muscles, sturdy shoes, sweat, and grime, were considered equally praiseworthy.[54] In this cartoon, the "poorer" woman was teaching the elite "Mrs. Van Butterworth" about sweat and its value. The ideal was that war work would level social classes.[55]

Other cartoons portrayed embellished scenarios of socialites who were working merely because war work had become, as the cartoonists again clearly hoped, glamorous. The artwork on a *New Yorker* cover has a woman in tailored blue coveralls and full makeup reclining on a chair. One maid, in a black and white uniform and starched cap, puts a professional-looking bow on her employer's bandanna, while another waits with her lady's lunchbox and work gloves.[56] Another sketch depicts a plump, late-middle-aged woman in work pants and shirt, cap, and snood. As other guests in long evening dresses and tuxedos look at her in astonishment, a grimacing butler removes her work equipment: One hand carries her welding mask, and the other holds her gloves at arm's length. The working woman addresses her corsage-wearing hostess: "I came right from work and didn't bother to change."[57] The cartoon efficiently imbues women's employment with both fashion sense and a sense of reason, the implication being that if this older, chubby, snooty, wealthy woman can come all the way from her drawing room to the production line, you can, too (because it's not nearly so far for you). In trying to trump gender lines, OWI also trumped class and age lines.[58]

The lines around gender and social status overlapped with the third topic the survey addressed: the fear that the work would be too hard. The official answer was this: "In most of the occupations open to women allowance is made for a training period, and newcomers are given less difficult operations to start with. A 'green hand,' for example, is not sent out immediately as a bus driver." The notion that driving a bus was work "too hard" for a woman accustomed to running a farm or home, cooking meals, doing laundry (in the days before automatic washing machines were common), and performing other kinds of manual labor may have seemed surprising to some. As one apron-clad cartoon mother with a baby tugging at her hem grumbles at her husband, "What are you complaining about? I've been working a 48-hour week for years and haven't missed a day yet."[59] The OWI letter's "Graphic Possibilities" section acknowledged the complexity of the situation and instructed artists in how to deal with the multiplicity of issues the survey had brought to the fore: "Any of these angles may be treated in a single cartoon, but they lend themselves admirably to a series, showing the heroine gradually overcoming fears and doubts and making good in a job, replacing a man."[60]

The worries inherent in "replacing a man" did sometimes reveal themselves in depictions of masculine women. One panel features an extremely large and bosomy woman who has seized a wrench and turned a nut on the

corner of a tank—so hard, in fact, that the metal has twisted up like a soft ice-cream cone. "Hey, Mrs. Worthington," the startled shop foreman is saying, his hand slapped to his forehead as he stares at the tank, "—we CONCEDE that women have a place on the production line!"[61] "Mrs. Worthington" is noticeably odd-looking and quite stout. Her hair is chopped off unstylishly at ear-length; her hands gripping the wrench are large. A much more lady-like woman, wearing makeup and with a long, "feminine" hairdo, looks on, shocked, in the foreground. The two women are clearly juxtaposed against each other, "Mrs. Worthington" is quite masculine, with immense bulk and strength, while the other woman has a decidedly feminine appearance. Even Mrs. Worthington's huge bust seems to emphasize how masculine the rest of her is; the attractive proportions of the other woman are highlighted by the comparison. Although society might have to "concede that women have a place on the production line," women still had gender standards to meet. (Having her be "MRS." Worthington might have been one of those standards. An outlandishly masculine woman might be redeemed by the fact that she was married.)

To deal with tensions around femininity and masculinity, depictions of women's motivations had to be seen as conventionally feminine. This femininity dispelled anxieties that women were becoming aberrantly masculine and wouldn't want to return to traditional womanhood following the war.[62] To add to work and parenting, a woman was expected to invest the money she earned in war bonds, to save fats from cooking (for munitions), and to use ration stamps for goods (thus thwarting the black market). As if that weren't enough to demonstrate her patriotism, a woman literally had to give her own blood. Female workers were thus constructed as "women of America and her allies [who] work[ed] tirelessly for the common cause," as the Cole of California advertisement implied.[63] But the Cole of California ad was entitled, "CHRISTMAS GIFT FOR HIM," as though a woman would not undertake this unfamiliar, unwomanly (though patriotic) work unless it were in support of a husband, boyfriend, or other relative in the service. To reinforce the new bridge between women's and men's worlds, the ad is inset with a tiny picture in the lower left-hand corner: A pilot in a flight suit and parachute is posed next to a woman wearing a Cole of California bathing suit. The text reads, "THEY WEAR THE SAME LABEL." The picture simultaneously connects women to industry and reinforces their femininity and their familiar status as sex objects—a theme that arises frequently in OWI cartoons.

Oddly, however, women's status as sex objects was at war with their status as mothers, so images also showed the difficulty of juggling home, work, and children. One cartoon has a mother in work clothes and headscarf pushing two small children toward a perplexed-looking police officer. "Just tell the captain they're lost," she's saying, "and I'll pick them up when I'm through at the plant."[64] Another cartoon mother informs her male supervisor, as he looks at her two toddlers peeping out of bomb casings beside her, "It's either that, or time off until a day nursery is organized"[65] (see Figure 1–3). A third mother says nothing but simply works at a machine; behind her are an infant in a high chair and a toddler in a playpen. Around the woman on the floor are a baby's bottle and some toys; strung above her is a laundry line with wash drying on it. Her foreman is saying to the factory owner, "It's the only way we can keep our help—by letting them bring their problems here!"[66] Yet one more panel shows a welder beside a ship, her welding mask tipped up, talking to another woman holding a wrench. The welder has a welding torch in her right hand; in her left arm, she cradles a baby. On the ground behind her is another, slightly larger baby, and clinging to her work clothes are three more small children of varying sizes. She is saying to the other woman, "And then in my spare time . . ."[67] These cartoons all provide evidence that a woman's parenting obligations were her "problems." Part of her essential duties, a woman's children virtually defined her identity as a female. The wartime changes to her gender role did not relieve her of this responsibility; they only added to it.

The difficulty of providing child care is a leitmotif in OWI cartoons.[68] Several depict women carrying babies in backboards or papooses. In one drawing, two workmen on a ship are watching a masked welder who has a baby papoosed on her back. The baby holds a teddy bear and has two feathers and its own tiny welding mask on its head. The men are saying, "That's Princess Flying Duck—family life doesn't interfere with *her* work!"[69] The implication: One need merely look at the stereotype of a Native American woman to resolve the issue of child care—if one needed to haul one's baby around on one's back—well, this was war. The mother in another panel with a baby in a papoose as she rivets is being watched by two other women workers: They gesture and smirk at her as one of them says, "Somebody oughta tell her about the Day Nursery!"[70] In other cartoons, the "papoose" is represented differently but the message is the same. In one, a mother has rigged her baby's basket with a rope over a pulley, as a counterweight to the riveting gun she hoists against an airplane side. "It not only amuses the baby," she tells the male supervisor staring at the contraption, "—it

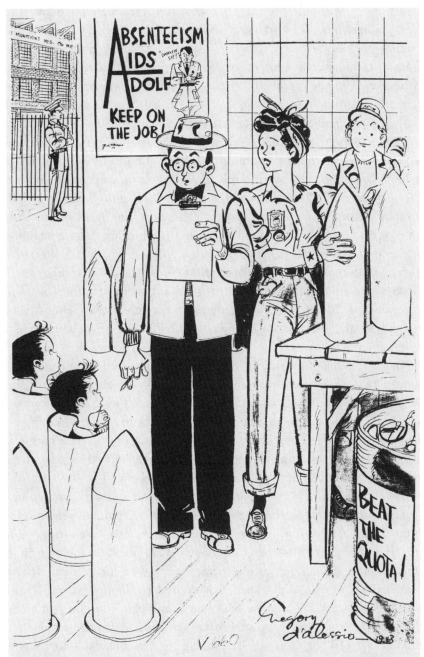

Figure 1–3: Maintaining feminine motherhood at all costs. Source: *Gregory D'Alessio (for OWI), 1943, National Archives and Records Administration, Records of the Bureau of Graphics, Record Group 208, E-219, Box 1.*

makes this dingbat easier to lift."[71] Clearly, as women were not allowed to bring children onto the work floor (and not all factories had nurseries), the riveting gun and the baby are being juggled both literally and figuratively, in terms of the coordination of jobs and in terms of gender behavior and expression. The one is a phallic symbol, the other an emblem of feminine motherhood. (Significantly, there is an American flag on the wall behind the mother—yet another nod to women's patriotic duties.)

The cartoons also revealed worries about the effect of women's working on children—especially that children would suffer gender-role confusion or be forced to become prematurely adult if their mothers were working. In one image, an irritated little girl in an oversized apron holds up a cloth liberally decorated with black, greasy handprints. She faces her mother, who has set down her welding mask, gloves, and lunchbox and is standing in front of a mirror, untying her headscarf. "Mother!" barks the little girl. "Just Look What You did to one of our Best Guest Towels!"[72] Another panel shows a little girl pulling on her mother's arm as they stand in front of a toy-store window. "I don't want a doll," complains the little girl as she tugs at her mother's hand, "—I want a welding set!" (see Figure 1–4).[73] The first child is literally wearing her mother's apron, taking on an adult role—formerly her mother's role—in managing the household. The second little girl, who wants a welding set, seems to combine the gender-role-skewing worry and the premature-adulthood worry. She not only wants a *gender*-inappropriate toy, but an *age*-inappropriate one as well. If adult women were "putting on the pants" of wartime masculinity, children were putting on their mothers' aprons, assuming the (adult) femininity that women had had to renegotiate by adding the masculinity that would help win the war.

In the same way that women juggled motherhood and work, images juggled encouragement for women to work with the constraint of gender roles in the workplace. In showing women as sex objects, OWI used images not only as inducement for women to work and as argument for their worth in the workplace (sometimes in unexpected ways), but also to demonstrate that working women could keep that desired femininity, as the "I lost twenty pounds and the men are whistling at me again" cartoon reinforces. The cartoons sometimes suggested that the presence of women spiced up a dull job: One OWI cartoon panel, depicting yet another busy factory scene, shows an attractive young woman expertly using a lathe. Male workers are all around her; one of them smiles hopefully at her as he wheels a dolly near her station. The shop foreman is talking to the plant owner: "We haven't had

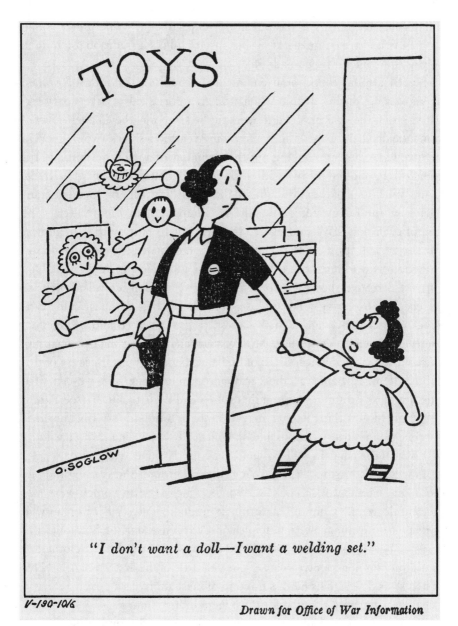

Figure 1–4: Changes in women's roles might mean children changed, too. Source: *Otto Soglow (for OWI), National Archives and Records Administration, Records of the Bureau of Graphics, Record Group 208, E-219, Box 1, no. v-190-1016.*

a day's absence since she was put in this department."[74] The pretty young woman is not masculinized at all but in fact fulfills a traditional feminine role as someone for men to admire.

Some cartoons found amusement in the traditional notion of women as sex objects during a time when women were asked to take up *"men's"* work — that they were wooed to work in the same way they'd been courted romantically before the war. A *New Yorker* cartoon shows two women in nightgowns. They are looking out their window at a man in a suit and tie, trench coat, and fedora serenading them with a mandolin under a street-light. "Why," one of them is saying to the other, "it's that employment man-ager from the Edgewater Tool and Die Company" (see Figure 1–5).[75] The aim of even non-OWI images like this one was to portray the female war worker as *more* desirable than the prewar fashion plate, for the very reason that she was working, even if her job was in a formerly male domain. One cartoon narrative shows a woman using her "Vacation Travel Money" to purchase a dozen war bonds. "This girl in slacks," begins the rhyming cap-tion, "invests her dough / In the finest, truest cause we know." Her for-merly fashionable counterpart, however, is seen boarding an airplane, using the country's valuable resources of fuel and space to travel. Because of this callow, "female" behavior, the cartoon continues, "the best we can wish this Brainless Beaut / Is a ten mile drop — and no parachute!" (see Figure 1–6).[76] The nonworking woman may be more traditionally stylish, but she is "brainless" and utterly disposable, in contrast to the woman who has liter-ally put on the pants in order to help her country's fine, true cause.

Indeed, this "girl in slacks" is viewed as a heroine. She is using the pay from her "men's" work to buy war bonds, which is what women were *sup-posed* to do, as the Cole of California ad implied. The stylish woman who is ready to travel may be trendy in the prewar sense, but she is an object of derision because she has not sacrificed her prewar wastrel ways, clothes, or femininity for her country's cause. The very title of the first woman — "This girl in slacks" — signals her assumption of masculinity as a positive thing, a behavior ultimately adopted for the benefit of her country.

During the war, American society struggled with conflicting desires: on one hand, to keep women as they had been; on the other, to rely on women during a war that required the full commitment of all America's citizens. Those conflicting desires were played out in art from OWI and other sources. The fears expressed in "Letting the Genie Out of the Bot-tle" carried tremendous significance. American women who took on duties

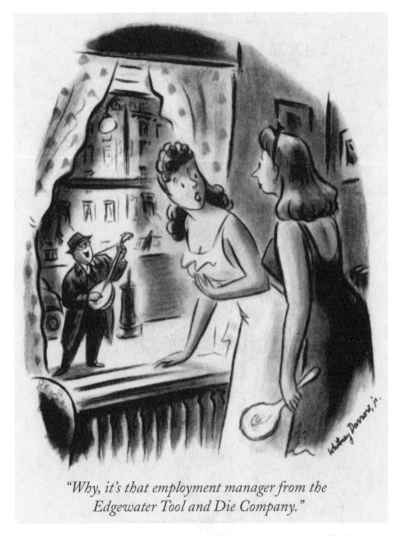

"*Why, it's that employment manager from the
Edgewater Tool and Die Company.*"

Figure 1–5: Wooing women to work. Source: *Whitney Darrow Jr.*, New Yorker,
*January 15, 1944, 22. (© Whitney Darrow, Jr. / The New Yorker Collection. Used by
permission.)*

beyond the household were gaining a selection of real tools for survival out-
side the home. Beyond a woman's service to her country, "HER OWN MAN'S
SIZE PAY ENVELOPE" was a sign of changing gender mores, women's grow-
ing personal independence, and women's increased societal value. The fact
that these changes were state sponsored made them even more remarkable.
In the end, as an American woman moved from buying bathing suits to

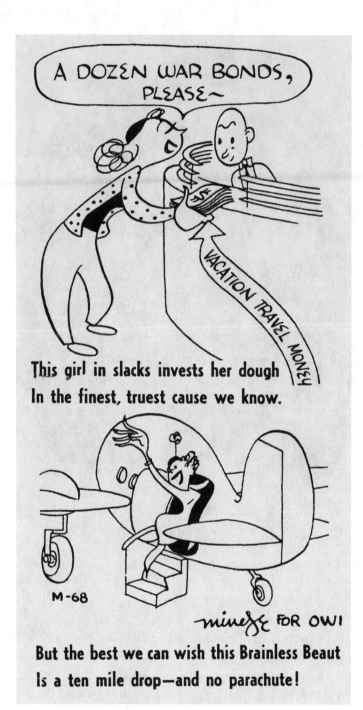

Figure 1–6: *The quintessential symbol of female masculinity: a woman in pants.* Source: *"Minje" (for OWI),* News Copy from OWI, *August 3, 1944, National Archives and Records Administration, Record Group 208, M-68.*

making parachutes and back again, she could know that "she ha[d] given all she [could]," as the Cole of California ad proclaimed.[77] Unfortunately, she could also know that these gender-role changes would only last for the duration of the war, and she would have to "come right back after the war is over!" The seeds of liberation planted by these wartime transformations would take many postwar years to grow.

2

"America Will Be as Strong as Her Women"

Femininity, Masculinity, and the Merging of the Spheres

You'll like this girl. She does a man's work in the ground crew, servicing airplanes, but she hasn't lost any of her feminine sweetness and charm.

— *McCall's*, April 1943[1]

"For the first time in history woman-power is a factor in war," an advertisement for Tangee lipstick begins, the text complementing a picture of a female pilot climbing into an aircraft. "Millions of you are working side by side with your men. In fact, you are doing double duty — for you are still carrying on your traditional 'woman's' work of cooking, and cleaning, and home-making."

"Yet somehow," the ad's supposed writer, Constance Luft Huhn, "Head of the House of Tangee," declares, "American women are still the loveliest and most spirited in the world. The best dressed, the best informed, the best looking.... It's a reflection of the free democratic way of life ... that you have succeeded in keeping your femininity — even though you are doing man's work!" Stirringly, she proclaims, "If a symbol were needed of this fine, independent spirit — of this courage and strength — I would choose a lipstick. A woman's lipstick," continues Huhn, "is an instrument of personal morale that helps her to conceal heartbreak or sorrow; gives her self-confidence when it's badly needed; heightens her loveliness when she wants

to look her loveliest." The ad copy finishes, "No lipstick—ours or anyone else's—will win the war. But it symbolizes one of the reasons why we are fighting . . . the precious right of women to be feminine and lovely—under any circumstances."[2]

The notion that the Allies were fighting World War II for the "right of women to be feminine and lovely" might have been as much of a surprise to Allied leaders as it is to the modern reader. As women entered the workforce and took over heretofore male jobs, however, American society began to come to grips with what those new jobs would signify in the larger sense. Women would need to "keep [their] femininity—even though [they were] doing 'man's' work," whether or not they chose to wear lipstick as they were doing so. Heartbreak, sorrow, and the need for self-confidence were hardly gender sensitive; certainly, women were doing what the country needed them to do, but there were greater implications for both men's and women's roles. How would "men's" jobs change women's behavior? How would men have to adapt to those changes? What would the new versions of masculinity and femininity mean for what World War II historians Penny Summerfield and Nicole Crocket have called "the wartime disturbance of normal social patterns [that] stimulated a contest over the meaning of masculinity and femininity"?[3]

Popular graphic art questioned not only the era's binary definitions of femininity and masculinity but also the ways in which women's new behaviors fit into them. While some depictions attempted to reinforce traditional gender roles, such as motherhood, others explored the implications of women's "masculinization" (most particularly in relation to lesbianism), advocating for women to maintain their performance of femininity even as they adopted masculinity "for the duration" of the war. Some visual propaganda implied that certain kinds of masculinity were excusable, particularly if women took on such roles as a patriotic act or if women had explicit or implicit male approval to do so. Yet still other images suggested that masculinized women might feminize men, further pushing together, while also reinforcing the distance between, the spheres of femininity and masculinity.

To understand these nuances and the anxieties they produced, it is important to contextualize the notions of gender that were in place in the years prior to World War II. In the era preceding the war, some Americans had begun to wonder if gender was, in fact, a fundamental and immutable identity. According to historian Beth Bailey, masculinity and femininity came to be seen, "not as natural traits, proceeding causally, masculinity

from maleness, femininity from femaleness, but as identities that must be acquired, earned and constantly demonstrated."[4] Americans had used popular culture in attempts to challenge or define these identities in the decades before the war, and they were negotiated in the theater of graphic art. One of the most famous posters from World War I, for example, is a Howard Chandler Christy recruiting poster: a lovely painting of a woman in a U.S. Navy enlisted man's uniform. Windblown and smiling, she coyly addresses the viewer. "GEE!! I Wish I Were *A Man*," she says. "*I'd* Join The NAVY." Underneath her words is stern advice: "BE A MAN AND DO IT."[5]

The polarized notions of femininity and masculinity expressed in the poster offer a traditional reading of gender roles, but the poster also raises questions about gender that it might have quelled. On one hand, the poster perpetuates long-standing beliefs that women were feminine because they needed protecting (she's not able to fight, so "A Man" must do it for her), and that men were masculine because they protected women. It additionally reinforces the traditional concept that men *become* men by engaging in masculine enterprises, specifically, in this case, by joining the military. The poster also suggests, however, that men *could* or *had to* be taught to "Be a Man," and that this teaching was a legitimate or desirable way to acquire masculinity. In this poster, the impetus for getting a male to "Be a Man" is his comparison to this windswept girl. If he doesn't join the navy, and, through the act of joining, acquire manliness (or earn that manliness because the navy "makes a man out of him"), the shameful insinuation is that he is, in essence, equivalent to this woman. Importantly, the woman in the poster is fantasizing about being a man and assuming masculinity by dressing in the male U.S. Navy uniform, but the implication is that a man, too, needs the uniform and what it represents in order to demonstrate masculinity.

Another World War I poster, entitled "Feminine Patriotism," also features a uniformed woman and calls attention to complex representations of masculinity and femininity. The poster depicts three women: one in a maid's uniform representing "Domestic Economy"; one in a nurse's uniform depicting "Aid to the Suffering"; and, unexpectedly, in the center, a woman in military uniform, holding a rifle, symbolizing "Home Defense."[6] Significantly, this is not a pioneer woman wielding a frying pan or the family shotgun against intruders; she is in military uniform and carrying a rifle at Right Shoulder Arms.[7] Although there was no real or official precedent for a woman holding a rifle she might actually fire in defense of her country, in a time of war, people were prepared to make allowances about what

was acceptable female behavior, with some exceptions. What stands out in this World War I image is that an armed and uniformed woman fighting for her home or country was made equivalent to the accepted female roles of homemaker and caregiver, and that these were all seen as patriotic endeavors. Further, by her mere graphic presence, she is encouraging other women to exhibit patriotism in this manner. What at first appear to be clear-cut characterizations of female and male roles become, on closer analysis, early twentieth-century examples of the complexity of those roles.

The era of the "Woman Suffrage" campaign (roughly 1848–1920, ending just after World War I) also provided a challenge to concrete classification of feminine and masculine roles. There were concerns during the crusade for the vote that Woman Suffrage would be masculinizing, destroying women's femininity. There was no overwhelming reason, such as war (or even the pursuit of equality), for tolerance of the female masculinity that might occur because of the vote.[8] One representative cartoon of the era, entitled "Suffragists on the Warpath," showed a group of Suffragettes beating a policeman to the ground. The caption reads, "Jump On Him. He Is Only a MERE Man."[9] Another cartoon, entitled "Election Day!" depicted a solidly built woman in bowler hat and necktie preparing to leave her house, presumably to cast her vote. Hanging on the wall behind her is a needlepoint sampler reading, "Votes for Women." She is casting a stern eye on her thin, nervous husband, who is timidly holding two screaming babies — and wearing an apron.[10] Both cartoons focused on aggressive women flouting the law and their place in society. If women became masculine, the visual logic went, the equal and opposite reaction was that men would then become feminine, allowing themselves to be overwhelmed and forced to take over child care and wear aprons. These images demonstrate a "wartime disturbance of normal social patterns [that] stimulated a contest over the meaning of masculinity and femininity," and they set a historical precedent in graphic art for later representations of women. By the time the United States entered World War II, women had had the vote for more than twenty years; they were more able to control childbearing, and women in paid employment were hardly unusual. Nevertheless, gender roles were even then contentious. Men were still deeply concerned about women invading their territory, and men and women alike worried about the consequences of that invasion, wondering what would differentiate men and women if gendered tasks and traits were homogenized. The apprehension centered on what would happen to society if men were "demasculinized" and women "defeminized."[11]

That anxiety became crucial when women were heavily recruited into male spheres. The theoretical notion of our day positing that women and men learn to "perform" their genders was not an articulated concept.[12] It was, however, a fear: "Male" work for women, especially in a civilian world without most of its young men, might result in women's acquisition of "masculine," "mannish," or "manly" qualities that women would not or could not shed after the war. In a world situation in which men's lives suddenly were fraught with risk and dislocation—though they had suffered from unemployment before the war, now they were literally being shipped off to destinations around the globe to fight—the possibility of women becoming permanently masculinized in their absence must have seemed like the last straw. To counteract World War II's unsettling changes, there was an implicit demand that women's assumption of masculine work, behavior, clothing, and speech was really only permissible *because* of the war, and was also only for the *duration* of the war. After that, these masculine characteristics would have to be sharply curtailed, if not eliminated entirely.

Women's paid positions outside the home were thus painted as "feminine," even when they were in heretofore masculine arenas or precisely the same jobs that previously had been considered manly, such as welding. This recast of gendered duties allowed women to seem to maintain femininity while actually performing masculinity. The formerly-male-work-is-now-women's-work approach took shape, in part, because propaganda encouraged men to approve of it, and also because those positions ostensibly *increased* women's ability to find husbands, manage their homes, and raise their children.[13] One cartoon of the era shows a woman war worker who is flexing her bicep as she addresses another woman working on a lathe. "You know," she says, "I feel so strong nowadays that housework's a pleasure!"[14] Visual propaganda reassured women that, though they might be munitions workers or even muscular, they were not "mannish" or unfeminine. After all, besides being patriotic, or strong, and performing these newly (theoretically) demasculinized duties, they also maintained their feminine duties, such as housework.

Images to be used to help recruit women into formerly male factory jobs, for example, might compare those jobs to "feminine" work (i.e., washing sheets of aluminum is just like washing bedsheets at home; the right "recipe" for explosives isn't so different from finding the right recipe for cookies). A cartoon of female munitions workers has one worker approaching others at a nearby worktable. "Can you lend me a cup of Thermite?" she is asking. "I just need a little to finish up a batch of incendiaries!"[15] Women entering

factories or other jobs received reassurance from these images that, within the parameters allowed by wartime necessities, society approved of their actions. (Though, to be sure, occasional ironies arose as part of this process of reframing "men's" and "women's" work. Another cartoon has a soldier eating at a lunch counter, jerking his thumb over his shoulder at the female counter attendant who made his meal. "Not bad the way women are handling men's jobs," he comments to a man beside him. "This is a pretty good sandwich."[16])

While promoting the idea that women stayed "feminine" no matter what, the prevailing representation of women was that they were reliable, tough, efficient guardians of the home front, seeing to it that society functioned smoothly in the absence of men. Probably because women were so vital to the domestic war effort, they became the symbol of a properly militant spirit and the model for correct civilian attitudes.[17] As World War II scholar Amy Bentley observed, "images of women . . . were used to portray American society as ordered, calm, and stable, particularly with regard to established hierarchies of race and gender."[18] This stability was rendered even more necessary because the wounds of the Great Depression, as the Introduction discusses, had damaged men's confidence in themselves as masculine providers.[19]

Women walked the boundary lines of masculinity and femininity, often attempting to demark which "feminine" hallmarks to retain despite their "masculine" jobs. Wartime posters actively discouraged such feminine standbys as long, loosely worn hair and jewelry, both of which were highly dangerous around factory equipment and not permissible while in military uniform. Company-published signs advertised that "Axidents," or a cartoonish gremlin, "Axey Dent" (both plays on the negative connotation of the "Axis"), gave "aid to the enemy,"[20] and showed women with agonized expressions as industrial machinery caught and twisted their long hair or dangling jewelry.[21] These warnings had basis in fact: One wartime welder commented, "We had to wear uniforms and we had to have our hair under control. Some girls just couldn't stand that and they'd have their hair out, and girls who worked around the drill presses, invariably they'd get their hair tangled up in that drill and lose part of their scalp."[22] There was practical need for "masculine" clothing and hairstyles—or at least less "feminine" ones.

Posters depicted women wearing heavy steel-toed shoes and large, beauty-obscuring goggles and nose-and-mouth protection. They advised women to wear "safe clothing," including caps and slacks (still hardly

"feminine" apparel in the early 1940s).[23] "The beautiful things," one war-time author wrote, "are now discovered often wearing khaki or coveralls," as opposed to prewar garb worn to "senior proms, night clubs, beaches and ... garden parties."[24] The "beautiful things'" clothing symbolized strong movement away from tradition, if calling women "things" did not. If a woman wore denim or khaki slacks or coveralls, eliminated jewelry, and cut or tied up her hair, many of the external features that marked her as "femi-nine" were concealed or gone. She might, in fact, even look "mannish."

Cosmetics had the benefit of not being nearly as dangerous as loose clothing or hair. Historian Melissa Dubakis has pointed out that makeup had come to function as an essential sign of femininity beginning in the early twentieth century. She noted, "Cosmetics defined the outward ap-pearance of femininity as massive ad campaigns convinced women that cosmetics were not only respectable but, in fact, a necessary requirement of womanhood."[25] A mask for welding or for gas protection thus restricted a woman's desirability simply by concealing her face. Numerous cartoons use this as a motif, showing women applying lipstick, eye shadow, rouge, and in the final panel, a gas or welding mask over all the carefully applied makeup (see Figure 2–1). These cartoons are often accompanied by a cap-tion saying something like, "It's hard to be beautiful," or even no caption, as the pictures said it all.[26] The cover of a humor magazine of the era sug-gests a sort of compromise. On it is a cartoon of a Wac in a Class A uniform, with Hobby hat, tie, WAC insignia,[27] and gas mask. Her owlish eyes stare through the top part of the mask at a compact mirror as she paints a lipstick mouth on the clear face-plate of the mask.[28] In a figurative sense, women were painting femininity over their "masculine" jobs as much as they were adding masculinity to their gender vocabularies.

Images also juxtaposed women's stereotypically feminine traits against their recently acquired "masculine" technical knowledge and languages, perhaps to ease the sense of awkwardness they and others may have felt about them having these new skills. One cartoon, for instance, shows two women, dressed in factory working clothes, riding a public bus (see Fig-ure 2–2). The men around them, also dressed in working clothes, are read-ing newspapers or looking out the bus window. The women sit with their lunchboxes on their laps, curls of hair poking out of their dotted head-scarves. One addresses the other brightly: "—I Suggest We Right and Finish Turning the Casings by Using a Stub Arbor and Center Tail Stock, With a Tang Driven Fixture."[29] Here, it is the women who are "talking shop" while the men couldn't seem to care less about their working lives. The women

The WAAC's reveille

Figure 2–1: Variations on a theme: making up, just to cover up — femininity overlaid with masculinity. Source: *"Dunkel" (for OWI), National Archives and Records Administration, Record Group 208.*

smile as though they are chatting over coffee. What mitigates the women's strange new language is that they are very feminine, sitting with their knees together, wearing lots of makeup, one woman's bust clearly showing. If they are now mechanical experts, they still demonstrate female norms of dress and appearance. Another cartoon is similar in theme, but more unusual because of the setting: A man and a woman are lying in a canoe together on

Figure 2–2: Speaking "men's" languages: the shop floor as women's new sphere. Source: *"C. A." [Colin Allen], ASMC (for OWI), National Archives and Records Administration, Record Group 208, Slide series 179-WP.*

a moonlit lake. He has his arms around her waist; she has hers around his neck. She looks into his eyes and says, " . . . and then I milled the slot down to thirteen-sixteenths of an inch, exactly as the blueprint called for, and when we put the eccentric in, it fit just beautifully."[30] Women's peculiar new modes of expression were acceptable, in part, because the women still upheld customs of femininity.

Although propaganda supported the notion of femininity coexisting with masculinity in the way depicted in these images, it had hard work to do as women entered that most male sphere: the military. In May 1941, Congresswoman Edith Nourse Rogers (R-Mass.) introduced the bill to create a Women's Army Auxiliary Corps (WAAC). Other service auxiliaries followed for all the branches, but women's military service was not accepted without resistance. Public anxieties about women's branches of the service were based on a culturally perceived schism between the concepts of "woman" and "soldier." Constructions of military service saw it as the ultimate expression of masculinity, much as the "I Wish I Were A MAN" poster demonstrated, and the asymmetrically gendered relationship ingrained in people's minds featured a dichotomy between the male "protector" and the female "protected." People feared that the state's recruitment of women into predominantly masculine organizations on such a wide scale could cause large numbers of women to assume a masculine identity. "Assum[ing] a masculine identity," however, though theoretically undesirable, would also enable women to do necessary wartime jobs. As one lyric from the WAVES songbook lightly put it, "Every hero brave / . . . Will find ashore, his man-sized chore / Was done by a Navy WAVE." Early posters did little to discourage the perception of military women as "masculine." One shows a Waac wearing sergeant's stripes, bellowing, *"Attention, Women!* JOIN THE WAAC" (see Figure 2–3).[31]

The goal of this graphic approach to very apparent masculinity in clothing and behavior was simply to portray the military jobs as "women's" jobs, as had been done in the civilian world with factory jobs. One poster, featuring a photo of a Wac positioning a wing camera on an Army Air Forces plane, declaimed, "Woman's place in War!" and below the photo, the advisory, "The Army of the United States has 239 kinds of jobs *for women*" (emphasis mine).[32] When a woman went into the military, her work would be restricted to these "kinds of jobs for women," which ensured that she would remain unthreatening to the men, allowing them to retain the more "masculine" jobs along with their masculine identities. Undeniably, by taking on

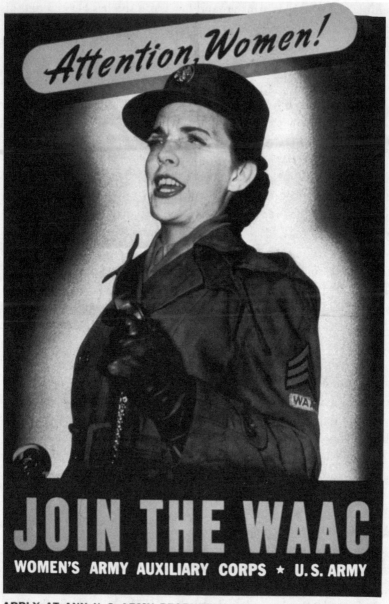

Figure 2–3: The masculine, militarized woman. Source: *National Archives and Records Administration, Slide 44-PA-433.*

those less "masculine" jobs, a woman would "free a man to fight" (the fact that *men* had been doing these "kinds of jobs" before women's entry into the military was a topic that was avoided, as addressing it would have been counterproductive to the campaign). Even a woman's social desires could be channeled as a sort of patriotic "job for women": A poster for the Coast Guard SPARS shows a lovely young uniformed woman, again with lipstick and perfect makeup, on the arm of an elderly man who is wearing a top hat. The caption reads, "Make a Date with Uncle Sam. . . . Enlist with Coast Guard SPARS."[33] Women's "feminine" traits could now be pressed even into military use, and visual propaganda framed those "feminine" qualities as women's patriotism and duty.

As women entered military service, however, it was not the feminine identity of the servicewomen that received most of the attention. Instead, the enlistment of women provoked a dispute over the "naturalness" of certain behaviors for women. As Leisa Meyer has explained, "The female soldier epitomized the wartime antiheroine, a figure whose potential sexual and economic independence from men subverted the 'natural order' and whose position as a female protector usurped men's status and power."[34] The negative term "unnatural" reflected discomfort with the wartime-exacerbated mutability of gender boundaries. An "unnatural" woman was one who had stepped too far over gendered lines and who felt too comfortable assuming a "male" role in any number of areas—including occupational and sexual—in civilian and military contexts.

The terms "unnatural" and "lesbian" hence became virtually synonymous. It was felt that a woman entering the formerly all-male military was assuming a more masculine identity, and this "deviant" female masculinity became associated with lesbianism; unfeminine or "mannish" women were therefore widely assumed to be lesbians or otherwise "abnormal."[35] If gender roles were permeable and women could become "masculine," the reasoning went, there was little to prevent women from assuming a dominant role sexually, and this would be in violation of the rules of nature. Leaders of one association, noted Meyer, "portrayed [the WAC] as an 'unnatural' organization," seemingly because it would make women " 'give up' motherhood for the duration of the war." The association in question also likely thought an all-female group strongly implied lesbianism—women "giving up" men being equated with "unnaturalness" (despite myriad opportunities for heterosexual dating on military bases). The equation of lesbianism with abnormalcy persisted even within the army, which wanted women who were not afraid of doing "men's" jobs, and which stoutly denied that

its Wacs were lesbian. One internal army psychiatric study said that "those who wished to play an active part in the war effort were displaying signs of 'masculine identification,'" and were still thus suspect, as being "mannish" or lesbian or both.[36]

The government recognized that there was conflict between military service and conventional notions of femininity, especially insofar as men were concerned. One government memo explained, "There is an unwholesomely large number of girls who refrain from even contemplating enlistment because of male opinion." The conclusion: "An educative program needs to be done among the male population to overcome this problem. Men—both civilian and military personnel—should be more specifically informed that it is fitting for girls to be in service. This would call for copy ... which shows that the services increase, rather than detract from, desirable feminine characteristics."[37] Government recruiting posters therefore often stressed that military service held benefits for women after the war. The exact benefits, however, went unspecified. One famous recruitment poster, for instance, featured the heads and shoulders of attractive, made-up, uniformed women from each of the four services.[38] Above their heads, the caption read, "For your country's sake today"; below, it read, "For your own sake tomorrow."[39]

The government also attempted to influence women's actions, such as whether or not they served, by using graphic art that implied male approval of desired actions. Some women in illustrations were portrayed as desiring "male" responsibilities that teetered over the line of what the government needed them to do; the women in these depictions retained very feminine qualities. One poster's Wac, for example, stands on a ship's gangplank, ready to ship out, beaming, "I'd rather be with them ... than waiting" (see Figure 2–4).[40] Here, a woman soldier, wearing not only a uniform but the very masculine necktie, helmet, and rucksack, is acceptable because of her feminine qualities: Extremely attractive, she also wears makeup, lipstick, and nail polish. The poster further implies that the masculine qualities of a uniformed woman are counterbalanced by her desire to "be with" the men, serving (with) them, speeding their return, and helping the country win the war.[41]

This recasting of women's military service as increasing desirable feminine characteristics in the women was critical: Prior to the war, a service member had been seen, without question, as male, as "epitomiz[ing] conventional masculine qualities; he was 'authoritative,' 'strong,' 'logical,' and 'well-disciplined.'"[42] The idea of a woman showing these qualities was often

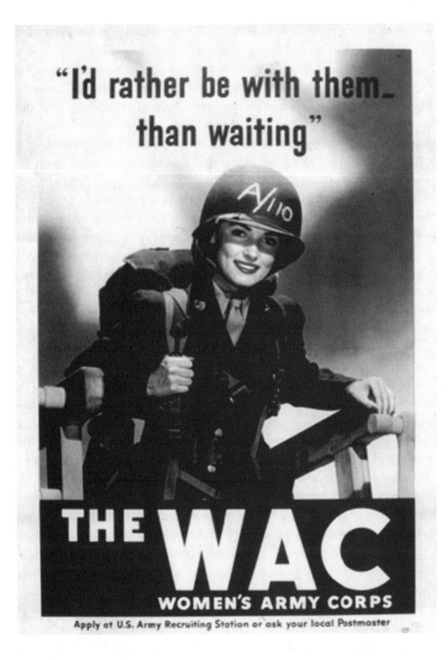

Figure 2–4: Tie, helmet, rucksack, and lipstick—ready to deploy with the men. Source: *National Archives and Records Administration, "The WAC/Women's Army Corps," recruiting poster, Slide 44-PA-235.*

perceived as oxymoronic by men and women alike. *Women* also tended, as an OWI document reads, "to regard military service as unfeminine ... with a questionable social status."[43] Because military service was seen as so thoroughly masculine, even civilian women dressed for production labor and doing "masculine" jobs could disapprove of women in uniform. One cartoon demonstrating this attitude showed four civilian women dressed in men's coveralls and work pants thoughtfully watching a WAVES officer, in a Class A uniform with a skirt, walk proudly past. "Yes, it's a nice uniform," one of them says, "but I don't think it makes her look very feminine."[44]

One of the posters created to address the wartime change in military personnel shows a very cute young woman wearing lipstick and flattering makeup who is smiling at the viewer (see Figure 2–5). Above her are just two words: "Good soldier."[45] It sounds almost like a fatherly endearment. Conspicuously, the necktie that would have gone with that khaki uniform is absent from this artistic rendering, most likely because a tie, so clearly associated with males, would detract from the sense of "femininity" being evoked. What works for the charming "good soldier" is her attractive femaleness alone—her job was simply to redefine what the public thought of as a "soldier." The image works to show that military service had "increase[d], rather than detract[ed] from, [her] desirable feminine characteristics," as the government memo had prescribed, with her soldiering becoming one of those "feminine" traits.

Women's military service was a hard sell to parents, and images like the "Good Soldier" validated women's efforts by invoking pride in fathers for their daughters' service. The Introduction to this book describes an advertisement in which a father's letter to his daughter explains that her potential enlistment gives him a "queer mixture of feelings."[46] That father was fictional, but real fathers did struggle to accept their daughters' enlistment into military service. In another poster, a father sits at his roll-top desk, having unwrapped a large, framed picture of his daughter, who has enlisted in the WAVES. Dressed in a bowtie, his shirtsleeves rolled up, holding a pipe, this "typical" father peers over his glasses at the viewer. "*Proud—I'll say*," his handwritten words read. He props up the picture for us to see. "JOIN THE WAVES," instruct the words below. Another father, fleshy and middle-aged, goes beyond mere pride. As he and a friend lean on their walking sticks and watch a rank of his four WAC daughters march down the street, he tells his friend, "Frankly, Aswell, the feeling of being the father of a task force is one of savage elation!"[47]

Figure 2–5: *Less masculine if you remove the tie: working to alter the definition of "soldier."*
Source: *National Archives and Records Administration, Slide 44-PA-254.*

Military service was not the only work that men disapproved of women doing; civilian women often experienced a similar censure. Even in early 1943, when the severity of the labor shortage was becoming alarming, less than a third of married men gave unqualified approval to the idea of their wives taking defense jobs.[48] One woman's husband, home on surprise leave, was aghast when he saw her "trudging up the back stairs in ... filthy saddle shoes ... men's socks and workpants, red-and-black wool lumberjack shirt over a full set of gray wool underwear, and an Italian laborer-type bandanna covering [her] entire head.... [H]e said, 'What the hell is *that?!*'" according to the woman. "He was wild," she recounted. "He said, 'You get out of there. That's disgraceful.'"[49]

In the attempt to gain male approval for civilian women's work, images showed women's masculinity not only as part of patriotic work or service but also as something men might *desire* for their wives, girlfriends, or sisters. Since the need for working women was so great, posters played up men's endorsement of their working wives. A typical one portrayed a couple with a man in a business suit, his hair streaked with gray, and his wife in overalls and a headscarf. The husband looks down at his wife, his hands supportively on her shoulders; the woman has her fists curled as though holding a factory tool (strangely nonexistent in the poster). "I'm Proud ..." she beams at the reader: "My husband *wants* me to do my part."[50] Women could now be proud of the men who *wanted* them to take up possibly masculinizing work; men who opposed it, in contrast, might expect a shot of propaganda shame.

There were other ways to represent men's approval of a civilian or military woman. A man's appearance in an image might signify that His Part in the war has become, by default, Her Part, that she is being allowed or even encouraged to enact this part of his masculinity *for* him. This was particularly true if a man was a civilian and his wife or daughter was in the military; it might mean he was unable to perform masculinity himself (especially if he was too old for the draft). Images attempted to reframe this defaulted masculinity as being, again, a source of pride. One cartoon demonstrating this principle was of two neighbor women watching a portly, middle-aged man escorting a young Wac on one arm and a young WAVES enlistee on the other. His chin is up and he grins broadly. One of the neighbors observes, "Looks like George finally got over his disappointment at having no sons."[51] If George cannot show his masculinity by having male offspring, the image implicitly says, his daughters, masculinized by military service, will perform it for him.

Images with a man's presence, or even implied presence, may also have had another important purpose: A husband or other male might deflect suspicions that a woman's "mannishness" meant that she was a lesbian. One boyish-looking machinist, with work-shirt sleeves rolled above her biceps and hair tucked under a cap, smiles, "I'm glad of the chance to DO SOMETHING REAL while my husband's in the Army. . . . And say, these machinists are swell!" (see Figure 2–6).[52] Her emphasis, and her strong statement of satisfaction, may be read as advice to unemployed women. However, she is validated not only by the implied approval of the "swell" machinists, but also by the understood existence of her "husband in the Army." Her masculinity is mitigated not only by his suggested approval of her job, but also, as in the case of "Mrs. Worthington" from Chapter One, whose enthusiastic wrenching has twisted up the corner of a tank, by the simple statement that she is married, which deflects impressions of lesbianism. This woman's "masculine" appearance is safely restricted and explained away: She is dressed this way only so that she may "do something real" for the war effort, and only "while [her] husband's in the Army." The Wac who would "rather be with them than waiting" also served to allay fears about masculinized women's possible homosexuality.

To counteract public perceptions of women as possibly lesbian, graphic art deliberately played on more acceptable ideas, such as that of the protective mother defending her children and her homeland. Motherhood was seen as the epitome of "natural," normative (non-lesbian) female behavior. Of course, the new public images of women, designed to prompt them to contribute to the national effort, did not subsume the ageless ideals of wife and mother. To the contrary, the media's pleas to women to assume novel responsibilities emphasized women's conventionality and femininity, and that meant conventional motherhood as well. For their part, women were expected to maintain high standards of parenting despite intensive government recruitment for employment and military service. "Feminine" motherhood now included toughness and strength: "*America* will be as strong as her women," declares one poster recruiting women to the workforce (emphasis in original).[53] The strength of the woman is represented by the fact that in the sketch featured in the poster she is holding aloft a child (a girl child, at that). Beyond just showing women as mothers, art portraying "strong" women was critical in convincing both males and females that women *needed* "masculine" qualities in order to perpetuate "feminine," patriotic, aims.

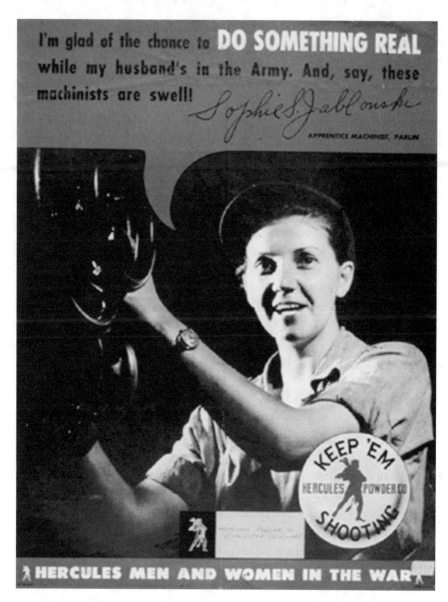

Figure 2–6: The implicit husband deflecting suspicions of lesbianism. Source: *National Archives and Records Administration, Record Group 208, Slide 179-WP-1566.*

Traditional motherhood was so important, in fact, that it had greater priority than war work, despite the country's enormous need. In 1942, the chairman of the War Manpower Commission issued a directive saying that "no women responsible for the care of young children should be encouraged or compelled to seek employment which deprives their children of essential care until all other sources of supply are exhausted."[54] Women with children under the age of fourteen were not permitted to join the WAC. Women's feminine obligation, no matter what other duties they assumed, was to keep their families safe and healthy until war's end.[55]

The government's task was nevertheless to explain that motherhood and work were not mutually exclusive. A (probably internal) report from the Women's Advisory Committee of the War Manpower Commission on women at work commented specifically on working mothers:

> We must not lose sight of the fact that women have always worked. Homemaking is a job. Caring for children is a job. Women have always been producers long before the misleading dichotomy between work in the home and work outside of it. . . . It is not usually included in statistics on war production, but . . . women since 1940 have produced five million new babies, over and above the normal production quota—a production equal to half the armed forces in number. . . . And this is a job; it is work to bring up children, and it is work to be mothers of men. . . . In a way it is foolish to think of women's work as something new. What is new is the pay envelope, the overalls, the uniform, and the recognition. The work, itself, is an old story, a very old story.[56]

The report goes from acknowledging the difficulty and value of homemaking and child care to looking at procreation as a kind of war production, complete with quotas, and then broaches the notion that women's traditional work has not only gone unrecognized socially but has gone unpaid, despite the effort it takes, the trouble it involves, and its importance.

Cartoon art showed women negotiating the two theoretically disparate fields of women's work: homemaking and motherhood on one hand, and factory work and military service on the other. One panel showed a factory scene with a matronly woman in coveralls standing at a wheel. She is adjusting the mechanism of a vast machine with huge drill bits, cogs, and gears. A younger woman and an elderly, bearded man, meanwhile, are adding oil and adjusting the works on different parts of the machine. A boy holding a wrench and wearing goggles complains to the matronly woman, "Hey, ma! Tell grandpaw and sis to stop picking on me!"[57] A woman might

even give birth on the job, in the world of images, in order to fulfill her dual wartime obligations of motherhood and work. Another image shows two men outside of an aircraft factory; they are watching a stork that is carrying a baby fly onto the premises. One man says to the other, "I think we've got this absentee problem *completely* licked, now!"[58] Because motherhood virtually defined femininity, it was imperative to show women maintaining maternity as they took up paid work. Women's work, as the report cited earlier suggested, was not new; but recognition and remuneration for women's work certainly was. And though women's entry into male spheres could be viewed as something new and different, their duties in those spheres continued to be "an old story, a very old story."

There were other "old stories" about retaining femininity in relation to women's (heterosexual) relationships. Articles from movie magazines of the time discussed how a woman might discover that "for the first time in her life she wants to be a man." It continues: "Because, during wartime, girls are doing the best they can, but still they are just second. Second to men." Since a "girl" couldn't "be a man," her duty was to "help . . . not suggest and advise—which is, perhaps, to confuse and irritate." A woman was supposed to listen and answer and be what a man was fighting *for*, not attempt to help him by being his equal.[59]

A woman who was man's equal, in fact, could be considered both goal and threat. In wartime, women's skills were absolutely necessary and desirable, and thus a goal to be desired; postwar, however, what effect would all these skilled, strong, independent women have? Further, was a masculinized, highly competent woman or a conventionally attractive one more of a menace during the war? The theme of the resourceful woman (for example, a Wac in front of a tank, with the caption, "Just give me a hairpin and I can fix anything!") was echoed frequently in cartoons.[60] These cartoons reflected the amazement that some men felt in real life at women's competence. "These WAACs are wonderful!" a male private, standing in front of a tank, tells his lieutenant in one cartoon. "She fixed it with a hairpin!"[61]

These highly proficient Wacs were also threatening to the social order, or, as the Women's Advisory Committee report put it rather obliquely, were part of the "concern for post-war security arising out of confusion as to the role of women in industry" (and, one might add, the military).[62] The Wac, with her most feminine of tools, the hairpin, could apply her knowledge to that most masculine of machines, the tank—and fix it—whereas the male private, with his oilcan, gears, and toolbox full of wrenches, could not. The women are potent where the men might not be. Women's competence,

it was feared, might emasculate the men and had the potential to upset the balance of male and female spheres. In yet another cartoon, there is the oft-occurring tank—but this time broken down by the side of the road with male soldiers crawling about trying to fix it. A carload of female workers from the factory in the background has pulled up alongside. The five women are leaning out of their car with interest, asking the men, "Need any help?" (see Figure 2–7).[63] In this reversal of the traditional scenario, in which the expert male always provided aid to the helpless female, women's competence was especially threatening: The tank provides a powerful phallic symbol, but it is the women, rather than the men, who have mastery over it.

A last panel fully expresses the notion of (competent) woman as both goal and threat. It depicts a man in a hospital bed, his head and arm bandaged. His wife, a plump, lunchbox-carrying woman in overalls and head-rag, puts a hand on her hip and takes him to task: "If you watched your machine as much as that blonde you wouldn't be losing time!"[64] Apparently, this was not a mere cartoon fancy; one woman who became a "counselor" at Lockheed in 1942 has told a similar story about her experience. Although she had been hired to assist the male supervisors, they "wanted nothing to do" with her. The second week she was on the job, however, a supervisor called her and asked her to come down to his area. "A girl had come in in a bare midriff," she recounted, "and all the men were hitting themselves with hammers."[65] Thus, the wartime goal was a woman feminized enough to be conventionally attractive (but not so attractive as to be distracting), and masculinized enough to be efficient (and make sure her husband is, too). It's the extremely attractive, distracting, highly feminine woman who is the threat, not the more masculinized woman—a "girl in slacks."

The worries over women in the production workplace were accompanied by concerns that their presence in formerly all-male spheres would feminize institutions and the men in them. One *New Yorker* cartoon has a burly male factory worker, holding a dripping oilcan, plaintively asking another male worker, "Have you seen my helper around anywhere—the one with the page bob and the deep red nail polish?"[66] The tough worker is using a highly feminized vocabulary to describe appearance; not only that, he is also implicating his male colleague as being feminized, as well—typically, "only a woman" would notice hairdos and fingernails. Additionally, he is showing the stereotypically female behavior of letting his work slide while he is distracted elsewhere, behavior that the government strongly reproached during the war when high factory production was seen as key to victory. The man may have been diverted because of his seeming

Figure 2–7: The embarrassing reversal of roles. Source: *Garret Price (for OWI), National Archives and Records Administration, Record Group 208, E-219, Box 1.*

heterosexuality, since he is looking for an attractive female. Nonetheless, the responsibility for his dereliction lies not necessarily with him, the one who has become distracted, but with her, the one who is providing the distraction. She has feminized the male-dominated factory both by her stylish presence and by her stereotypically "female" wandering. Further, she has feminized the male workers in their vocabulary and behavior. Another cartoon articulates the worry about feminized institutions without words: It shows a Wac driving a deuce-and-a-half with curtains hanging in the truck's windows and a flowerbox mounted on the driver's side door.[67]

Many cartoons express the fear that men might become feminized by portraying them doing "women's work," child care being the ultimate symbol of this. In one cartoon, a male worker is riveting the side of an airplane. But he is carrying a baby sucking a pacifier in a papoose on his back (a twist on the theme of the papoose-carrying women discussed in Chapter One). Meanwhile, he is heating two baby bottles in a pot of hot water over a fire he has built on the tail of the aircraft. To complete the domestic picture, he even has a small dog on a rope tied to his leg. A sign hangs near him that says: "Lost Time Makes Hitler Happy."[68] Much as women assumed masculinity in wartime, so this man has assumed feminine behavior. In another cartoon, a large, middle-aged man, owner of "D. Brown Aircraft Corp.," is carrying his child in a papoose as he walks across the office. This is explained by the office workers as "the only way he can keep Mrs. Brown at her lathe every day."[69] A third cartoon shows a frazzled-looking man struggling to balance a baby on his shoulder while he uses one foot to keep a toddler from tipping over a sugar canister. There's a high chair behind him and disarray all around, and on the floor, a cat laps milk from an overturned glass. With his free hand, the man is holding the receiver from an old-fashioned wall telephone to his ear. "I know your home defense work is important, dear!" he is saying. "But someday, will you tell the kids what I did to help win the war?"[70] Wartime, which has produced the (unwanted) masculinization of women, has, logically produced this (similarly unwanted) feminization of men. There was probably context for this cartoon. One woman who worked during the war recalled, "Mostly we worked seven days a week. It was hard with two kids. My husband and I worked different shifts. I worked the swing shift, so I could be there in the morning and until afternoon." The implication was that her husband was with the children while she worked.[71]

But although women had entered men's spheres, men had not entered women's, at least not to the same degree. Civilian men may have had a

good idea what women were enduring on the home front because of rationing, employment, childrearing in time of world crisis, and changing sexual mores, but servicemen were more cut off from these things and lacked a full understanding of what civilian women were going through. Women and men in some ways learned to speak different "languages." One *Male Call* cartoon strip depicts a soldier on furlough, talking about his experience with a failed combat operation. He's saying, "Yessir, you'da thought the CG wrote most of the AR himself! He had us all PO'd half the time. . . . Well, this day he stuck us out ahead of our OP and the MOS went blooie! We had every GEE on a BAR or M1. . . . The entire T/O from the CO to the lowest PFC got a PH, thanks to that one 88!" (ellipses in original).[72]

When the soldier's mother complains to Miss Lace, the main character in the strip, that she (the mother) doesn't "understand half of what he says," she and Lace formulate a plan to use lingo about the point system used to sell rationed goods. "Did you know that number 36 in Book 4 is good for 5 through August 31st?" the mother queries Lace as the soldier looks on, mystified. "Yes," Lace replies, "—but I had to check on the Red K2-P2! They went July 31st! I'm glad to get 6 on Number 16 in the 'A' Book!"[73] The last panel has the G.I. worriedly thumbing through a "Pocket Guide to the United States" in an attempt to decode this mouthful of (home-front) women's jargon.

Images struggling with femininity and masculinity and the merging of the spheres reflected an additional struggle: that caused by the disjunct between the need to empower women in order to achieve wartime aims and the desire not to empower them too much. Posters sometimes reflected this struggle. One juxtaposed two women: in the background, a colonial-era woman in a bonnet and plain, late 1700s clothing, loading a muzzle-loading rifle; in the foreground, a smiling "Rosie the Riveter" type in a headscarf, wielding a handheld rivet gun against a piece of metalwork.[74] The poster is captioned "It's a Tradition with Us, Mister!" The poster is calling upon the mythical figure of Mollie (or Molly) Pitcher, famous for coming to her country's defense when needed.[75] Another poster shows a different, more menacing "Rosie," whose sculpted eyebrows point downward in a scowl at the reader. She operates a pistol-like hand drill against a piece of equipment, underneath (and seemingly equivalent to) a silhouette of American soldiers manning a machine gun in a Pacific-theater scene. Across the bottom, in bold cursive lettering, is the legend, "It's Our Fight Too!" (see Figure 2–8).[76]

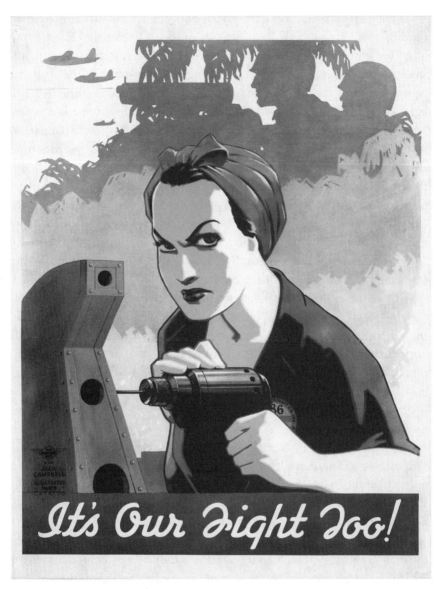

Figure 2–8: Rosie, the angry version: fighting for her right to, well, fight. Source: *National Archives and Records Administration, Record Group 208, Slide 179-WP-1565.*

These two images reflect the social and gender conflict provoked by needing women to be involved in an all-out war. The second Rosie is unusual for posters of women at the time in that she is portrayed in muted shades. Her brown and orange are set against the grays of the drill, the equipment, and the silhouetted soldiers, whereas typically, brighter, primary colors were used for women (the modern "Mollie" in the first poster, for example, has glowing cheeks to match her red polka-dotted bandanna). The colors give the picture in the second poster an ominous, sinister tone; the woman's facial expression, too, while perhaps meant to look determined, looks unmistakably hostile. It is unclear whether she feels antagonism toward the enemy or toward anyone who does not want her to feel too empowered by her work or skills. Both posters, however, indicate a rationalization of women's paid wartime employment as a form of masculinity. "It's a Tradition with Us, Mister!" again addresses men's protests against women entering formerly all-male spheres.[77]

Although these images validate women's participation as equal to men's, they fail to validate equal empowerment. Mollie Pitcher is shown only *loading,* not firing, the rifle, and the menacing "Rosie" is armed only with a drill, not a real weapon. A poem by Phyllis McGinley, paired with another cartoon image, also called upon the Mollie Pitcher legend to reinforce women's disempowered status. In the poem, entitled "Mistress Pitcher, '43," the poet compares the women of World War II with the heroine of the same name from the American Revolution.

But while Mollie Pitcher was engaged in *combat* in the Revolutionary War, aiming a cannon while under fire, her counterpart in World War II has only a panful of bacon grease to contribute ("She's saving the fats that make the powder/ She saves the drippings, she saves the grease . . ."); her battlefield is the kitchen ("firing a gun from her kitchen door"). In the poem's last line, "Mollie Pitcher—the modern one" is praised for her contributions to the man in the war effort even though she is only a "lady behind his gun."[78]

Though the campaign to get women to work in the war industries and to enlist in the military emphasized their worth and patriotic efforts, the images themselves also showed women's *lack* of agency by depicting them without real firearms. One poster stated that disempowerment quite frankly. It shows three female figures: a woman in dark blue coveralls, work gloves, and the ubiquitous polka-dotted red scarf knotted on her head; a woman in a plaid workshirt with the (also ever-present) welding-mask tipped up above her face; and a third woman, a clerical worker, in a dark dress with

frilled white collar, seated at a typewriter.[79] The poster is titled "SOLDIERS *without* guns," and although superficially it gives women status as kinds of soldiers, it speaks strikingly to the way in which women were disempowered, both literally and figuratively. A large number of posters and cartoon panels show women using rivet guns,[80] drill guns,[81] or assembling guns,[82] or in the process of loading guns,[83] or even, in one case, using a rifle as a plasma stand,[84] but images of women actually *firing* guns are very rare (see Figure 2–9).[85] The significance is potent even if, in these images, the women are not. They could supply materials and labor to support men's fighting efforts and be shown *figuratively* fighting, but they could not do the *literal* fighting themselves, nor be pictured doing so.[86] Perhaps firing real weapons would have been seen as too masculine an action for women to perform, or it would have been seen as too feminizing for men to have women defending them, or both. During World War II, women would eternally be cast in a supporting role. One poster demonstrating this principle shows a female war worker helping the Statue of Liberty hold up her torch. The caption reads, "The *Girls* Behind the Men Behind the Guns" (see Figure 2–10).[87] Thus even America's most powerful national symbol was only a "girl behind the men," a label categorically reducing her status.

Ultimately, it seems that what was most important was depicting even the most desirably masculine women with their power under control. A cartoon panel entitled "The Hand That Rocks the Cradle," for example, shows a large crowd of angry women who are labeled "U.S. Women/War Production" (see Figure 2–11).[88] The women are in factory workclothes and are holding armloads of rocks, which they are throwing with great aggression at three swastika-wearing figures: Hitler, Hirohito, and Mussolini. As the women throw them, the rocks turn into planes, tanks, rockets, and bombs, which, upon impact, explode on the Axis leaders. Hitler is struck in the ear by a bomber; Mussolini takes a tank to the gut and an artillery shell to the head; and Hirohito, with a rather phallic fighter plane hitting his mouth and a rocket striking his groin, drops his sword, which is labeled "Back-Stabber." The women are presided over by an anonymous man in coveralls, who smiles widely and approvingly as the women attack their targets.

Here, finally, the women have moved beyond passive womanhood, but in a rather disturbing way. Their anger and the symbolic missiles they throw not only show a level of aggression that women were (and usually still are) discouraged from displaying, but picture almost a sexual assault on the

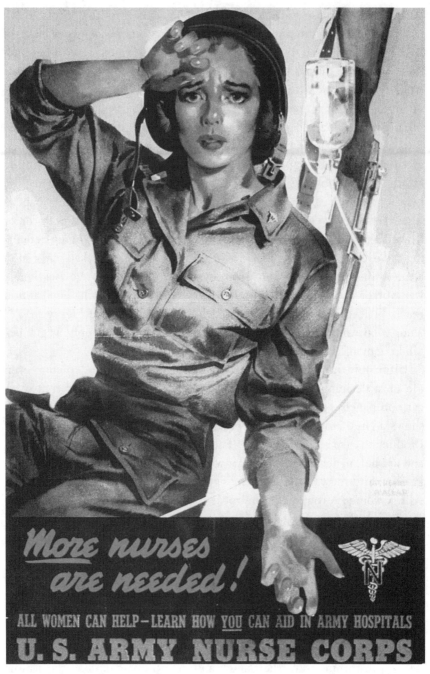

Figure 2–9: The rifle as field-expedient plasma stand—but never fired by a woman. Source: *National Archives and Records Administration, Slide 44-PA-205.*

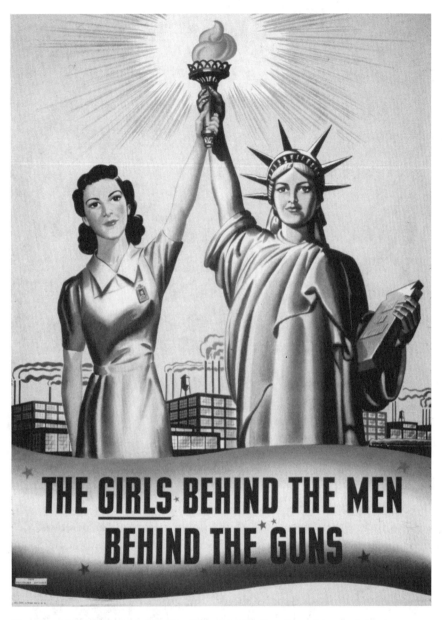

THE GIRLS·BEHIND THE MEN
BEHIND THE GUNS

Figure 2–10: "The Girls Behind the Men Behind the Guns" — but again, never firing them.
Source: *National Archives and Records Administration, Record Group 208, Slide 179-WP-1569.*

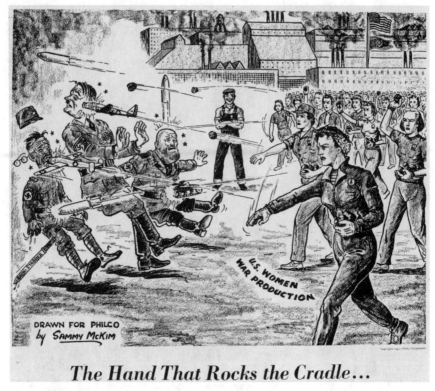

DRAWN FOR PHILCO
by SAMMY McKIM

The Hand That Rocks the Cradle…

Figure 2–11: Supervisory men mitigating female masculinity. Source: *National Archives and Records Administration, Record Group 208, Slide 179-WP-1017.*

Axis leaders, especially the "back-stabber" Hirohito. The image shows a distressing new agency for women: In their newfound strength, they have developed or acquired the masculine prerogative of rape.

This image, then, also spoke to the implicit fears of "a society of 'de-masculinized' men and 'de-feminized' women," and the reasons such concepts were allowable in the image speak to the ways that cartoons and war posters in general attempted to define the boundaries of femininity and masculinity.[89] First, as I have shown, the government had campaigned hard to make women's work and military service acceptable as a patriotic duty. In fact, behind the women in this image, on their side of the scene, an American flag flies between two sets of smokestacks. If these women were committing any sort of aggression, it was seen as a part of or as a sideline to that patriotic duty. It was in defense of their country, and particularly, as attested to by their targets, because their country had been provoked

(Hirohito's "Back-Stabber" label). The memory of Pearl Harbor remained a stinging wound throughout the war (and has long after).

Second, the assault and consequent emasculation of the Japanese leader were permissible because of the racial attitudes of Americans in World War II. The current widespread American view of the war tends to portray the people of the era as "The Greatest Generation," although many—even Tom Brokaw—have acknowledged that "race and broader economic opportunity" ranked high among "the unresolved issues at home."[90] Although the achievements of that generation are indeed massive and impressive, the United States still struggles with the legacy of Japanese American internment during the war, American treatment of Jews concerning wartime immigration, and the negative experiences of many American women who entered the workplace.[91] The government distributed propaganda discouraging discrimination based on sexism and racism, but sexism and racism were clearly still in existence, even in government policies and programs.[92] The particular violence against the Japanese leader that the women demonstrate as a mode of patriotism in this image is made acceptable by way of an acceptable target. What might have been seen as disturbing, physically aggressive women, becomes patriotic—and negative judgment of the women is deferred.

The last reason this depiction of sexual assault was permissible was that the women have implicit male approval of their actions in the person of the grinning, powerful man who is dressed as a shop foreman. Men's approval of women's masculinity was highly reliant on whether men could control that masculinity; if the image showed men controlling a situation, it lost much of its intimidating character and became, as discussed earlier in this chapter, a source of male pride (for example, a father taking pride in his daughter's military service or a husband taking pride in his wife's work). The women in the picture are throwing rocks and displaying aggression, but all is well because the man is smiling, his arms crossed in apparent satisfaction with the proceedings. The women thus stay safely in the zone of acceptability.

In essence, the cartoon reinforces traditional gender roles. Although the title, "The Hand That Rocks the Cradle," is meant to be ironic, it ironically is not. The women are, after all, the "hand that rocks the cradle." Despite throwing missiles, tanks, and planes, they maintain their traditional, "natural," "feminine" subservience to men as well as their role in motherhood. They take up "masculine" war production and military service in a context in which they implicitly maintain femininity, even as they adopt

masculinity for the purposes of the war. The women display outward markers of femininity, wearing makeup, clothes tight enough to show their busts, and the "feminine" standbys of the snood and the headscarf. The image explores some of the implications of women's "masculinization"—that women would acquire (possibly harmful) power by dint of their wartime work—but channels that power in acceptable ways and ensures male control over it. The cartoon allows women to desire the freedoms and responsibilities of patriotic wartime "men's" work and behavior, but validates them by showing men's approval.

That men would validate women's aggression might be seen as a move in a positive direction; but that women would need validation from men shows that women were still subordinate to men. Women's and men's spheres were in flux, with the boundaries of acceptability changing and undergoing exploration because of wartime requirements. It is not surprising, then, that male and female spheres were in some ways merging (for example, women entering formerly male spheres of employment and the military, and men making some corresponding adjustments into formerly female arenas) but in other ways moving apart (for example, men leaving the home scene nearly entirely to go into the service). Women and men performed femininity and masculinity fluidly and in ways that frequently overlapped, and those sometimes fragile spheres moved apart, merged, and moved apart again in myriad ways. The Tangee lipstick advertisement described at the beginning of the chapter—in which women were said to have "succeeded in keeping [their] femininity—even though [they] are doing man's work!"—delineates the line women walked as they added a masculine touch to their feminine duties, or vice versa. As some images reinforced traditional gender roles, others explored how masculinized women might appear, especially if those women were lesbian, or worse, armed. A nation of feminized men might never be able to stop those masculinized women, and as the spheres of masculinity and femininity moved closer and apart, the changes in gender expression were added to the fears inherent in being involved in world war.

3

"Does Your Sergeant Know You're Out?"

Women's Sexuality in Wartime

Dirty Gertie from Bizerte,
Hid a mouse-trap in her skirte,
Tied it to her knee-cap purty,
Baited it with Fleur-de-Flirte,
Made her boy friends' fingers hurty,
Made her boy friends most alerty.
She was voted in Bizerte,
"Miss Latrine for Nineteen-Thirty."

—doggerel "originating from the A.E.F. in Africa"
appearing in an army camp newspaper, 1943[1]

"Dirty Gertie" was not, as far as we know, a real person, but she might as well have been. She exemplifies the sexual conundrum facing women in World War II: On the one hand, her name implies that she is free with her body, and she is clearly expecting a situation where one of her "boy friends" will have his hand where it might be caught in the trap. On the other, she is "dirty" not because she has a lot of boyfriends or because she has sex with them, but because of her dirty trickery. She hides a mousetrap in her skirt, ties it to her knee, and baits it with perfume, but she is a tease. In walking

the line between sexual purity and sexual daring, "Miss Latrine" has made her boyfriends "most alerty," but they are no closer to having sex.

The doggerel's description of Gertie is similar to the depictions of women's sexuality in popular graphic art of the era. This graphic art showed women both encouraged to express their sexuality and urged to restrict it, so that they could be thought of as accessible, but as neither promiscuous nor lesbian. That art also represented women as targets of sexual harassment and showed the military as both promoting women's regulation of their own sexuality and enacting constraints on it, particularly with uniform regulations. In this way, the military stood *in loco parentis* for the young servicewomen who had left their parents' homes to join the women's branches. The military sent very different messages about sexuality to men, however, especially concerning "sex hygiene." Taken together, the two treatments of sexuality in graphic art, one kind for females and the other for males, presented sexuality not as personal freedom or as natural consequence of changing social mores during war, but as physical and cultural threat, embodied through disease, both to men and to conventions of "femininity."

Sexuality and Gender Expression: Walking the Line

Sexuality was a prime focal point for the negotiation of ambivalence about women's roles, of the boundaries between masculinity and femininity, and of the relationship between autonomy and gender expression. Women walked a line of propriety: Encouraged to maintain cultural mores of femininity, women who took control of their own sexuality or appeared to be independent sexually were under very close scrutiny.[2] Further, World War II understandings of "sexuality," more simplified than modern ones, included not only women's physical contact with men (kissing, petting, intercourse), but also affectional preference (whether they preferred, before or now, intensely emotional, romantic, or physical contact with women). Two issues were at stake: First, many wondered, did doing a man's job justify allowing women to have sexual autonomy parallel to men's — in essence, did women assume male freedom and power in terms of dating, courtship, and sex as they took on "men's" jobs? Second, did doing a man's job or taking on masculine roles suggest lesbianism or the threat of lesbianism?

Images of women's sexuality are especially complex, as they are rooted in the powerful social and cultural ambivalence of the time. The cartoons themselves, as they are products of a society in which public respectability is deemed critically important, often avoided direct references to sex and

sexuality.[3] This avoidance of direct sexual references could be attributed to censorship regulations, which helped define what cartoonists and other artists were able to produce and how they might phrase written text. An accustomed vocabulary of suggestion, pun, and indirection developed in the medium of graphic art in response to both formal and informal regulation.[4] Finally, images tended to muddle sex, sexuality, and gender roles—in part because women's work, femininity, and power became conflated with women's sexual expression. Anxieties about gender roles manifest themselves in and around portrayals of sexual involvement or interest. In a time of crisis like that of World War II, when women were asked to assume "masculine" jobs, behavior, clothing, and language, concerns about gender roles came to a head.

Cartoons produced and published by institutions, ranging from official to extremely informal, however, generally worked to manage fears about women's sexuality, implicitly or explicitly insisting that changes in women's work lives did not signify changes either in their sexual orientation or in their accustomed status as sexual objects.[5] Working women would still be judged on the beauty of their faces and figures, no matter if those faces were hidden under welding masks or their figures disguised by coveralls.

If popular culture implicitly or explicitly stated that women had control over their own sexuality, however, there were further implications. A (hetero)sexually active woman could be read as a slut, whereas a strong or controlling woman, less interested or disinterested in men, expressed masculinity, and thus carried suggestions of lesbianism. These matters further complicated the issue of what defined proper sex or gender roles in a time of worldwide crisis, when women were now working in male spheres, uniformed, and were sent overseas into imminent danger. American society, particularly as it produced and consumed images of females in the military, wanted its women to be sexy, but not "immoral" or "unnatural."

Sex and the Uniformed Woman

Because of the wartime establishment of women's service branches, in which roughly 350,000 women served—roughly the number of sailors serving in the U.S. Navy in 2011—American society was entering uncharted waters. Official messages that women's service was patriotic were more than counterbalanced by fears of what that service would mean, particularly in terms of sex and sexuality. Part of military service is taking orders; Americans wondered what "taking orders" would mean in terms of what we would now call sexual harassment, when women were not allowed to

command men, but men were clearly allowed to command women, possibly in compromising situations. The military struggled with the endorsement of women as self-sufficient and self-regulating while also promoting itself as a positive controlling force in the absence of young women's parents.

To understand what a project the military was tackling in terms of women's sexuality, it is important to understand the attitudes that women entering the military faced. A cartoon from very early WAAC history captured expectations of women's behavior. Captioned "Members of the Women's Army Auxiliary Corps pass a golf course," the cartoon shows six Waacs in a jeep, shouting "YOO-HOO!" to two men golfing.[6] The popular assumption was that women, sanctioned by their new uniformed and empowered status, would carry their silly, civilian behavior into the Women's Corps. Further, having entered a formerly all-male sphere, they might try to convert that empowered standing into conduct that encroached on men's behavioral prerogatives concerning courtship.

Certainly, sex and sexuality were of great practical concern in the military. As Leisa Meyer has noted, WAC administrators were convinced that the corps needed to portray itself "as a protector of young women and an organization that would act both as a guardian of their morals and welfare and to regulate and control their sexual behavior."[7] This was easier said than done; even eight years after war's end, the male general writing the foreword to the official WAAC/WAC history confessed that Wacs had "found [themselves] in a man's army that was somewhat shocked by the advent of a women's corps in its midst." His perception was that misunderstandings between the WAC and the Regular Army were due to the fact that "the WAC did not always understand the Army ... [and] the Army did not always understand the WAC—its needs and temperament, and the many other things that man, being the son of woman, should have known but did not, much to his continued embarrassment."[8] This awkward final sentence of the foreword reflects the army's awkwardness with women generally, especially their sexuality—the "things that man, being the son of woman, should have known but did not."

Authorities within the Women's Army Corps also understood that the changes in gender roles resulting from women's entrance into the military might translate into issues about sexual expression. A pamphlet called "The WAC Officer: A Guide to Successful Leadership," published by the War Department in 1945, addressed the matter directly: "The woman in uniform in the military setting is often doing a man's work," it says. "Yet she must constantly remember," it warns, "that her effectiveness is going to be

decreased if she tries to imitate the man or if she trades on her sex. She must remain feminine in her personality ... [and] should not be afraid to accept gracefully the courtesies which American men naturally accord to women."[9] The supposition here is that American men would be naturally chivalrous, rather than sexually aggressive or harassing, a supposition that was put to the test in army units all over the world during the war.

Women of lesser rank ran into problems with these "courtesies" when accompanying higher-ranking men, who, according to military protocol, entered vehicles and rooms before their subordinates. As one Wac tells the story, "While attempting ... to let a general precede me onto an elevator, I resorted to what became known as the Queen Street shuffle: into the car, out of the car, glide to the side then—if all else failed—take the next car up. The General stood his ground behind me [and] finally ordered me aboard, saying, 'After you, private. I was a gentleman before I was an officer.'"[10] Perceptions of a woman's femininity depended on her ability to "accept gracefully" the multiple gender behaviors demanded of her.

The advice from "The WAC Officer" was accompanied by further counsel that, "especially in regard to sex conduct, social standards are more exacting for women, the physical hazards greater.... Although some [women] may feel that they should be able to exercise a man's freedom in their conduct, they must bear in mind that they are in the Army to do a job, and not to settle an old social problem."[11] Although no explanation is offered as to the specific hazards a woman might face that are greater than a man's—rape? pregnancy?—the strict message was that a woman should not become masculinized by her work; indeed, she should remain firmly within a societally established code of feminine conduct, which was understood to include sexual conduct. Additionally, she should behave with the caveat that her freedom was accorded her by the army and by the needs of a country at war, and she should not assume that that freedom was hers—it was, essentially, provided only by the uniform she wore. Patriarchy, sexism, or outright misogyny are dismissed in the manual as "an old social problem," merely a distraction from her "job." Women's liberation, including sexual liberation, was almost explicitly prohibited.

Perceived sexual liberation was nevertheless the cause of public outcry at least once, when a newspaper columnist (erroneously, and possibly maliciously) reported that Waacs were issued contraceptives and prophylactics, as men were.[12] Subsequent protests and corrections by Eleanor Roosevelt and leaders of the WAAC were generally ignored by the public—only the original false report was remembered and believed. This incident was just

one of many in the slander campaign against the WA(A)C that served to regulate women's behavior and sexuality.[13]

Often, women were perceived as feminine or masculine less by their behavior than by the look of their uniforms. Uniforms for the various services (including voluntary ones) were used as selling points—and they were persuasive ones—to recruit women to the ranks. Posters and recruiting ads for the Cadet Nurse Corps included detailed descriptions of "smart gray" winter uniforms. Clothing designer Main Bocher had created a stylish (and more "feminine") contribution to the U.S. Navy WAVES and U.S. Coast Guard SPARS. Recruiters emphasized these fashionable uniforms; as for enlistees, some women even chose which service they would join based on the chicness of the uniform.[14] The WA(A)C uniform, however, was based on the male version, and, as official WA(A)C historian Mattie Treadwell pointed out after the war, "Gallup polls showed that eligible prospects for enlistment rated the WAAC's uniform last in attractiveness" of all the services.[15] Despite enormous wartime changes, society needed visible reassurance that women would retain feminine signifiers of being "womanly."[16]

The WAC uniform continued to be problematic in all aspects of its production. The quartermaster seemed ill equipped to provide female clothing of appropriate size, quality, and amount.[17] There were extensive problems outfitting the women; although WAC leaders made the uniforms a priority, there were often multiple obstacles in their way. One ex-Wac, speaking about the WAC director's difficulties in this area, said, "Poor Col. Hobby. She tried so hard to get the best for her gals."[18] After military uniforms were finally issued, in some cases well after basic training, and altered for general fit, women who had the means (usually officers) often took them to civilian clothiers to have them tailored.[19] This could have the effect of adjusting the sometimes boxy, shapeless WAC uniform to a more "feminine" fit, but it did not mute the public critique: Attitudes regarding the WAC generally stayed negative throughout the war. (Even the terminology for women's military equipment could be problematic. Many Wacs, for example, derived amusement or chagrin from the double entendre suggested by the footwear term "overshoes, low women's."[20])

The problems with the uniform were symbolic of the difficulties the services had with the women themselves: The topography of the female form tended to reveal itself, especially if the uniforms or regulations had not originally been designed with women in mind. One cartoon shows a rank of women at attention, including one with an unusually bulbous chest,

being inspected by a WAC officer. The female officer barks, "Empty your pockets, Cogan!"[21] The officer has assumed the role of regulator not just of military uniform protocol but of sexuality, demonstrating again service-women's unique situation. Cogan's cartoon illustrates the army's discomfort with women's bodies and the sexuality they represented.

An actual WAC officer like the one in the cartoon would have had re-course to one of a couple of solutions implemented by the army. As *The History of the Women's Army Corps* succinctly (if vaguely) puts it, "Experiments with carrying necessities in breast pockets quickly produced a rule against even so much as a pack of cigarettes in that location."[22] In response, the quartermaster changed the "Jacket, wool, o.d. [olive drab], Women, WAC, Officer's," to a "barathea jacket... with ... *simulated* breast pockets" (em-phasis mine).[23] One former Wac remembered that the uniform shirts also had false pockets by the time she enlisted in 1943, but that "the boys used to ask me if I had apples in there."[24] Military S.O.P. (Standard Operating Procedure) held its own challenges, both in terms of uniforms and women's anatomy. Charity Adams Earley, commander of the first "Negro" WAC bat-talion overseas, explained that, "dressing the line, checking to make sure a line of soldiers side by side was a straight line, required that each person look to the left to the second shirt button or the necktie of the second per-son down and align herself on that button or necktie. This may have worked for the men, but for the women it was hilarious. The hills and valleys varied in shape, size, and location."[25]

Cartoon depictions of this iconically female feature were so prevalent that they became a problem. Treadwell's history of the WA(A)C noted that, "from the first, cartoonists had found the WAAC amusing and had contrib-uted caricatures which ranged from light humor to emphasis on anatomi-cal detail." Official frustration with portrayals of this sort resulted in the conclusion that there was no legal recourse that would restrain unflattering professional caricatures of female service members. A bigger trouble ap-peared to be "soldier products from camp newspapers," which, in the words of Treadwell, "held with rather monotonous lack of originality to the idea that the best way of ridiculing a woman was to exaggerate those portions of her figure that differed from the masculine version. Although particularly masculine garments were not considered funny, the mere depiction of a brassière, empty or otherwise, was alone enough to seem comic to [ama-teur] cartoonists."[26] Treadwell gave an example: Two soldiers in the camp quartermaster's supply room are unpacking and stacking boxes. A corporal

putting a box on a shelf asks, "What makes you think the WAAC is coming to this camp?" as the other soldier incredulously holds up a brassière from a boxful labeled "Size 36, color pink."[27]

The cartoonists' "field day" over bras and breasts was widespread. "Winnie the Wac," a well-known cartoon character, was portrayed in all her cartoons strips as "pert, pulchritudinous, [and] pin-upy,"[28] a reference probably to the fact that her breasts were boldly defined in almost every panel, whether she was wearing an apron, a fatigue dress, pajamas, or a Class A uniform. One panel had Winnie seated on her bunk in the barracks, holding up a sweater she has just taken out of a package—a sweater with the breast shapes pre-formed into it. She tells another Wac, who looks on, "My boy friend knitted it for me."[29] Even if there is implied feminization of her knitting boyfriend, Winnie's voluptuousness and thus sexuality are never in doubt. Breasts signaled many things: femininity, availability, heterosexuality, and a comfortable familiarity in gender roles, the female an object of the spectator's gaze.

Ultimately, innumerable cartoons focus on women's breasts as fodder for humor. Jeanne Holm confirmed Mattie Treadwell's observations when she wrote, "Cartoonists had a field day over bras and bosoms," and this was no exaggeration.[30] In one cartoon, a stout, buxom Wac sits on her bunk, again with an open package. As another Wac looks on, she is holding aloft a tiny brassière top that would not even begin to cover her vast bust. Obviously annoyed, the first Wac echoes Winnie the Wac when she scowls, "It's from that soldier I knitted a sweater for last spring!"[31] Another panel shows a male G.I. staring raptly at the perky chest of a Wac as she plaintively asks him, "What's the matter?? Haven't you ever seen a soldier before??"[32] Yet another "Winnie the Wac" cartoon depicts a general holding up a military decoration to pin on Winnie. Although his hand is only a few inches from her, there is nowhere on her chest to pin the medal without touching her bosom. He hesitates with his hand hovering near her breasts; the caption reads, "Er,—Ahem!"[33] No doubt many male officers were at a loss for appropriate words to say to women or how to act, often to WAC officers' chagrin. Another cartoon also shows a general about to pin a decoration on a busty Wac; this one, rather than being hesitant, is eagerly poised (see Figure 3–1). The WAC officer standing behind him dryly directs, "Just hand it to her, General."[34]

The military's predicament was that, whatever the comfortable familiarity of her role, it couldn't force a woman not to *have* sexuality; it could only regulate how she *expressed* it, and the easiest way to do that was by external

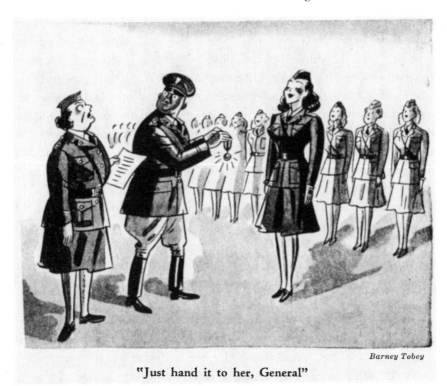

Barney Tobey

"Just hand it to her, General"

Figure 3–1: Not exactly like men: the Awkward Breast Situation. Source: *Barney Tobey, "Humor/ Cartoons" Folder, United States Army Women's Museum, Fort Lee, Virginia (no publication information). (© Barney Tobey)*

means. Keeping the uniform from being feminized or sexualized was only part of the story; the military felt that it bore responsibility (and the public felt that the military bore responsibility) for the woman wearing it. An Eveready advertisement for batteries (part of a cartooned series) has a WAC Military Police (MP) officer shining her light on a civilian man and a Wac who have clearly been necking on a park bench. The Wac is disheveled, her blouse rumpled, her tie and Hobby hat askew. "Remember, Murdock," the MP is saying to the woman, "the cap is always worn straight on the head!"[35] A gruff male MP from another cartoon also catches a Wac corporal and a civilian man in a clinch on a park bench. In a slight departure from the standard cliché, he asks the Wac, "Does your sergeant know you're out?"[36] Clearly, along with feeding, clothing, and housing servicewomen, the military, the images indicated, had also taken over parenting duties.

The topic of many images was how the military could regulate other pieces of the uniform that it had simply never encountered, created, or

issued to men—clothing that was still fairly sexualized in the forties, even beyond the bra. A WAC MP in a "Winnie the Wac" cartoon whispers behind her hand to Winnie, "Hey, soldier!—Your slip is showing!"[37] A panel by another artist has a male MP gesturing at a Wac's skirt and grousing, "And what's more, that slip ain't regulation!"[38] Variations on the theme addressed the struggle between women's familiarity with each other and the demands of formality, both in terms of military language and between officers and enlisted. "Begging the Captain's pardon, Ma'am," a Wac hesitantly approaches an officer in one panel, "but the Captain's slip is showing!"[39] Another cartoon panel, this time picturing WAVES officers, has one whispering to another, as they walk down the street, "Your slip is showing on the weather bow."[40] Uniquely female clothing foregrounded women's sexuality in a way that men's clothing had never foregrounded theirs, further reflecting the social schism between women and military service.

Specific uniform items were hence designed with functions of sexual regulation in mind. The "overcoat, field, women's," contained a "buttoned-in wool liner" that was "designed for use also as a dressing gown" and was described by the quartermaster as being "both warm and practical."[41] The notion that a soldier would simply don her bathrobe and then button her overcoat onto it apparently struck no one in authority as odd. Again, no such dressing gown/overcoat liner equivalent was apparently ever designed for men; the dressing gown was in response to concerns (or hopes?) that women might walk around the barracks nude.[42] One cartoon expressed it this way: A G.I. is apprehended by an MP outside a WAC barracks; as the MP grabs the soldier by the neck, and the shocked Wacs look on from inside the window, the G.I. says angrily, "I am NOT a spy! I'm only a peepin' tom!"[43] The regulation of women's clothing and bodies had the subtext of Wacs' effects on male soldiers, sometimes serving to regulate their behavior, as well.

More gendered complications arose from uniform regulations concerning skirts versus the more practical trousers. Colonel Oveta Culp Hobby, director of the WA(A)C, "desired that women wear skirts instead of slacks wherever possible, in order to avoid a rough or masculine appearance which would cause unfavorable public comment."[44] As Leisa Meyer noted, the controversy surrounding the issuance of trousers to female soldiers strengthened the perceived connections both between male attire and male power and between mannishness and lesbianism. A woman "wearing the pants" was a sign of how women were usurping power and status conventionally associated with men, and trousered servicewomen generated

anxieties among male military personnel that their positions of authority were under threat.[45]

Women soldiers in trousers emphasized the "problem" of female masculinity. Despite the fact that Colonel Hobby "cringed at the thought of her troops in trousers," those whose work demanded it were issued herringbone twill utility trousers and shirt or coveralls as fatigues.[46] And although Wacs in many parts of the South Pacific adopted makeshift trousered uniforms and wore them throughout the war, because they provided much better protection than skirts against heat rash and insect bites, which were endemic to the area, the stigma against pants remained.[47] It was so stringent, in fact, that although American women informally obtained them from British tailors, trousers never became an official part of the non-fatigue uniform. This was so even though pants were warmer and superior to skirts in preserving servicewomen's health during European winters.[48] Many of the Wacs had trained at Fort Des Moines in Iowa, where snowstorms were common. They complained that the required skirts "exposed to updrafts the loin in winter," another example of their less practical qualities.[49]

Impractical or not, constraints on pants had the added effect of restricting women's ability to walk with "long strides"—yet another "masculine" quality. Evolving American uniform standards were due in part to "the adverse reactions of male military personnel and commanders."[50] The WAC struggled with its fears of too-masculine women: "It seems to me lately," wrote Hobby, "that I have seen too many women officers who are hard. The last thing we want to accomplish is to masculinize a great group of women."[51] Far more concrete than perceptions of "hardness," pants were the strongest marker of a masculinized woman.

The high visibility of the women's military uniform also reflected on the army itself. The director of intelligence who investigated Fort Des Moines following public complaints about WAAC personnel found that the public reaction was not due to "disorderly or promiscuous conduct." Indeed, he "conclusively determined" that "the morals of the members of the Corps are exceptionally and surprisingly good." He pointed out that even one example of WAAC misconduct in a bar would have far greater impact on public opinion than identical conduct by countless civilian women.[52]

Regardless of whether women in uniform were guilty of "disorderly or promiscuous conduct," opinions were often formed about them on the basis of their uniforms. Women's military uniforms presented a particular problem in terms of gender presentation and expression. Whereas female factory workers had to adhere to safety standards (no long, loose hair or

jewelry), but could still feminize their apparel, women in the military could not. This problem was not unique to the U.S. military: The uniform provided to women of the British Auxiliary Territorial Service (ATS) was also generally seen as unflattering or unfeminine, despite regulation underwear that included "boned corsets," which in a previous era one might have considered quintessentially feminine. According to British historians, the uniform was seen as either defeminizing women, which could turn them into sexual sluts, or as making them manly, and thus, presumably, not interested in heterosexual relationships.[53]

In an era when sexual harassment not only was not a crime but was a man's prerogative, even heterosexual relationships were fraught with questionable gender behavior. As Treadwell succinctly put it in her official WA(A)C history, "the Wacs were gradually able to convince the enlisted men that their mission . . . was a military one."[54] Treadwell was referring to the rumor campaign that women were in the WAC to be prostitutes for the officers.[55] One cartoon acknowledged the problem, showing a rank of Wacs being addressed by a WAC sergeant. Behind her, an older male officer, hands on hips, gazes at the women, moustache bristling. "I want a volunteer for a dangerous assignment," she is saying. "The colonel's looking for a secretary."[56] This setup was unfortunately far from a joke. Ethel Starbird, a Wac serving in a clerical position, told a story about her then-boss, a branch chief with an all-enlisted WAC staff who "thought he had inherited a harem with whom he could play pasha." As a warrant officer, he could date either officers or enlisted women, but feeling as though enlisted women would tarnish his image as an officer, "this little charmer," as Starbird termed him, "tried to set up back-alley deals: you bring the body, he'd bring the booze." His revenge for rejection included threats of negative efficiency ratings, delayed promotions, and blocked transfers.[57]

In a move to deal with women's sexual behavior and its consequences, the military was forced to create new policies and standard operating procedures. Obviously, sex was on the military's collective mind, as it were, especially as it compared women's and men's sexuality. How equally to men could women be treated, once they had entered a previously all-male sphere? Notions about equality between men and women — around, for instance, frequent venereal disease inspections — ran up against reality. As one post surgeon pointed out to the surgeon general of the army: "Venereal disease in women could not be detected by inspection, as in men," yet, to emulate men's "sex hygiene" inspections (often referred to as "social hygiene" for the women) in the WAC, women were given pelvic examinations

monthly, at some stations.[58] For these inspections, women were lined up on their bunks, typically without even the most rudimentary privacy (of drapes, for example). The examinations of entire units of women were often performed by medical personnel who had little experience examining women, and, according to Treadwell, "a woman might suffer pain for a week after a rough or inexpert examination."[59]

Whole comic strip series were devoted to the sexual availability that soldiers wanted from women. One entire cartoon feature, "The Wolf," portrayed the male G.I.'s perspective of women, "The Wolf" being a (literal) dogface whose identity centers entirely on his sexual appetite.[60] A typical panel showed two beautiful Wacs standing in the background as a top sergeant snarls at a group of G.I.s (including the Wolf) on fatigue detail (they are raking up trash). "Well, well!" the sergeant growls, "— Th' foist robin! *Who whistled?!!*"[61] A "Private Breger" cartoon has the G.I. smugly examining his fingernails as two Wacs, one enlisted woman and one officer, fight over him. One shouts, "I don't give a damn if you *are* an officer[,] you cat — you can't steal him from me!" The other woman kicks the first Wac in the shin as she screams, "Attention[,] you little corporal hussy! He's mine and that's an order!"[62] In a third example, a WAC officer complains to another, "They used to say, 'hello, Babe.' Now all they do is salute!"[63] The Wacs' accessibility was the issue at question, and in some overseas stations, according to the official history, "no Wac was so old or unattractive as to be neglected."[64] Even if women's role wasn't nearly as sexual as men fantasized, and despite the warped and wishful thinking on the part of the men, many heterosexual women dated and desired men's attentions as they carried out their military duties. Here was the conundrum: Women were encouraged to be available, but that availability was both demanded and damned. If a woman was not sexy, she could be seen, as Colonel Hobby had noted, as "hard," but if she showed any trace of desirability, she could be pursued mercilessly, the pursuit its own form of harassment, its hearty representation in images yet another form.

In fact, because women in uniform were without "the social checks and safeguards" accorded women in civilian life, the public also had the "impression" that the WA(A)C was "the ideal breeding ground" for homosexuality. In response to an allegation that Fort Oglethorpe was "'full of homosexuals and sex maniacs,'" for example, WAAC Director Oveta Culp Hobby requested that the Army Inspector General (AIG) investigate to "determine the true situation." The AIG, however, "was able to find very little evidence of homosexual practices," and further found that the incidence of

homosexuality seemed no greater and was probably less among WA(A)C members than among women in the civilian population.[65]

The *Male Call* comic strip heroine, Miss Lace, demonstrated one of the public's "impressions" in a cartoon that was never published. Miss Lace stretches as she awakens the morning after a sexual encounter. There is a blanket-covered form in bed next to her. Eyeing the army uniform hanging on a chair nearby, Lace is surprised as she hears a female voice exclaim, "Oh, boy! No reveille! No police up! No close order drill!" As the owner of the voice, a WAC private, sits up and asks her what is so funny, Lace chuckles and sighs, "They should have more distinctive insignia on those WAC uniforms!"[66] Leisa Meyer suggested that there were strong popular correlations "between masculine appearance and female homosexuality, in particular the explicit connections between women in uniform and lesbianism." Further, she proposed that "Caniff's casual treatment of the lesbian Wac also implies that the presence of lesbians within the women's corps was well known."[67]

While this may well be true, the cartoon is a great example of the difficulties of interpreting women's behavior as lesbian in an era in which sex, let alone sexual identity, was not discussed. Women frequently slept with each other nonsexually in the same bed; the fact that the Wac in question is in full pajamas to the neck may be problematic to a sexual interpretation of the cartoon—would a sexual pickup really bring pajamas?[68] Likewise, would Miss Lace really not have been able to tell she was with a woman, once the confusing WAC insignia and uniform were doffed? Additionally, assuming that the AIG's finding on lesbian numbers had credibility, and given the hysterical tenor of some of the allegations ("sex maniacs"), the presence of lesbians in the women's corps could have been only popularly supposed or inflated, rather than necessarily "well known." What is probable is that Caniff, too, was walking a fine line—between what was publishable and what was off-limits—the image being the environment in which cartoonists negotiated.

There would clearly have been incentive for both individual soldiers and military officials to hide any lesbian presence in the WAC. However, Treadwell wrote the WAC official account some years after the fact—1953—a time that, although hardly fantastically liberal, might at least have been able to attribute a lesbian presence to wild wartime behavior. On the other hand, the military was still struggling with this issue during the Korean War. The *Woman's Home Companion* ran an article in August 1952 that asked, in bold, half-inch capital letters, "ARE WOMEN IN UNIFORM IMMORAL?"

over the heads of servicewomen linking arms with servicemen from each of the military branches. The subheading goes on to say, "No question, these look like fine young men and women. But then why the tales of promiscuity and abnormality in our women's services? Here are the facts—from men who work with women in uniform." The irony of having servicemen vouch for women's morality and normalcy, when some servicemen had already slandered servicewomen so thoroughly, is difficult to ignore.[69]

Military women obviously struggled with physical desire during the war, moral or not, and cartoons especially played with that theme. A "Winnie the Wac" cartoon shows her at a movie theater that advertises "Servicemen 25 cents." Winnie is saying to the ticket seller, "Give me 4 soldiers, please!"[70] Two "Cuties in Arms" panels continue the man-chasing theme: The first has a Wac saluting her superior officer, who sits at a desk. "Lieutenant Wilson reporting," says the first Wac. "There are no eligible men in Company C, but Company F has infinite possibilities!" The second cartoon panel shows a Wac alone, writing in a notebook. "Dear Diary—," she begins, "Life here at camp is no bed of roses, but we have the sweetest, loveliest captain you ever saw. He's a man!"[71] These images probably did little to remedy the idea, in the campaign against the WAC, that the corps was created to serve men, or that women were in the service to search for male partners. It does deflect the thought, however, that women in the service—even "normal," moral, nonslutty ones—had sexual desires, and instead imposes on them the stereotypically silly behaviors assigned to "man-chasing" women.

As a way to help monitor sexuality in the women's corps, the "Women in Uniform" section of an official army publication, "The WAC Officer," attempted to use popular psychological terms and concepts, mingled with current mores about sexuality, to educate officers and alert them to their obligations to women unfamiliar with wartime freedoms. "One of your responsibilities as an officer is to teach and encourage high moral standards in your troops," it noted firmly. "Your influence can go far to replace the social checks and safeguards of the home and community, which have been temporarily withdrawn." The officer's influence was necessary, it said, because, although some women would "carry wholesome family standards with them into the service," others would be "swayed by wartime emotionalism," probably into sexual liberties. Still others would be frankly glad to be let off the leash. When "the restraints of the home" were released, women might even note with glee the thousands of sexually hungry men around them.[72] This glee might lead them into "unwholesome relationships," which would occur because the women were "lonely or unhappy and misled," although

the exact nature of the unwholesomeness was left vague, especially as to hetero- or homosexuality.

The guide, which, though credited to the War Department, was probably written by army psychiatrists for WAC officers in response to the public concerns about (homo)sexuality in the Corps, hastened to reassure the WAC officer reading it that "sex hygiene problems have not offered serious difficulties in the Women's Army Corps." It noted academically that "the liberation from Victorian prudery has not been accompanied by a correspondingly clear and accepted code of conduct." Further, "sex," it observed, "is an area of human expression that is too often still thought of as a conduct to be judged rather than behavior to be interpreted."[73] The creators of "The WAC Officer," though adopting an academic tone they may have deemed appropriate for educating officers, demonstrated more basic desires: not only to determine which Wacs were sexually active, especially with women, but also to display to the public that the army was keeping a careful eye on Wacs' sexual morality.

Hence, the army vowed it would provide instruction about sexuality to its female members, for knowledge about sex was "the first requisite for a healthy attitude toward sex and for an understanding of the social implications of sex conduct." This meant understanding one's "body mechanism" and "the nature of various sex relationships," among other topics. The army would thus chart for Wacs "the normal course of sexual development," which moved through childhood and "increasing interest in the opposite sex," and which would "culminat[e] in mature love for a life-partner." The notion that a woman could develop normally through childhood and still feel "increasing interest" in her *own* sex as "life-partner" was, not surprisingly, never discussed, despite the guide's assurances that the army would instruct "every woman in the corps," relaying "excellent and comprehensive" knowledge of these "various sex relationships."[74] Thus, heterosexuality was normed as "mature," while alternative sexualities were ignored and implicitly derogated as "immature" or worse.

Yet homosexuality was discussed some pages later with the notion of "feminine companionship." The guide told the story of "Private Jordan," who

> came to talk to her CO [commanding officer] very much upset because she had learned that there was talk about her friendship with another girl. The interview revealed that she had never gone out much with young people, never had a "boy friend." She had not wanted any, she

said, because "father and I were such pals we did everything together." He was overseas now, so she was doing her part as a soldier.[75]

Although it was "understandable that Private Jordan should have turned for companionship to another girl—an athletic, outdoor type like herself... who wasn't 'silly like the rest, with all their talk of "dates,"'" the responsibility for this "intimate friendship," which "should not be considered as necessarily unwholesome," was laid at the door of the overattentive father. That scenario is presented as the least offensive of the homosexual-type relationships, the understandable product of a misguided paternal model.

Other, more insidious parental wrongdoing could come from the mother, who, "because of her own domestic difficulties, ran down all men and held before her daughter an ever-present example of marriage as something to be shunned." Or the culprit could be a father who, "by his bad temper or sex irregularities, turned her against the male." This resulted in "a girl who ... has not been able to shift her interest from her own to the opposite sex, and so has become, potentially or in reality, adjusted at a homosexual level."[76] The subtext was that women became lesbians because their mothers had taught them to hate men, or that they themselves had grown to hate men because their fathers had emotionally or sexually abused them (or others). Such women had become lesbians, that is, in actuality or *potentiality*. If a woman was not already a homosexual, her childhood experiences might make her into one in the future, given the right (or wrong) circumstances. The fairly astounding onus was on the WAC officer to determine if there was simply a close friendship between women, or something, again, more "unwholesome," a blanket term that indicated a large category of coded, unnamed, and shadowy concepts, including sexual promiscuity, unmarried pregnancy, sexually transmitted infections, homosexuality, and other unsavory developments. "Unwholesome" behavior could be handled, like most behavioral issues, up through the chain of command, starting with counseling from the officer to the Wac, with a potential end of court-martial and/ or dishonorable discharge.

Amateur assessments or speculation about what was "unnatural" or lesbian or the gradations thereof sometimes did carry into formal proceedings. Transcripts of a court interview of a Wac accused of "perversion" (lesbianism) noted that the prosecuting officer informed the accused, "It is a well-known fact that an affair of this sort [that initiated the charge] would be in degrees, some degrees being more aggravated and more unnatural than

others" (referring probably to active and passive sexual roles).[77] An "unnatural" woman could be assumed to be lesbian, particularly if she took a more assertive or aggressive sexual role. WAC officers, however, were reminded that "often the homosexual impulse which is in so many of us expresses itself when there are insufficient outlets for more normal affection."[78] The reference to normalcy immediately invalidates the conciliatory language about the ubiquity of homosexuality. Further, the implication that a woman would not turn to other women if her needs for affection or sex could be met heterosexually is rendered unlikely by "moral" constraints on women's behavior with men.

A popular understanding of women's sexuality of all kinds, including lesbianism, probably came, to no small degree, from a long-running column in the *Ladies' Home Journal* by psychiatrist Dr. Karl Menninger.[79] During the 1930s, Dr. Menninger offered psychiatric advice on "mental hygiene" in each monthly issue, and one of the myriad topics he addressed was homosexuality. Though he maintained, as one scholarly look at his work stated, that "homosexuality ought usually to be left alone, since few homosexuals wanted to be cured," Menninger also "viewed homosexuality as an illness, or as an arrested state of psychic development, a phase that everyone experienced, but that healthy people passed through." Thus his attitude was not unlike the one presented in the training the army provided.[80]

Menninger's advice to one woman, who sought comfort concerning a "regrettable" homosexual experience, and was experiencing the fear that she might be "one of those terribly unfortunates [*sic*] designated as being 'queer,'" contained not only what he hoped was "a little mental relief" but also a rudimentary explanation of "the theory of sexuality" à la 1930. "The experience that you have been thru [*sic*]," he began, "is a perfectly normal and very common experience. It does not mean that you are homosexual. It does not mean that you will ever become homosexual. It does not even mean that your friend [with whom she had the experience] was a homosexual." His "theory of sexuality" was based in large part on interpretations of what gender expression meant about sexual orientation: "Most people assume that the quality of being male is one thing and the quality of being female is another and that men are all male and that women are all female," Menninger wrote to her, adding,

> Now that is not correct at all. It is more nearly correct to say that men are mostly male but have some female element and women are mostly female but have some male element in their makeup. . . . On the other

hand, the mixture of male and female traits is not exactly the same in all individuals. Some women are more mannish than others, as you know. . . . The woman you describe was evidently more mannish than you[,] and you are evidently a very feminine type of woman, with very little mannish element. Therefore, it is apparent that she was attracted by you and you were attracted by her to some extent. . . . But this is nothing serious at all.[81]

Menninger then continued to attribute both the experience and the feelings of the women involved essentially to environmental causes:

It is a very common experience[,] and whenever people of the same sex are thrown together a good deal and denied the company of the opposite sex this experience is exceedingly common . . . for example . . . for girls who are thrown together in dormitories and schools. . . . It is sometimes carried quite far and violent love affairs come from it which are unhealthy as you know. . . . The affair that you had with this woman was not a full-fledged case of sexuality. It was indeed a kind of homosexual attraction but homosexual attraction is not a serious thing and usually means only that the individual is denied normal sexual outlet and is given a peculiar and particular opportunity.[82]

During the war, this attribution of lesbianism to environmental causes provoked considerable concerns — despite the fact that Wacs were not necessarily generally assigned as whole WAC units but often as adjuncts to male army units, and thus had plenty of opportunities for "company of the opposite sex." Menninger went on to reassure the woman, who had been married to a man for six weeks, that "the fact that you have normal and enjoyable sexual relations with your husband is proof that you are not sexually abnormal at the present time and I don't believe you ever will be."[83]

This psychiatric opinion was the prevailing educated social attitude at the time, and it was published in a highly popular women's magazine. It thus may not be at all surprising that "The WAC Officer" pamphlet took a fairly conciliatory and Freudian stance concerning the sexuality of the women in the officers' command. Sexual contacts between women were undoubtedly going to occur; and the army, from its perspective, was simply taking pains to discover the best way to handle these incidents and other mental and emotional "conditions" that arose.

Changing Social Mores, or Threat?

If women were encouraged to walk the line between feminine purity and sexual daring, men in the military were given very different messages about sexuality, and indeed about women themselves. "Sex hygiene" posters, pamphlets, and films represented women's sexuality not as women's expressions of personal freedom or as a (welcome) manifestation of changing wartime social mores, but as physical and cultural threat. Sexual women embodied disease and thus endangered men; moreover, they did not stay within the bounds of women's normative "femininity." Even military women, whose "sexuality" was inherent in their mere *presence* in a combat theater, were suspect, as their sexual appeal might tempt their fellow soldiers to battle with their own desire in violation of American codes of masculinity and chivalry.

Actually, civilian women were sometimes portrayed in popular art as having desire with no outlet during the war. (Military women obviously had a large selection of possible outlets, though implicit and explicit restrictions on women's dating prospects did limit their actions to some extent. As Winnie the Wac says to a friend, as they sit in the midst of dozens of male soldiers, "Do you miss men since you're in the army, Thelma?"[84]) One panel shows a woman in evening dress on a bench, languishing outside on a moonlit night, winking at a balding, bespectacled man passing by. Startled, he is pointing to himself and saying, "Me?", obviously not expecting to get the nod from such a young, attractive woman.[85] Another cartoon has a large matron in a vast striped bathing suit and bathing cap walking down the boardwalk with her scrawny husband in old-fashioned bathing trunks and singlet. He, too, is balding (the signifier most used to indicate lack of virility), but has a little smirk on his face, as all the young women in scanty swimsuits on the boardwalk are checking him out as the pair proceeds. "You needn't be getting any exaggerated ideas about yourself," his wife is telling him. "You just don't happen to have much competition nowadays!"[86] "Not much competition" resulted in civilian women gazing wolfishly at what they were missing most: men, as objects of affection, love, and sex. Especially because the ratio of eligible men to women on the civilian front was so small, depictions of women often reinforced stereotypes of man-chasing women trying to grab a man before other women could.

One popular song from the era articulated this sexual frustration:

You marched away and left this town
As empty as it could be,

I can't sit under the apple tree
With anyone else but me
For there is no secret lover
That the draft board didn't discover . . .
They're either too young or too old,
They're either too grey or too grassy green,
The pickin's are poor, and the crop is lean
What's good is in the army,
What's left will never harm me . . . [87]

The singer bemoans not just the loss of her lover's emotional presence, but also his sexual presence. "What's good" simply isn't there anymore, and neither is the excitement of what might "harm" the singer. She acknowledges that of the two remaining options, one is unlikely and the other indecent ("too grey" being equated with too old; "too grassy green" being too young), and further explains, "I'm either their first breath of Spring / Or else I'm their last little fling!" If she were even considering doing something rash sexually, she sings,

I must confess to one romance I'm sure you will allow;
He tries to serenade me, but his voice is changing now!

The couplet is a telling admission that her swain is still going through puberty. In the end, she reassures her sweetheart,

I'm finding it easy to stay good as gold . . .
The battle is on, but the fortress will hold . . .
I've looked the field over, and lo and behold,
They're either too young or too old.

The sentiment of the song is echoed in countless others from the era, but its frankness in declaring the singer's "battle" with her "fortress" is perhaps unusual.

However, even if a woman struggled with her desire, she should not be a sexual aggressor, according to the prevailing view of the time. The male prerogative of sexual aggression did not transfer to women, whatever the difficult or unusual circumstances people faced at home and abroad. A "Guide to Stateside," a humorous amateur manual produced and mimeographed by "Pacifican" Wacs returning to the United States, spelled this rule out humorously but succinctly: "Whistling at attractive members of the opposite sex is a custom reserved for men."[88] One cartooned WAC officer chastises

another, as the second woman hungrily sizes up a civilian man strolling by on the street. The first woman tells her, "Don't be a cad, Major."[89]

Men's expression of sex drive in World War II has been well documented, as has their lack of opportunities to do so, and it was certainly no surprise that men found other "sexual" expressions more appropriate to a certain code of masculine behavior.[90] A *Life* magazine article from April 1943 quotes a pilot in the "China Air Task Force" who concludes that combat is a frankly sexual affair. The war in which he flies and the raid in which he participates are "a substitute for sex," because of "the throbbing gun underneath you"—a frank assessment of the phallic nature of armaments.[91] In a *Yank: The Army Weekly* piece entitled "Psychology for the Fighting Man," under the subheading "Food and Sex," the "enlisted man's weekly" seems to avoid characterizing men's sexuality as indiscriminate, instead portraying it as a symptom of yearning for home, like "hunger . . . for food." Men "may not realize it," the article says, "but often the truth is they have become homesick. They are longing for those upon whose presence and affection they have long depended. They want their wives or mothers." Noting the forms that "want" usually took—smoking or drinking to excess, or the eating of "quantities of candy or ice cream"—the article continues, "In some men the sexual instinct is expressed as a direct and not-to-be-denied demand. When excited strongly, especially under the influence of alcohol, almost any woman, the easier the better, will serve to reduce the pent-up tension."[92]

It was *men's* sexual appetites that, paradoxically, focused attention on tight military regulation of *women's* sexuality. In the South West Pacific Area (SWPA), for instance, where Wacs had been sent overseas, their existence was problematic. Even beyond the heat, disease, and insects to which all residents were subject, enlisted women led an "unexpectedly restricted life." WAC advisers, having been informed of the safe and civilized nature of the Port Moresby area in the SWPA, had believed that the ordinary camp security system would afford women sufficient protection, since there was little danger at this date from "either the enemy or the natives." Instead, the headquarters directed that, in view of the large number of male troops in the area, some of whom allegedly had not seen "a nurse or other white woman" in eighteen months, Wacs must be locked within their barbed-wire compound at all times except when escorted by armed guards to work or to approved group recreation. Not surprisingly, the women's reaction to the limitation was unfavorable; inspectors reported that they believed that higher commanders thought them "children or criminals," and therefore

were confining them in "a concentration camp." Given the circumstances of their living arrangement, this opinion hardly seems misplaced. Those restrictions that also applied to men were accepted by the women without comment; women who perceived themselves as being treated equally to men had little dispute with the army way of life.[93] Women, however, still represented a threat to men, as they were thought to tempt men, who then had to war with their own desires.

Ironically, the ultimate threat to Wacs was apparently from their own white, male comrades-in-arms, despite the presence of "the natives," who were equated with "the enemy" (and for the moment putting aside the racism inherent in this statement and the implication that both were sexual predators). (White) women's sexuality was further protected by the fact that no leaves, passes, or one-couple dates were allowed at any time.[94] Even the "safe and civilized" men of the Allied forces presented a danger to the women, or, from another perspective, the women presented a danger both to the men and to themselves—thus the women's own notion that they were perceived as criminals. If white women were in the area, went the unspoken logic, the mere presence of their white bodies would drive men—even safe, civilized, nonnative, nonenemy men—to rape.[95] Ultimately, the women themselves were the cause; thus the men must be protected from the women, and the women must be protected from themselves (or their effects on the white men). In a turn of logic reminiscent of that used to intern Japanese Americans, they were "locked within their barbed-wire compound" in order to "protect" all concerned.

The actions undertaken to protect women were not entirely without cause. Men in the service, particularly when stationed overseas, still valued women for sex, obviously. The article on the "Psychology of the Fighting Man" reiterated the natural virtue of the American soldier for its readers, enlisted males,[96] but hastened to correct the notion that America's warriors would copulate with any woman with a pulse. Some readers might have begged to differ, and perhaps that is why the article took such pains to make its point: "The typical man in the Army," the piece hedged, "cannot find true satisfaction with prostitutes or in other promiscuous relationships. Most men choose a sexual partner not solely for the relief of purely sexual tensions but for the satisfaction of much more complex needs."[97] These tended to a range of characteristics, lumped together under the category "the innumerable delights of feminine companionship," and for these, many soldiers had already obtained "a sweetheart, fiancee, or wife" [sic] before entering the service. Even a military publication like *Yank*, it seemed,

sought to reassure American men that their "pure" desires were matched by their "pure" women.

In much the same way that they vilified military women, military sources often portrayed civilian women's sexuality as a danger. Boys could enter the service when they reached enlistment age, but girls had few outlets for their patriotism. "Victory girls" who would not have sex with a civilian would thus willingly have sex with men in uniform. Roughly 85 percent of the girls near army camps who had frequent sex with soldiers were not prostitutes but "amateurs"—that is, they didn't charge.[98] A "Cuties in Arms" cartoon has a young, voluptuous woman sitting on the lap of a soldier. He looks a little stunned, and his lips are still pursed. She has answered the telephone and is saying, "Well, no, I'm not exactly busy, Jane, but I AM engaged in a little war work at the present time!"[99]

With this kind of female sexuality on the rise, venereal disease rates rose, too: Between 1941 and 1944, New York City's V.D. rate among girls aged fifteen to eighteen years old increased 204 percent.[100] Clearly, male soldiers were often entirely willing to overlook a girl's or woman's virtue (or lack of it) in the heat of the moment, the "Psychology of the Fighting Man" article to the contrary. They were therefore given multiple official messages about women and the dangers they carried, part of a government campaign cracking down on prostitution.[101] One official government propaganda poster was created to help stem the tide of venereal disease that existed before widespread use of antibiotics in late 1943.[102] It shows one sailor restraining another from running up to a busty blonde prostitute leaning against a lamppost. "A sailor doesn't have to *prove* he's a man!" the first sailor exclaims to the eager seaman he's trying to control. "Remember:" continues the legend below the clownish picture, "THERE'S NO MEDICINE FOR *REGRET*."[103] "VD Bulletins," published by the Federal Security Agency of the U.S. Public Health Service, encouraged the sexually active to get tested for sexually transmitted diseases and not to "take . . . chance[s] with venereal disease." Although they were sometimes unwittingly humorous (one bulletin admonishes readers, "Don't be cocksure about your ability to judge whether your companions are free from venereal disease"), and they were often dramatically titled (VD Folder No. 5 was called "Gonorrhea the Crippler"[104]), the pamphlets provided information where little or none had been before. The graphic illustrations in these pamphlets were used to disseminate information about venereal diseases, the use of condoms, and legitimate and "quack" treatments for syphilis and gonorrhea.[105]

Images show that men's sexuality had to be checked by concerns about disease and women's sexuality; femininity as exhibited through sexuality became suspect, and "syphilophobia" was instilled into servicemen through pamphlets, sex hygiene films, and other media.[106] The cartoons on this topic exemplify the fear of venereal disease as symbolized by female sexuality. One "Sad Sack" comic strip shows the soldier Sad Sack sitting with his buddies watching a projected V.D. film, then going through several stages of surprise, dismay, disgust, and eventually nausea. After the film, when he is hailed by a friend to be introduced to the man's buxom date, Sad Sack ostentatiously dons a rubber glove before shaking hands with her.[107] Sad Sack is sufficiently traumatized (or indoctrinated), it seems, that even his sexual dreams, in another strip that observes him sleeping, warrant a trip to the "Pro[phylaxis] Station."[108] In these images, women are a threat because they embody the diseases men fear.

One comic strip, from an OWI poster probably distributed to military camps for servicemen, addresses the risks of sex even more directly. Entitled "Sneaky and the Professor," it details the story of two con men whose get-rich-quick scheme to sell a V.D. remedy to soldiers is thwarted by a savvy sergeant (who, incidentally, also defines the origin of the term "clap-trap") (see Figure 3–2). One enlisted man who is offered the "phoney" treatment gives the popular opinion against which these cartoons and posters were fighting: "You ain't a man 'til you get a dose" (sexually transmitted infection). The sergeant gives the men "the straight stuff" on the topic, however, and tells them that if they get gonorrhea, "in about a week you're a sorry mess. Itching, burning when you urinate, with pus dripping from the end of your penis. . . . Your balls may swell up and hurt like the devil. . . . If you do go out . . . use a rubber and take a pro."[109]

Clearly, the sergeant, a large man with a buzz cut and a lantern jaw, is not just a model of the voice of authority but an ideal of pure masculinity. His lecture to the soldiers is scholarly and knowledgeable, his image backed up by diagrams of both the gonococcus bacterium and the male reproductive system, showing that he is not just handsome and manly, but smart, too. He is positioned as the opposite of the more feminized Sneaky and Professor characters: The Professor is soft and overweight and wears glasses; Sneaky smokes cigarettes in a holder and begs the irate sergeant (who finds him trying to sell his fake cure) not to hit him. The poster's G.I. audience is thus given yet another lesson in masculinity through knowledge about the risks of sex and the ability to, as the sergeant counsels the men, "take care of

Figure 3–2: "You ain't a man 'til you get a dose" v. "Lay off these dames you pick up": the sergeant's model of masculinity. Source: *National Archives and Records Administration, Records of the Domestic Operations Branch, Record Group 208, Box 4, E-6-A, "OWI Posters—Released (Photos)."*

yourself." His strong message is that manliness is to be gained by abstaining from sex and "lay[ing] off *these dames you pick up,*" who are implicated as the singular source of these diseases. Indeed, it is the women — not the bacterium, the men who patronize the women, or some combination of women, men, and infection — who are blamed.[110] The images thus reveal a thinly veiled misogyny. Although the men are encouraged to shoulder some responsibility for their actions, "these dames" are portrayed as the real threat: They carry, symbolize, and embody disease.

The attitudes about women and disease that the military attempted to instill into servicemen did not come just from images; it came from text as well. Soldiers were given pamphlets early after their entry. "You're in the Army now," one begins. "Naturally you want to get off to a good start. . . . One of the surest ways to start wrong is to show up sick the first few days," the pamphlet reads, rather vaguely. "If you couldn't help it, no one will hold it against you," it continues, "but if you went looking for the disease, you won't get much sympathy."[111] Here the text gets more explicit: "When the doctors went over you they looked for venereal disease. If you come back with either gonorrhea or syphilis they'll know you caught it since your indoctrination." The text then shifts to a more menacing (and misogynist) tone: "Just remember that you can't tell what girl is diseased. If she lets you use her, the chances are she's letting someone else also, and if there have been enough 'someone elses' she's sure to have been infected." The pamphlet specifically states that sexually active women must be viewed as likely to be contaminated. No matter if the new soldier and the woman in question had been dating previously, or are dating exclusively (which is not even considered a possibility); the mere fact that a woman would have sex with a man (be "used" by him) means that she is probably "diseased." Although the warnings about sexually transmitted infections in a pre-penicillin era may not have been entirely misplaced, in the pamphlet's unspoken equation, sex equaled disease, and implicitly diseased women were career destroyers.

Walking the Line Again: Sexy, but Not Too Sexy

Cartoonist Milton Caniff's heroine in *Male Call,* "Miss Lace," who had been portrayed as having an encounter with the lesbian Wac, was an important symbol of women's sexuality in popular graphic art. Miss Lace manages to dodge much of the misogyny inherent in the women-as-disease concept, becoming representative of a different, more expansive and accepting view of female sexuality. Created initially as Caniff's contribution to the

war effort (he was 4F—that is, ineligible for service—and "felt guilty as hell about it"[112]), the character that grew into Miss Lace sprang from an assignment "to do cautionary posters about venereal disease" not unlike the "Sneaky" comic. Caniff's effort, unfortunately, was not successful. "They turned down my poster because the bad girls were too good looking," he reported. One assumes this meant he was not sending an appropriately negative message.[113]

It seemed permissible, however, for Miss Lace to have a certain come-hither attraction. Bill Mauldin, whose cartoons garnered him two Pulitzers (and hence credibility in this area), recognized Miss Lace, some forty-five years after her birth, as "probably the most delectable pen-and-ink creation of all time, the camp follower of every fighting man's dreams"—an intriguing comment on the desirability of prostitutes or "camp followers." Because "Caniff produced in Miss Lace a confection of femininity," she "put [pin-ups such as Rita Hayworth and Betty Grable] ... all into the shade."[114] It is ironic that a cartoon representation of a woman could have more sexual appeal than photographic pinups of actual, live women. Caniff had derived Miss Lace from the characters "The Dragon Lady" (an orientalized figure) and "Burma" (a blonde) from his popular thirties' strip "Terry and the Pirates." "The Dragon Lady was great, but unapproachable," Caniff remembered. "With Burma, it was always 'maybe.'"[115] Burma was a "good time [girl]," and was apparently received by the men who read the Camp Newspaper Service offerings as "Everybody's girl friend; everybody's wet dream."[116] If Caniff's intent was *not* to create such sexy characters (although it fairly clearly was), his readers nevertheless received his strips that way.[117]

When Caniff ran into problems with his syndicate for using characters from "Terry and the Pirates," the solution was to change the name of the strip and change the main female character. He created Miss Lace to be, in many ways, the opposite of Burma. "Lace," he noted, "was never anybody's girl friend, really.... She might be playing poker with you, but she won't necessarily be going to bed with you." Still, the word "necessarily" held what was probably the key to her continued appeal week after week as she appeared in camp newspapers: "If you played your cards right, just *maybe, maybe, maybe....* The 'maybe' is always better than the accomplishment; there's that anticipation of what's ahead," Caniff wrote. "[T]he unattainable nature of Lace was more useful over the long haul," he added, meaning, presumably, more useful than portraying a character the readers knew had definitely had sex with another character (emphasis in original).[118]

Miss Lace usually acted, in fact, not only as an enlisted men's sex object

but as their advocate and defender, and that counterbalanced her racy image. Despite her apparent sexual agency, she behaves in a very traditionally "feminine" fashion. With all of her ambivalent implications, she is the ultimate "victory girl." In one strip, a soldier is "the only guy in the outfit who got no letter" at mail call. To make him feel better, Miss Lace kisses him seductively and promises that if he drops by her place later, there "won't be any other male around to keep [him] from registering!"[119] In another, she drops in on two depressed soldiers up on the fighting line who are smoking and darning their dirty uniforms by candlelight.[120] In a third, she moves aside two officers on a bus to offer a seat to a corporal who's been "standin' up in a train for days!"[121] In a fourth strip, she is seen protecting a blind veteran (in a sport coat and "ruptured duck" discharge pin) from a soldier who thinks the blind man is a draft-dodger from "essential industry" (men who were given deferments, who were ostracized by servicemen and civilians alike).[122] And in other strips, Lace goes to bat (almost literally) for veterans.[123] Soldiers rightfully wanted to make sure everybody, especially women, appreciated their sacrifices, and Miss Lace is the quintessentially grateful woman.

Miss Lace manages, really, to walk the line: Although she is "sexy," she is never "slutty," and so retains a level of acceptable sexuality. In almost every strip, as much agency as she has over her own sexuality, she is available for "registering" with the men and seems eager to encourage the possibility of this notion. In fact, one strip, entitled "Physi-oh-thera-beaut-ics," shows Lace acting as a sort of sex therapist with a depressed soldier missing an arm. Her approach is through the metaphor of firing a gun, and she helps him "fire a round for effect" by kissing her. Another soldier, noting the first man's mood turnaround, is told, "I just qualified with the MM-M-M One!"[124] Lace's sexual behavior is acceptable because she is respectable—her sexuality as action, as actual intercourse, is never certain, and it is always for the support and to the advantage of servicemen. Unlike "Dirty Gertie," from the verse at the beginning of this chapter, Miss Lace is not expecting men to make a move, then trapping them by dint of their own desires. Indeed, Miss Lace, in her own way, manages to make the possibility seem as good as the real thing, so that even her sexual behavior is "moral."

In World War II, changes to women's work and gender roles pushed their sexuality to the forefront of public consciousness. Women were encouraged to display "feminine" sexuality that made them seem accessible, but not

promiscuous, while their sexuality was portrayed both as "immoral" and as the personification of disease. Popular art intended to control the spread of venereal disease among men often was thus a thinly concealed depiction of misogyny. During the war, a woman doing "a man's" job might feel she had every right to express her sexuality by taking the initiative with men; if she did so at that time, however, she broke conventions of femininity by violating gender norms. If a woman felt that doing "a man's job" entitled her to take a masculine role sexually with women, or if she simply desired to do so, she broke those same conventions and risked being called by the derogatory label "lesbian." Military uniforms often conveyed masculinity and were thus, through the exaggerations of the slander campaign, emblematic of "immoral" or lesbian women; the military used uniform and other regulations to restrict women's expressions of sexuality, and thus stood *in loco parentis* for servicewomen. Cartoons and comics dealt with that sexuality humorously, falling back upon old stereotypes of women, as they attempted to portray soldiers, lesbians, patriots, camp followers, flirts, war-workers, victory girls, prostitutes, or disease incarnate. Perhaps not far indeed from "Dirty Gertie," those images painted a complex picture of the sexuality of women during the war.

4

"Now, Let's See Your Pass," or, Wonder Woman and the "Giant Women Army Officers"

Female Power and Authority as Masculinity

"Yes, Steve—'Kaysham ww yago pelha'—... Good Hera, I know that
language—it's Atlantean! The words mean—'Tell Wonder Woman I need help!'"
—Wonder Woman, on hearing the contents of a coded message
tapped into a transatlantic cable, 1944[1]

Wearing a star-spangled skirt and red strapless top with an eagle superimposed on the bust, Wonder Woman burst onto the comic-book scene in December 1941, almost simultaneously with U.S. entrance into the war. With her red, white, and blue outfit, she not only was iconically American but also symbolized real women's entrance into formerly all-male spheres. As a comic book character, she herself was entering a formerly male arena, and like Rosie the Riveter, the other famous female face of the war in graphic art, Wonder Woman was a previously unexplored combination of feminine and masculine, queer and conventional characteristics.[2] What's more, she zoomed to popularity as a symbol of the qualities American women were expected to display in wartime, reflecting and affecting changing impressions, behavioral norms, expectations—and other images of women from OWI and civilian publications. Moreover, because she existed in an almost entirely all-female setting, the comic strip provided a site of negotiation for anxieties about all-women organizations such as the women's military

branches. In concert with other images of wartime women, the iconic cartoon superheroine is crucial to examinations of women and their gender-role changes as depicted in popular graphic art during World War II.

Although this chapter reprises my analysis of female masculinity in images of civilian work and the military, its most important focus is the Wonder Woman comic book. During World War II, both government agencies and independent cartoonists frequently portrayed women who were physically strong and who exhibited authority and autonomy — characteristics that artists needed to render unthreatening and acceptable. Wonder Woman illustrates popular fears of masculinity in both the civilian and military arenas; she and other female characters like her were masculine, but threatening only to the bad guys. She and her sisters became tremendously popular, even as other cartoons or characters emphasized the threat of women overstepping the proper boundaries of their sex.

Strong Equals "Mannish"?

As men left the home front and went to war, and civilian women took on positions of authority that would have been unthinkable for them before the war began, anxiety about powerful women increased. New and necessary roles for women failed to supersede the established image of women as homemakers. Women were still thought to be unsuited by nature for positions in which they would be called upon to exercise power or physical strength outside the domestic province. As, out of necessity, the U.S. government encouraged women to take on these new roles, both as civilian workers and in the nation's armed forces, it employed images that seemingly encouraged women to become masculine. Popular anxiety coalesced around these images, which both fostered anxiety and worked to ameliorate it.

As I have shown, popular graphic art was important for regulating both women's assumption of physical strength or authority and anxieties about that assumption of power. Comics like those featuring Wonder Woman were another venue in which these contradictory forces were worked out. Other scholars, such as Maureen Honey, have demonstrated the social importance of fictional productions like comics, pointing to how they have made use of "fiction as a vehicle for propaganda." Comics are well-suited to conveying propaganda; they are, as Honey says, a "powerful technique because the reader is not examining the story in a conscious, rational way and may therefore be more receptive to the message."[3] As used in World War II, characters in cartoons and comic books like those in the Wonder Woman

series carried dual messages to women: Be strong, be powerful; but in the end, society will enact strictures on your behavior to make sure you don't violate gender norms too gravely. A woman who flouted gender norms too outrageously was a risk to the social order. As Leisa Meyer observed, "The text of . . . cartoons revealed the emasculation of men at the hands of empowered women, made smaller not only in physical stature but also by . . . women's assumption of the duties crucial to constructions of American manhood."[4] The Wonder Woman storyline I analyze in the last section of this chapter exemplifies this conclusion very plainly.

Part of the difficulty of women's new autonomy in World War II lay in the fact that many women were attracted to the increased power available to them in wartime; many men and women may have seen the acquisition of power, positively or negatively, as a move toward gender equality. Some women no doubt viewed access to power as an extension or a form of high social standing, and women had traditionally been interested in status issues. As one stout OWI-cartoon dowager said, addressing a man at the U.S. Employment Service office, "No previous experience but, obviously, I'm best suited for a foreman's job!!"[5] The implication was that women wanted power without fully understanding what was required of those who exerted it outside the home. A woman who equated power with high social standing would naturally want "a foreman's" position.

The OWI answer to concerns raised in cartoons that women were "unsuited" to power was to use those same cartoons to quell them. The cartoons would presumably convince both women and men that women's contributions should or would be validated and equal to men's, and so their power would be acceptable. Another OWI cartoon panel was entitled "All Hands!" It shows four arms, holding various tools, hitting a Hitler-headed octopus that is labeled "The Axis Menace." Three of the arms are men's. Labeled "Specialists," "Farm Labor," and "Skilled Labor," they wield pitchforks and sledgehammers. Next to them is another muscular arm holding a large wrench. Labeled "Woman Power," the burly arm is marked as female only by the puffed sleeve at its shoulder. The woman is working in parity with the men, and her arm shows equal strength with the men's.[6] The shock of the new reality of a woman's arm being there at all among the men's is mitigated, however, by other elements of the illustration. There is the essentially "feminine" clothing, for example, and the fact that the woman has a separate label referring to her femaleness. While all the arms are distinct limbs on the body of power, and thus theoretically could be removed postwar, the notion that a growing nation would be able to do

without specialists, farm laborers, and skilled laborers is unlikely. "Woman Power" is considered distinct and separate, not part of the others. Its separation provides for its amputation; women's power, and their moves toward equality, were tolerable—and equal—only "for the duration" of the war.

Women's power in the workforce is taken up in another OWI cartoon depicting neat rows of bombs. Three energized women stand behind a stout woman gripping (again) a large wrench. Two of the women are using hand mirrors to touch up their hair and makeup, and a third dangles a hammer by her side. The lead woman is saying to a male munitions factory owner, "We just settled a little argument about women's ability to turn out ammunition," as, in the background, four men with black eyes and bloody noses crawl away from them; a fifth man is laid out completely on the floor (see Figure 4–1).[7] There was a recurring theme in wartime art, despite moves toward female validation in images, of the intimidating woman with a dangerous tool in her hand. Not only does the implement make her menacing, but its symbolism as a phallus can't be ignored. The "women's ability to turn out ammunition" revolves around this phallic symbol: Their power originates, in part, from their ability to use tools, and it derives from and is symbolized by those tools. The message: Women not only could do the job, but also presented a threat to anyone who thought they couldn't. In taking up "male" tools, women took up masculine power—and they could use it against men, too.

There were, of course, differences between official representations of women (from OWI) and popular comics and cartoons. Whereas OWI often sought to address issues revealed by polls of employers, of women not yet working, and the like, to broach these issues for the public and defuse them, creators of popular comics and cartoons could take a less formalized approach, simply taking on topics they found amusing or compelling. A salient feature of wartime cartoons is that artists who drew for a nominal sum for OWI also often drew and submitted cartoons to nonofficial publications. Thus, a cartoonist who drew for OWI might be able to take a cartoon rejected by that office and have it published by *Collier's*, *The New Yorker*, or another publication whose editors found it appropriate for their readership.

Some non-OWI cartoons raised the concern that women might also misuse the endowment of masculine power for stereotypically feminine aims. In one image, a WAC officer, legs outstretched and crossed, relaxes at her desk in her office. She says officiously into the phone, "Lieutenant Murphy speaking. Now just when may I expect those pink princess slips?"[8] Another panel shows two Wacs standing in front of a tent encampment. As a mass of

Figure 4–1: "*We just settled a little argument about women's ability to turn out ammunition.*"
Masculinized women with dangerous tools. Source: *"Alain" (for OWI), National Archives and*
Records Administration, Record Group 208, Slide series 179-WP, V-229-II/3.

bubbles pours out of the tent behind her, the enlisted Wac salutes the WAC officer, saying, "Your bath is ready, Lieutenant."[9] Women, even women interested in joining the service, might be prone to "flighty" behavior even as they assumed the mantle of military command. The implication was that a woman would mishandle the authority given to her because she would be self-centered and possibly uncaring about the people or materials diverted from Uncle Sam for her own purposes; she would care only about what was needed to fulfill her wishes.

Other non-OWI panels voiced concern about how female authoritative behavior and knowledge might affect romantic relationships. In one cartoon, two airmen are talking at a dance. As one lights a cigarette, his buddy gripes, "Say! Why didn't you warn me that some of these cuties work in airplane factories and know as much about bombers as I do?"[10] By changing the power dynamic of courtship, the "cuties" have leveled the playing field; the men can no longer impress women with their superior or alien knowledge. This change in the power dynamic of courtship might go even further: Women might not only not be inferior, as was previously supposed, but might try to be *superior*. In a "Winnie the Wac" panel showing Winnie about to go on a date with a civilian man, the man's mother is saying, "Now, don't forget—don't keep Hubert out too late!"[11] In another cartoon, Winnie enters the barracks carrying a struggling man slung over her shoulder. She is saying, "Girls! Guess who I have here?—FRANK SINATRA!"[12] In a third cartoon by another artist, a large, short-haired WAC captain sits at her desk with a small, male, PFC stenographer perched on her lap, in a reversal of the traditional executive/secretary scenario.[13] In each of the cartoons, the women have assumed authority over the men; the women's usurpation of "masculine" power, sexually or in courtship, has reversed (even to the point of sexual harassment, in the last panel) the gender hierarchy. The cartoons are "funny" because of the reversal; indeed, it is difficult to tell whether such humor defused or raised anxiety about women's new roles.

Not surprisingly, given the hegemonic gender hierarchy, the acceptability of expressions of women's power and/or authority depended largely on their acting under the aegis of a male. In many cases, men's control provided a specific contrast between "good" and "bad" qualities of strength, power, or authority in women. Male guidance, support, or regulation was seemingly necessary, not only because women were doing "manly" things they had never done before, and might need men's help, but also because women's assumption of masculine clout—literal or figurative—might otherwise be emasculating. If men were controlling the show, women's power

was far less intimidating than if the women themselves were controlling it. In other words, women might be doing men's work, but the men were still in charge; thus, everyone could relax—the women were not truly taking over. Or so the logic went. Even something as unthreatening as a romantic walk needed a touch of control: One *Collier's* panel showed a male captain and a female junior officer walking down a moonlit path, their arms around each other's waists. The captain turns to the Wac and says, "I hate to bring this up, Lieutenant, but you're out of step."[14] This cartoon suggests that a male soldier could alleviate his military girlfriend's masculinity by regulating her behavior in a subtly controlling way, thus reducing the threat presented by her power.

On the other hand, if a woman would *not* acknowledge men's control, her autonomy was portrayed as "unacceptable" masculinity. One *New Yorker* cartoon shows a general and his wife, both of whom have turned to glare at a young Wac who has walked past without acknowledging her superior officer. As the general impotently clutches a small swagger stick, his wife carps, "You ought to go right back and *make* her salute you!"[15] Although the general's (Freudian) grip on his swagger stick seems to try to counter the Wac's perceived threat, men were not the only ones judging the acceptability of women's new "mannish" behavior. There is the general's wife's outrage, which, though ostensibly on his behalf, indicates that in diminishing the general, the young woman has also demeaned the general's wife. Women were not immune to what modern scholars might call internalizing the values of the oppressor. Older women, especially, having been raised in a tradition where men "wore the pants" and women obeyed their authority, often expressed disapproval at the "mannish" qualities that caused young women to assume their equality to men. The Wac in the cartoon is symbolic of fears about military women; striding along, head up, she embodies independence, determination, and a frightening reorganization of the social order.

Military Women: A New Authority

The military, which encouraged physical strength and authority in women, was often more problematic than the civilian workforce in terms of female masculinity. Ostensibly, the military should have been ideal for "mannish," strong women. What was perceived of as masculinity in a female enlistee would not have rendered her undesirable for service (nor, incidentally, in the world of comics, should such qualities disqualify her from being a superhero). Because the military needed women who wanted to

do work that was traditionally considered masculine, such a woman might even have been more desirable for that service.[16] Authority was a feature of that masculinity; officers and noncommissioned officers found themselves responsible for the welfare of military units of ten, twenty, a thousand, or 100,000 women.[17]

These command situations presented unique opportunities. Newly powerful women could be read as masculine as they learned to give military orders and developed "command presence." Cartoons showed this process taking place, with formerly male labels being applied to females in power. In a *Stars and Stripes* cartoon, a WAC major and captain glare at a male private. One of them says, "Even if we *are* officers[,] stop addressing us as 'Sir'!" (The private replies, "Yes Sir!")[18] Another cartoon by the same artist has a slightly different object but the same message. "Private Breger" stands in front of a nurse's desk at an army base hospital. The corporal next to him says sharply, as the nurse-lieutenant scowls at the private, "Even though nurses are officers[,] you DON'T address them as 'sir'!"[19]

One of the special worries about women who commanded others was that they might carry that sense of authority beyond the military into their heterosexual marriages or relationships. The idea that female power within the military might translate unfavorably to women's interactions with men in their homes was clearly depicted in popular media. Images portended the subversion of men's position as head of the household and women's role as "supporter" and "helpmeet" to men.[20] As Winnie the Wac puts it, as she helps another Wac wash a mountain of dishes under the watchful eye of a noncommissioned officer, "When I get married[,] I'm going to be the sergeant!"[21] Women might have accepted men ignoring their opinions before attaining military rank and status, but now, with new authority in the workplace or in the military, they might believe they had new authority in relationships. One *Saturday Evening Post* cartoon husband, carrying packages for his wife, a stout, tough-looking WAC sergeant, complains, "Don't 'On the double' me!"[22] In another nongovernment cartoon, an irritated husband is trying to adjust the radio to his wife's satisfaction. As she, a scowling WAC captain, stands over him with her hands on her hips, he grouses, "Can't you remember where you are and stop ordering me around!"[23] A powerful woman often carried implications of masculinity simply by virtue of her rank, uniform, or military service, alone or in combination; any "commanding" behavior she displayed only exacerbated the situation.

The ways women could exhibit power over men were many, including financial. In a small article entitled, "It Depends, It Depends," the issue of

dependency allotments (part of a serviceman's paycheck, sent, usually, to his wife) arose. A Wac's monetary support of her husband was looked on as an amusing counterpart to the traditional setup: "If it were . . . true that the first three grades of WACs get dependency allotments for husbands they have left sitting on a hot stove 3,000 miles away," the writer chortled, "a lot of fun might result." While, as the article muses, "37.50 a month [the amount of the allotment] is not really a sum to get excited about," the notion that being the money-earner equaled power in a relationship was not lost on the writer. This was especially true in a situation where a man had been so feminized that his *wife* was in the army while he was at *home*, "sitting on a hot stove," a powerful symbol of domesticity. The gender hierarchy might have gotten really switched, in fact: "Suppose, for instance," the writer ruminated, "that a WAC decides the old boy back home is doing a bit of two-timing on his day off from the factory. Will she withhold his allotment? And if she does, what will happen to the money? Will she spend it herself? Will she waste it on silly carousing?"[24]

The author might just as well have said, Will she behave like a man? The business of a woman's having sovereignty and authority opened up a minefield of problems. The issue boiled down to whether the Wac's earning capacity—the pay and thus the power in a marriage—gave her power and authority over her husband. One nongovernment cartoon panel has (yet another) balding, bespectacled husband, holding a broom and dustpan and wearing an apron, talking on their doorstep to his wife, a thick, tall Wac holding a suitcase, returning home from military duty. He says to her, "I missed you, dear—but where was my money allotment this month?"[25] What was probably less amusing to Wacs of the time was that their families were denied dependency allowance,[26] a (moot) point to the author of the article, who apparently never investigated the truth of the humorous possibility. The perceptions about an emasculated or feminized man being supported by his wife lived in rumors and images, but not in reality.

Even when the relationship was not a spousal one, a powerful woman still carried a threat. The "Private Breger" cartoon strip, which was published in *Stars and Stripes* and *Yank*, ran a series on "The Articles of War," featuring humorous depictions of how each article might be interpreted. Article 120 is captioned, "When different corps . . . do duty together, the officer highest in rank . . . shall command the whole . . ." (ellipses in original).[27] The drawing shows mixed ranks of men and women together, with a frowning male officer and a smiling WAC officer both saluting a large, glowering WAC officer who has just taken command. The former commanding officer, who is

male, grumbles to Private Breger, "And it *had* to be my mother-in-law over me."[28] The mythically bad relationship between a man and his mother-in-law reaches epic status in this panel, because her animosity toward him is now backed up by her military rank. The mother-in-law's use of authority is even more intimidating as her attitude might affect the relationship between the man and his wife. Here, too, reality was different from cartoon humor; female officers could not in fact issue orders to male personnel.[29]

Whatever the regulation, female officers were occasionally called upon to assume temporary authority over men. Major Charity Adams Earley, commander of the 6888th Postal Directory Battalion, the only "Negro" WAC battalion to serve overseas during the war, wrote of a time when a convoy of vehicles under her command ran into another convoy of white male soldiers, including one seriously injured, in an enormous fog bank in the European Theater of Operations (ETO). The young white male officer commanding the other convoy, relieved to shift responsibility to a higher-ranking officer, even a black woman, deferred command to Adams. In images, however, a woman's command over a man was depicted as particularly emasculating behavior.[30]

Physical strength was perhaps the most obvious feature of "masculine" women, whose threat of violence was usually indicated by a scowl accompanied by clenched fists and/or the woman's hands on her hips. A *Saturday Evening Post* cartoon of a scowling Wac standing outside a guardhouse articulates unease about this body language. Her right hand is balled into a fist, and her left hand is reaching out for something from the civilian man in front of her. His hat is askew, his tie pulled out, his clothes rumpled, and he has a black eye and a bruise on his jaw. The Wac is growling at the man, "Now let's see your pass—this time without the gestures" (see Figure 4–2).[31] Both a woman's physical strength and her authority, the cartoon implies, will inevitably be used over a man. The guard, with her fist clenched, seems even more masculine because she is juxtaposed against a man, in civilian clothes, who has been beaten up by a woman. The cartoon Wac's use of physical force to back up her authority has emasculated him.

Apparently, there was precedent in reality for the cartoon emasculation. A piece from the Camp Newspaper Service, entitled "STRONG-ARMED WAVE KO'S CIVILIAN SOUSE" ("KO" being an abbreviation for delivering a knockout punch; a "souse" being a drunk), tells the story:

> Strongarmed Apprentice Seaman Audrey Pearl Roberts, WAVE, k.o.'d
> a civilian (male) souse while she was pulling guard as an S.P. [shore

"Now let's see your pass—this time without the gestures."

Figure 4–2: No rifle—but no matter: women's physical strength as masculinity. Source: *"SALO"* *[Salo Roth], in* Laugh It Off: Cartoons from the *Saturday Evening Post, edited by Marione R. Derrickson (New York: McGraw-Hill, 1944). (© SALO 1944. Used by permission.)*

patrol] at a Naval-gals training center here. She had orders not to permit anyone to pass the gate at which she was stationed without proper authority. Two drunks tried to negotiate the passage. She "knocked one of them flat" in her own words and then bluejackets [(male) sailors] took over. She was the first member of the WAVES to receive a citation for "successfully defending her post and efficiently carrying out her orders with disregard for her own personal safety."[32]

It is notable that Apprentice Seaman Roberts had to use her fists, rather than a firearm, with which women were not provided. All the services made a clear effort not to masculinize women too much by giving them rifles with which to guard their posts, but that lack also either restricted them from fully performing guard duties or forced them to fulfill those duties using very "unfeminine" means—fisticuffs, in this case. Somewhat surprisingly, the navy not only acknowledged but also rewarded this admittedly

"masculine" behavior. The delight the writers take in relaying the story, however, is unmistakable; partly that delight is permissible because the "souse" in question is civilian (and thus suspect anyhow). No doubt an element of the amusement is pride, or the fact that a "Naval gal," especially anyone with the delicate moniker "Audrey Pearl," knocked anyone "flat." The enjoyment, nevertheless, is also a laugh at the civilian man's expense: Despite the fact that Apprentice Seaman Roberts had no (phallically symbolic) rifle, he, too, was emasculated by a woman—a deeply wounding event.

Military women's muscle was sometimes permissible in other situations as well. Another cartoon very reminiscent of the Apprentice Seaman Roberts account (which appeared in camp newspapers on June 12, 1943) is a *Male Call* cartoon strip entitled "Auxiliary Power," which appeared on June 27, 1943.[33] Perhaps cartoonists were drawing upon reality for cartoon ideas. The first panel shows two male soldiers noticing a Waac on the street and commenting, "I dunno about this business of wimmin sojers . . . ," just as they also notice two civilian "zoot suiters" making rude remarks about soldiers in general. The second panel has the soldiers perking up as one says to the other, "Listen! . . . Yellin'! Sounds like a fight!" and his friend replies, "Those zoots went down the street where we saw the Waac! . . . Let's hike!" The two men take off around the corner to protect the Waac, just in time to see one zoot suiter flat on the sidewalk and the Waac bludgeoning the second zoot with her handbag. In the last panel, one male soldier grins to the other, "As the colonel would say—'The action was terminated without loss to our forces!'" while the Waac, hands on her hips, legs apart, watches the two "zoots" run away down the street.

The strip holds messages about race that integrate with its messages about gender: The "Zoot Suit Riots" had reached the zenith of their violence in early June 1943, a few weeks before this cartoon was published. In the strip, "zoots" are emasculated by the woman who knocks them down and chases them away, but the emasculation is portrayed as acceptable because they are (1) civilians—civilians harassing a servicewoman, no less, and (2) not white (the "zoot suiters" in the riots were Mexican American).[34] Like the assault on the Axis leaders from the "Hand That Rocks the Cradle" image (see Chapter Two), the woman's emasculating behavior is condoned or even encouraged because its targets are not white. Like the souses in the Apprentice Seaman Roberts incident, the zoot suiters had tried to overpower a woman they erroneously thought was powerless. Clearly, the

two male soldiers, like Apprentice Seaman Roberts' "bluejackets," had also thought to step in and protect the woman.

The hitch lay in the fact that the woman in question didn't necessarily need protecting. The strip catches, again, the pride at a uniformed woman's self-sufficiency, but it is mixed with a note of the threat inherent in a strong woman, whose masculinity is signaled not only by her own forceful defensive actions, but also by her "mannish" stance, hands on hips, as the (feminized) men run away.

Wonder Woman: Heroine versus Cautionary Tale

Cartoons were not the only type of art showing tough women beating up men. A particularly complex example of the acceptability of women's public authority, autonomy, and strength as expressed in wartime images is found in the Wonder Woman comic-book series. Wonder Woman comic books were civilian publications, and the appearance of the first issue of the series was nearly simultaneous with U.S. entry into the war. The series thus has unique cultural value in showing the place of women in society, their growth during the era, and the expansion of their envelope of permissible behaviors. Ultimately, in her mix of queer and conventional, masculine and feminine qualities, Wonder Woman brought together opposing traits in an admirable package that both adults and children could accept and celebrate. She displayed masculinity but was threatening only to the villains in her stories—a number of which were masculine women themselves.

Wonder Woman was the first female comic-book star who had her "own" comic book, and she became a title character less than six months after her initial appearance (Superman and Batman both took a year to achieve that status). No woman had ever appeared in her own comic book before, and previously, even women as supporting characters had been inevitably short-lived, only showing up for a few issues before disappearing entirely. Despite her "masculine" qualities of strength and independence, Wonder Woman attracted a huge following. At its peak (1942–1944), monthly issues of Wonder Woman sold around 2.5 million copies each, and by 1944 she also had her own newspaper comic strip, having been promoted by her syndicate as a way to increase newspaper readership. This popularity was surprising, because women in that genre had usually been girlfriends, companions, or sidekicks, or most commonly, victims in need of rescue by male heroes. They offered decorative femininity as distressed damsels, characters who

provided challenges for the protagonist. Increasingly, though, comic strips depicted these female characters as assertive women with sufficient courage and resourcefulness to rescue *male* superheroes. Wonder Woman became a powerful advocate for all women. Autonomous, authoritative, and physically and mentally strong, she promoted the ideal of male-female equality in relationships and exemplified self-respect, self-reliance, and the power and possibilities of female cooperation.[35]

Wonder Woman also raised questions about what else female-female interaction implied. By World War II, as mentioned earlier, the term "queer" had already taken on some of its current meanings—not only as "odd," but as unconventional, particularly concerning sexuality and gender expression. The fact that men played a far lesser role than women in Wonder Woman stories did little to ease anxieties about all-female organizations like the WAC or WAVES. Critics of the proposed establishment of military service for females in the early 1940s compared women who would be interested in enlisting to what a writer for the *Miami News* called "the naked Amazons . . . and the queer damozels of the isle of Lesbos," to whom Wonder Woman's resemblance cannot be ignored.[36]

William Moulton Marston, Wonder Woman's creator, deliberately drew upon notions of masculinity to craft his female superhero. His idea was to contradict the male-produced masculinity in comics at that time by creating a female action hero. "It seemed to me," he mused, "from a psychological angle [Marston held a doctorate in psychology from Harvard], that the comics['] worst offense was their blood-curdling masculinity":

> It's smart to be strong. It's big to be generous, but it's sissified, according to exclusively male rules, to be tender, loving, affectionate, alluring. "Aw, that's girl stuff!" snorts our young comics reader, "Who wants to be a girl?" And that's the point: not even girls want to be girls so long as our feminine archetype lacks force, strength. . . . Women's strong qualities have become despised because of their weak ones.[37]

Marston's aim was to provide a powerful female character while softening the comic-book milieu both with a woman's presence and by mixing feminine characteristics (conventional physical beauty, lovingkindness) with masculine superhero qualities (strength, speed, etc.). He also advocated the revolutionary opinion that "girls might want to read about and identify with a strong heroine," despite the ridicule he received from publishers. "My suggestion was met by a storm of mingled protests and guffaws," he wrote. "Didn't I know that heroines had been tried in pulps and comics

and, without exception, found failure? Yes, I pointed out, but they weren't superwomen."[38] Described in the introduction to every issue as "Beautiful as Aphrodite, Wise as Athena, Stronger than Hercules and Swifter than Mercury," Wonder Woman represented a reassuring balance: women could be tender *and* strong; loving *and* swift; and alluring *and* forceful.[39] She did not prevail because of masculine or feminine qualities alone, but because of the integration of both sets of behaviors.

In her storylines, Wonder Woman is, of course, *physically* "feminine": beautiful, sexually attractive, and dressed in a way that reveals her unmistakably female form (unlike a masculinized uniform). Although she is portrayed as having muscular shoulders and athletic legs, her revealing strapless, backless costume, which began as having a short, flowing skirt, shrank in time to expose part of her shapely torso and her legs down to her red, high-heeled, knee-high boots.[40] She is drawn with a large number of what biologists term "estrogen markers": a general daintiness of face (estrogen retards growth of brow and jaw bones), large eyes, and a voluptuous form with breasts and broadened hips.[41] She also wears a stylish hairdo, lots of fashionable makeup, and rather large red earrings. By every physical standard of the day, Wonder Woman was highly feminine, and these qualities counteracted the "masculine" traits of sharp intelligence, visible musculature, physical strength, and agility that otherwise marked her.

Further, Wonder Woman's *behavior* was often very traditionally feminine. In her back story, Amazon "Princess Diana" meets Major Steve Trevor when she rescues him after his plane crashes onto Paradise Island.[42] She, in a caregiving role, nurses him back to health, falling in love with him in the process (probably playing to the fantasy of many a young girl in World War II who dreamed of nursing a wounded soldier). She takes him back to the United States and moves there herself to fight injustice in "the man's world," disguising herself as both an army nurse and as "Lieutenant Diana Prince," who serves as Trevor's boss's secretary, incidentally getting to remain near (but not outrank) him in the process. Her life centers on Steve Trevor, making her heterosexual motivations very customary.

Wonder Woman's conventional femininity also derives from strictures on her behavior that reflect male control or aegis. Much as the women's branches of the U.S. military operated under the regulation of the men's military branches, "Diana Prince" often hears of the need for her superheroic presence from Steve Trevor, and so would seem to act under his guidance or direction. Trevor also, at times, rescues *her*, despite the fact that *she* is the superhero. In one of the stronger limits on superhero power, Wonder

Woman's creator specified that she *cannot remove physical restraints that are applied by men.* That Wonder Woman's strength and freedom are, in the end, regulated by men is a way of controlling her might and her autonomy, and, by extension, allaying male fears regarding those qualities in women during the war. Many Americans adjusted to women's new prominence in the public realm (i.e., the military and war plant)—and certainly in the cartoon realm (i.e., Wonder Woman)—because women's new status was defined in terms that denied the erosion of valued social norms.[43] Despite the revolutionary ideas about women that Wonder Woman embodied through her strength and other powers, Wonder Woman, like many of her cartoon counterparts, often reinforced the formula of female subservience both in the comic-book genre and in reality.

Trevor is helpful, ironically, not only for showing that Wonder Woman's behavior is under male aegis, but also for appearing as a viable heterosexual partner for her. Like the highly masculinized sergeant who teaches his soldiers how to avoid gonorrhea (see Chapter Three), he has lots of "testosterone markers": a strong, prominent, wide jaw; little fat, making for sharper features; thick hair; and broad shoulders.[44] His presence within the comic casts Amazons (or this particular Amazon) as virginal, in a sort of male fantasy, rather than lesbian, such that after he crash-lands on Paradise Island, for example, she follows him back to the "man's world,"[45] rather than preferring the all-female island. He is smart (he's in Army Intelligence) as well as handsome, and he vouches for Wonder Woman's heterosexuality by deflecting suspicions that she is not feminine enough to attract a male partner.

However, Wonder Woman also demonstrates *unconventional* characteristics because her masculine traits oppose her feminine ones. It is her masculine attributes that make her stronger and faster than male gods: She is *as* beautiful as Aphrodite, and *as* wise as Athena, but she is *stronger* than the male god Hercules and *swifter* than the male god Mercury.[46] Young wartime readers read about a woman who was not only intelligent, strong, and courageous but also willing to assert that she could never love "a dominant man who is stronger than I am."[47] In the stories, she is cast as a woman who is subversively superior to men, who can shed her plain-Jane appearance to reveal the Princess of the Amazons. As "Diana Prince," she usually finds a way to work with Major Trevor, an intelligence officer who exists, cartoon historian Trina Robbins pointed out, "because of an unwritten law of superhero comics: the hero must have a love interest so there will always be someone to rescue." In other words, wrote Robbins, "he is the Lois Lane to

Wonder Woman's Superman."[48] When Wonder Woman sheds her Clark-Kentian cover identity, her true powers emerge; she is the strong one who rescues others, including Trevor, from evil. This amazing reversal of the power hierarchy reveals her masculinity as a positive rather than a negative quality, and she appears a queer rather than a conventional figure.

Moreover, Wonder Woman is easily read as an unconventional or queer figure for other reasons: She can admittedly be read as lesbian, since she is known as the "Mighty Amazon"[49] and came from Paradise Island, "where men are forbidden to tread."[50] Since her myth of origin is essentially as the child of lesbian parents, Wonder Woman is suspect, as well.[51] On a related note, men other than Steve Trevor are rarely seen in the comic stories in which she appears. There are often entire all-female sequences; the world of the series is, like Paradise Island, a woman's world. Women are always the strongest characters in the stories, and even the majority of the villains are women. Perhaps the choice of villains is an editorial device so that Wonder Woman is not shown overpowering men, but that does not negate the fact that Wonder Woman also demonstrates "mannish" physical behavior. Although critics have noted that, compared to most male-oriented action comics, Wonder Woman comics are fairly nonviolent, the stories often show her *using* violence—hitting, choking, tackling, fighting with swords—hardly "feminine" activities. Those "other things" include tying people up, which leads to the last queer or unconventional Wonder Woman trait: She seems to be fond of bondage, which is a feature in many storylines. Due to these unusual characteristics, Wonder Woman was, psychiatrist and comics critic Frederic Wertham later claimed in 1947, "a frightening image" for boys.[52]

Billed as a "Saga of Girls under the Sea," the main storyline in the November 1944 issue of the comic book clearly demonstrated Wonder Woman's blend of masculine and feminine, unconventional and conventional, successfully rendering her masculinity nonthreatening. The story begins with a coded message from a transatlantic cable that Wonder Woman, in her secret identity as Diana Prince, recognizes as "Atlantean." She translates the message, and it says: "Tell **Wonder Woman** [her name is always written in bold in the comic book] I need help!"[53] Wonder Woman immediately takes off in her invisible airplane for the undersea scene, somehow meets pilot Steve Trevor in midair along the way, and discovers that the source of the distress call is Octavia, queen of the matriarchal "Atlantean country of Venturia," who is being held prisoner by female anarchist rebels.[54] The female anarchist rebels are served by small, bald, malformed,

unattractive "manlings," who are slaves. The convoluted plot line features Wonder Woman saving Queen Octavia, another powerful woman, from these rebellious and robust female subjects.

The story shows how Wonder Woman displays masculinity—but only to the villains—and balances it with femininity. Steve Trevor emphasizes Wonder Woman's status as a sex object by referring to her in the story as "Beautiful" and "Angel," and inquiring where she's going in case he "er—need[s]" her. Wonder Woman understands his question as one of male protectiveness—he wants to save her from harm (much as the soldiers in the *Male Call* cartoon wanted to protect the Waac from "zoots"). She replies, "Good Old Steve—you mean in case **I** need **you!**" In spite of the logical gaps intrinsic to the story (if she's "stronger than Hercules" and "swifter than Mercury," why would **she** need **him**?), his presence is reassuring. Art of the time implies that a husband or male partner negated a woman's possible homosexuality. If a masculine, heterosexual man found a woman attractive, the art suggests, she either couldn't possibly be a lesbian or wasn't pressed to be by the absence of men.

Handsome, masculine Steve Trevor is juxtaposed against the weak, ineffectual, homely men of Venturia, who are physically smaller than, and enslaved by, the women. By comparing male characters, the Very Manly against the Hardly Manly At All, the story becomes a cautionary tale about men deprived of inherent, patriarchal masculinity and command. It is no wonder that the women of Venturia are out of control, the story seems to say: The gender hierarchy has been reversed from the "natural" order; with women in power, men are emasculate.

The female characters are also contrasted, though all of them display masculinity: Wonder Woman, Octavia, and her subjects are tall, muscular, athletic, and even armed. They, too, are juxtaposed against the "manlings," poor representatives of masculinity, indeed. Wonder Woman "performs" femininity in classic ways in this story. The reader first sees her readying for her "hectic adventure," for example, by prosaically sitting on her bed in order to put on her high-heeled red boots.[55] She is also not as aggressive or as large physically as the Venturian women, who are variously termed in the story as "Big Girl," "Giant Atlantean Girl," "Guard Girl," "Army Girls," or "Giant Women Army Officers."[56] This last term speaks to fears of military service imparting offensive female masculinity. All of Wonder Woman's terms for the Venturian women are code for "not feminine" (or "not feminine enough"), and there is no appropriate male authority to contain their masculinity into acceptable parameters. The Atlanteans call Wonder

Woman "stupid little earthling" and refer to her as "a runt," but their taller, strapping stature paints them as too masculine, leading Wonder Woman, in a fight with one of them, to exclaim, "The bigger you are the easier you fall!" (The Atlantean cries out, "Aee—ee—woof!" as she is thrown down.) Thus, in spite (or perhaps because) of her smaller size, Wonder Woman is victorious over the larger anarchist women; it is her femininity that makes the difference in her triumph.[57]

Queen Octavia also balances masculinity and femininity—with questionable success. A democratically chosen ruler, she has been "lenient" and merciful with subjects who, because of abuses by past rulers, distrusted and tried to assassinate her. She nobly tells Wonder Woman, "I can endure my captivity but I grieve for my country—it's horribly **misruled!**" She thus demonstrates "feminine" qualities of nurturing and selflessness. Octavia represents the weakness of women in compassion and mercy for subjects (read children) who need discipline and a stern hand. Octavia's failings highlight how Wonder Woman demonstrates the correct way to be both tender *and* strong.

Octavia's subjects, however, are unacceptably "masculine" in multiple ways. Besides their physical masculinity, the women comprise an entire society of strong, powerful, untrustworthy women who misuse their power to overthrow their rightful leaders (much as the cartoon officers described earlier in this chapter misuse their power to order lingerie and baths). Moreover, Wonder Woman has to come to their rescue, helping to place and keep Octavia on the throne. The Venturians represent the threat inherent in having a society, and particularly men, dominated by women. Octavia's female subjects are portrayed as mannish, treacherous anarchists who smoke cigars (harking back to the early cartoons of "mannish" Suffragettes puffing on stogies). The cigars are yet another phallic object, much like the wrenches and rifles of cartoons of the era, and are representative of the subjects' attempts to subversively usurp "masculine" power.

Examples of bondage and/or sadism and masochism, present in so many Wonder Woman storylines, occur in this tale as well.[58] In one set of panels, Wonder Woman hurls herself at the knees of one of the Venturians, wrestles her into "a bundle" that she calls "the **kitten** hold," and finishes by sitting on her. As she holds the woman's legs between her own, she ties the woman's hands and upper arms with her "Golden Lasso" of truth, declaring, "On Paradise Island . . . we play many binding games . . . !" After she bursts into a cavern where Queen Octavia is being imprisoned, the captive greets Wonder Woman with, "Oh, Mistress Darling, I knew you'd come!"

And when other Venturians take Wonder Woman prisoner, they do so by attaching electric wires to her bullet-deflecting bracelets, then chaining her so she cannot escape.[59] The written text does not aid in defusing the bondage/domination implications of all this binding and chaining, as Wonder Woman exclaims, "Bonds of love never make the wearer weaker—they give him greater strength!" That "greater strength" is demonstrated by a sword fight, hand-to-hand combat, and a brawl in which she throws a Venturian woman across a room. The proclamation does little to calm charges of queer sexuality, and that sexuality also mingles rather uncomfortably with her very masculinized and aggressive physical force.

Wonder Woman's "feminine" nature prevents even this Herculean woman from breaking chains that men impose—but Trevor shows up in the end to shoot away Wonder Woman's chains. These she cannot remove, because, as she exclaims, "**Men** [the "manlings"] chained my bracelets together! By Aphrodite's decree, my Amazon strength is **gone!**" (see Figure 4–3). Steve Trevor must symbolize both the imposition and the freeing of Wonder Woman's fetters. This is male management of women's power. Thus, popular formulas help to maintain cultural consensus about the nature of reality and morality, confirming existing definitions of the world. One aspect of this story's formula is that it affirms the strongly held conventional view that women *needed* control of their newfound power and authority.[60] The symbolism of the chains is barely symbolic; it is utterly blatant: Men must regulate women, even Wonder Woman, or else women will become like the unnatural, rebellious, anarchist, cigar-smoking man-women of Venturia, overthrowing their rightful leaders and running amok. Given the creation of female soldiers, sailors, Coast Guardsmen, and Marines, and other wartime upheavals of gender-role behaviors, it is no wonder that Wonder Woman suffered at the hands of critics and other Americans who worried about the postwar implications of that upheaval.

Comics and cartoons were hardly received without critical comment, which was delivered before, during, and after the war. *Chicago Daily News* literary editor Sterling North complained that comic books were:

> badly drawn, badly written and badly printed—a strain on the young eyes and young nervous systems—the effect of these pulp-paper nightmares is that of a violent stimulant. Their crude blacks and reds spoil a child's natural sense of color; their hypodermic injection of sex and murder make the child impatient with better, though quieter, stories. Unless we want a coming generation even more ferocious than

Figure 4–3: Men both impose and free Wonder Woman's fetters. (Wonder Woman™ and © D.C. Comics. All Rights Reserved. Used by permission.)

the present one, parents and teachers throughout America must band together to break the comic magazine.[61]

Psychiatrist Frederic Wertham made a career out of trying to destroy comic books; a great deal has been written on Wertham and his "Comics Code." Wonder Woman was one of his favorite postwar targets.[62]

Ultimately, though, the power of Wonder Woman and of all cartoons lies in their excitement, their subversive capacity to transmit social values while their audience hardly notices, their ability to make the powerful seem personally possible. The social impact of Wonder Woman's mix of conventional and unconventional, feminine and masculine behaviors was possible in large part because of her superhero status. Since the audience identified with the fictional female superhero, her status, qualities, and achievements became an important vehicle of wartime social values and prewar traditions.[63] Particularly in the "Girls under the Sea" storyline, the dangers of

gender-role subversion are averted by a woman's duality of identity, a syllogism of wartime gender expression: if masculinity, then also femininity; if strength, authority, autonomy, then male control of those qualities. In the end, if women were deprived of firearms and had to resort to their fists to do their jobs, that disempowerment was as present in reality as it was in graphic art. And if Wonder Woman comics and other depictions of women mitigated their masculine traits with feminine ones, that did not negate the fact that women were almost literally bound in male regulation. Symbolically and literally, only men could free what they had chained. Wonder Woman and other powerful cartoon women came to represent not only women's authority and strength during World War II, but also the ways in which their public power was weakened, until, at the end of the war, they were fired or demobilized to make way for men, and it was removed almost entirely.

5

"Here's One Job You Men Won't Be Asking Back"

"Reconversion" of Masculinity at War's End

To assure the women of an even break with the men in job opportunities, the War Manpower Commission has avoided setting up separate categories of occupations for the sexes.... [As a War Manpower Commission representative] explains, "A hard-and-fast distinction cannot be set for the jobs of either sex. Whether a job is to be filled by a man or a woman depends on the qualifications of the individual rather than on whether the person is a male or female."

—from an article considering "the valuable assets for readjustments which our G.I. Janes are acquiring in the various women's services," in *The Independent Woman* magazine, May 1945[1]

"American women are more cruel, more selfish and more material in outlook than American men," began a *Collier's* article written by a "distinguished author and leader in the battle for social progress" in 1946. "American women ... have an inescapable responsibility for the preservation of our highest traditional values in terms of contemporary needs. The road which the majority of them now choose will determine to a great extent the future of our civilization."[2]

At war's end, women faced almost as big a sea-change in their lives as they had at war's beginning. Having taken on unfamiliar and difficult work for patriotic wartime purposes, they were now getting strong messages that

they were cruel, selfish, and materialistic; further, that they now had apparently sole responsibility for traditional gendered values. They also had to give up all the advances they had made. One cartoon did not even depict human beings but still painted a vivid picture of their circumstances. It showed a chicken in the foreground and a surprised-looking rooster standing on a perch behind her. The chicken has just laid an egg, which is lying, bright and new-looking, at her feet. Very annoyed, the hen is looking at the rooster, complaining, "Here's one job you men won't be asking back after the war" (see Figure 5-1).[3]

Women faced a challenging postwar situation. On one hand, most were thrilled to have the war over and men coming home, and many were equally happy to leave the jobs they had held during the war. On the other hand, the men's return meant that women would be stripped of many of the elements of their lives that had added a positive touch to a very difficult phase, and hence much of the societal value they had acquired through those elements. Like the chicken laying the egg, they found that the only areas they did not have to surrender to men were those embedded in the roles women had been encouraged to play all along. What they had to relinquish with the end of the war was their pay, their independence, the strength they had been so encouraged to foster—in short, to use a phrase that few, if any, of them would have claimed, their masculinity.

The quotations in the opening epigraph and at the beginning of this chapter, from different sources and published a year apart, demonstrate the polarity of American opinion about women's roles. *The Independent Woman*, with its primarily female audience, not surprisingly, expressed the opinion that women ought to, in fact, *be* independent, and encouraged the idea that women—and most especially military women—would want and deserve jobs that utilized the skills they had gained and honed during the war. The *Collier's* article, in contrast, perhaps because of its mixed-gender audience or its particular postwar perspective, vilified American women as cruel, selfish, and materialistic. If a woman wished not to be viewed in this manner, according to the author of that article, she needed to exhibit "traditional" behavior—to fulfill the "contemporary need" to have children, to advance "the future of our civilization." In order for men to return to their "rightful" place in society, for them not to suffer further dislocations as they returned from war, they deserved to have women return to some simulacrum of prewar behaviors, even if that vision was idealized.

Female masculinity was thus highly mutable and contested at the end of World War II, and popular graphic art at war's end portrayed the struggle

Figure 5–1: Rightfully annoyed at losing wartime value. Source: "C. A." *[Colin Allen] (for OWI),* *National Archives and Records Administration, Records of the Bureau of Graphics, Record Group* *208, E-219, Box 1.*

for "reconversion," both of female masculinity specifically and of gender roles more generally. Here I recast the term "reconversion," which at the end of the war referred to the retooling of factories and other institutions from the production of war materiel back to peacetime goods—from parachutes back to bathing suits, to reverse the title of Chapter One—and the adjustment of American society from wartime to peacetime economy and culture. I extend the meaning of "reconversion" to describe women's move back from wartime masculinity to renegotiated femininity. Such reconversion and renegotiation meant that the masculinity women had been called upon to produce in multiple forms during the war was now sharply restricted.

Reconversion of factories and reconversion of women's roles occurred together, and the result was that women quickly lost production labor jobs. Not all women reconverted happily. Those who had seen the war precisely as a way *out* of traditional values and their attendant restrictions, or had found in their new roles some positive result, a consolation from the horrific destruction and deprivation of war, resented the almost complete prioritization of men's wartime contributions over women's. It was taken for granted throughout most of society, however, that women would be displaced from their positions of wartime importance.

The issue about women's roles was unavoidable. As World War II drew to a close and men flooded back into civilian life, gender-role renegotiation became a vital part of the movement back to prewar "normalcy." For the first time there were more women than men in the United States (and in many other places around the world). Because of the highly publicized "scarcity" of males, a number of women felt they needed to be ultra-"feminine" in order to "catch" a man.[4] The birthrate had climbed during and after the war, but in order to perpetuate "the future of our civilization," American women wanted to have children (or were pressured to do so) in order to begin their families (or to continue families interrupted by wartime dislocations). The "return to traditional values"[5] espoused in the *Collier's* article was often happily embraced by women who were simply and utterly grateful to see their men back again, when roughly 360,000 American men had died.

Unfortunately, demobilizing a vast number of servicemen while at the same time ceasing war production resulted in widespread unemployment. During one month in 1947, nearly 8 million unemployment claims were filed with the Veterans Administration, and by the end of that year, the government had paid nearly $2.5 billion to unemployed veterans.[6] A *New Yorker* cartoon panel depicting a factory gate demonstrated a widely

recognized feature of reconversion. Above the gate is a large sign, obviously erected during the war, when labor demands were highest. It reads, "MEN AND WOMEN WANTED," and in smaller letters below, a long list of company benefits that had been used in wartime to tempt workers to employment. Underneath the large sign is another, smaller sign, reading only, "NO HELP WANTED."[7]

Because postwar America was so concerned with the readjustment and reintegration of male veterans, it was highly unlikely that women, even those who had stepped into the void created by men who had left their civilian production jobs for the military, would be "[assured] ... of an even break with the men in job opportunities."[8] In an upheaval of the already disrupted wartime employment situation, women lost or left their jobs in production labor in great numbers. Groups of women that were especially symbolic of women's wartime masculinity, such as the Women Airforce Service Pilots, or WASP, were abruptly disbanded under pressure to give returning male veterans priority in employment and to allow (or force) women to reintegrate back into their prewar gender behaviors (and/or shed their masculinity). There was no arguing with the fact that men in the service had done an extremely difficult and dangerous job well, and this gender reconversion, including women's surrender of the much smaller number of jobs that remained, seemed one way to repay them.

Male veterans were *expected* to come back to and receive preference for employment because of all they had sacrificed for the country. Indeed, civilians were reminded frequently of all that servicemen had been through. An outpouring of psychological and advertising literature concerning the return of veterans to civilian life reinforced women's crucial roles in the social readjustment of the veterans. Books and articles called upon women to strengthen the male ego, to relinquish some of their own independence, and, above all, to adapt their needs and interests to those of their returning men.[9] It was also clear that men's needs or desires in this postwar environment superseded women's. One government poster shows a returning soldier, suitcase on his shoulder, arm extended as if to shake hands with the viewer. "HELLO, GANG!" he's saying, "THANKS FOR EVERYTHING!"—and pointedly, below that, the text reads, "AND IT'S GREAT TO COME BACK TO A JOB."[10]

Male veterans' lack of jobs was seen as especially perilous; their other readjustment difficulties were exacerbated by the lack of steady, gainful employment. Furthermore, men (pilots, for instance) as well as women had learned new skills in the military, and many did not relish returning

to prewar, unskilled labor. They had grown and matured, along with their skill sets and their horizons. And although men may not have had displacing women at the forefront of their minds, most wanted "a good job" and a way to support the families to which they were returning. In addition, male veterans were dealing with the emotional fallout of war, particularly if they had seen combat. Gender reconversion and its pains took a social backseat to the needs of these homecoming heroes.

The 1946 film *The Best Years of Our Lives* attempted to portray the difficulties of "rehabilitating" male veterans to civilian life. The highest-ranking of three men to return to their hometown, Captain Fred Derry, an Army Air Forces bombardier, comes home with a chest full of decorations (including, we learn at the end of the film, a Distinguished Flying Cross). He also returns with a heavy case of what we would now call posttraumatic stress disorder. When, once he is back, he looks for his wife and cannot find her, he learns that she has taken a job at a nightclub, a piece of information she has kept from him. When they are reunited and begin living together, they argue frequently, having only known each other for a short time before marrying during his flight training, and it becomes obvious that they are unsuited for each other. She wants him to wear only his uniform and decorations in public—she has married him, it is implied, because of the glamour and status of his uniform, and she dislikes him in civilian clothes. As he cannot find a good job, he is forced to ask for his old post as a soda jerk at the drugstore where he worked before the war. After his high-intensity wartime experiences and the recognition, rank, and pay he got for his bravery and daring, he finds scooping ice cream demeaning and boring, though he gamely takes it on. He is not sorry when he loses the job defending one of the other two servicemen, a sailor who has lost both hands (he hits a blowhard customer who says that men who fought for their country were "suckers").[11] The film captures the difficulties the three men encounter for a postwar audience, and as the men are of different socioeconomic classes, it conveys a sense of how widespread such problems were. The third man, a sergeant, was a banker both before and after the war; the sailor was fresh off the high-school football field when he entered the military; and the soda jerk, literally from the wrong side of the tracks, had become a captain in the AAF. There are highly moving scenes representing the experiences of a large number of servicemen and highlighting the need for returning male veterans to have jobs and opportunities—the same jobs and opportunities that were taken over by women during the war and that the women now had to relinquish to reward the men.

Best Years also depicts ideal postwar womanhood and demonstrates appropriate behavior for the women the men were returning to. Fred Derry's wife, Marie, the night-club entertainer, is hardly the desired interpretation. She takes up with a thuggish ex-serviceman, with whom it seems she has had a relationship when Derry was overseas. Later, as Derry jerks sodas for low pay, Marie is resentful and depicts "cruel, selfish, and material[istic]" behavior, going out with couples or with single men who can take her to fancy places. Derry, meanwhile, falls for the virtuous daughter of the older sergeant who returned with him, who is now back at his job as a banker. The daughter, whose name is Peggy, is the exemplary model. She puts Derry to bed in her frilly bedroom on the men's first night back, when she and her mother have to drive the two men, quite drunk from bar-hopping, home. As the mother, played by Myrna Loy, undresses her husband and puts him to bed, Peggy parallels her actions with Derry (the two women share a knowing and rueful laugh afterward). A wartime nurse at the hospital, Peggy expertly removes Derry's outer clothes and shoes, chastely loosens his belt, and sleeps on the couch. During the night, she hears him shouting and awakens him from a posttraumatic nightmare; wiping his perspiring face and stroking his hair, she soothes him back to sleep. In the morning, she fixes him breakfast and drives him to Marie's new (tawdry) apartment. But Derry's nightmares are recurrent, and later in the movie, when he shouts the same things in his sleep that he did when Peggy awoke him, Marie impatiently needles him, charging that he can't "get over" his combat experiences. At the end, Marie divorces Derry, and he finds a job helping to convert old scrapped planes into new homes for servicemen. The movie draws a fairly obvious analogy between the junked planes and their human crews. The foreman of the new job initially finds Derry among the derelict wartime equipment, sweating in the bombardier's nose of a B-17, having a flashback.[12]

Through the entire film, Marie and Peggy are juxtaposed against each other: One is selfish, cruel, and materialistic; the other, an exemplification of ideal wartime and postwar womanhood, supporting and caring for the veteran she loves. The film shows Peggy and her mother as exemplars of women who have an ideal combination of qualities: enough wartime masculinity to give them toughness, capability, and wisdom, and enough traditional femininity to make them caring, loving, and welcoming to returning veterans.

Best Years handled the postwar gender situation in a gravely sober way—but other visual representations called upon slightly different types

of rhetoric in order to make their point. Some advertisements expressed in subtle ways that "ideal" women were crucially important in postwar society. As former military men attempted to adjust to their new situations, the message often was that they required flexible adaptation from their women. One ad for an aircraft engine company, entitled "Now that he's back," drew a detailed picture of a returned veteran's predicament. It was not unlike that of Fred Derry:

> People who knew him before seem puzzled, and say, "Changed a lot, hasn't he?" ... Hell's bells! Nobody wears wings and rank for three years, earns an Air Medal with clusters and a stack of service stripes on his sleeve, and comes back the same old pre-war model. ... It's going to take time to make him a civilian.
>
> People who know him say, "Doesn't seem very happy to be home, does he?" ... Well he isn't, yet. He's harassed with a set of habits that don't fit. His clothes seem too loose. Little decisions, such as picking a necktie, ordering a lunch, doing this or that first ... all bother him. His sleep is sometimes broken by some not very nice dreams. He bounces awake in the dark at 3:30 a.m., all set for something big to happen. He's lonesome, misses the old gang, the old grooves ...
>
> All he needs is time. He has given a lot of time to do the toughest kind of a job, for all of us. He deserves the time he needs to readjust, to slow down to normal living ... (Ellipses in original)[13]

The returned veteran deserved the time because, as the ad says, "these fellows who did their fighting in the air were the best the country could find, the best any country could have, the peak of national manpower."[14] Here, too, while a man's father might be the one to see him in readjustment difficulties, women might be even closer, watching their husbands or sons struggling with the demons of wartime service. Whether helping fix too-loose clothes or waking men from nightmares, women implicitly had to adapt to readjusting men the most.

Because women's movement into previously all-male spheres had been accompanied by reminders that it was temporary—specifically because men would return—women's wartime advances in employment and social importance were reversed at war's end. Women were fully expected, whatever their feelings about it, to relinquish their jobs, independence, and autonomy in order to give employment to men. If a woman could not be the "pretty solid all-round ... sincere ... [heterosexual] girl" that men were looking for, she should simply make room for a man by her absence from

the workforce.[15] A woman in the military, too, should quietly endure demobilization and let a returned veteran resume his position, whether or not she wished to be demobilized. A cartoon from *Collier's* demonstrates this notion: A WAVES officer stands in a recruiting office, showing an empty desk to a chief petty officer with rank and hash marks up and down his sleeve. As he leans happily on the desk, marked "Recruiting Officer," the WAVES officer exclaims, "Welcome back, Chief! Your old job's waiting."[16]

No mention is made, of course, of whether the WAVES officer would like to stay in the navy or keep that position. Although it was still possible for women who wanted a job to find one after the war, employed women's economic status deteriorated significantly. In 1946, 90 percent of women were earning less than they had earned during the war. Furthermore, the range of jobs for women in the military shrank considerably after the war, partly in response to public opinion: It was clear that with the return to peacetime, society would no longer tolerate women being in military occupations.[17] After the war, although the women's services still existed, military women's numbers dropped dramatically. The total percentage of female servicemembers and promotion opportunities, moreover, were capped severely: The Women's Armed Services Act of 1948 gave permanent status to women in all the armed forces, but capped their numbers at 2 percent service-wide and limited each service to only one line full colonel or navy captain.[18] If a woman left the military, her fortunes promised to be equally dismal. Despite the hopes expressed by the opening *Independent Woman* quote, fewer than half of female veterans were able to find jobs that made use of the skills they had learned in the military. To make matters worse, these female veterans were not considered providers, but dependents in their homes, and were therefore ineligible for many of the important veterans' benefits that were available to their male counterparts.[19]

Female veterans, like the WAVES officer, were seen by default as of lower status than male veterans. As men returned from the military, there was a widely held notion that all of them were combat veterans, when in reality only roughly 27 percent were.[20] In one *Collier's* cartoon, a private has gotten off the train bringing him home. He is greeted by a brass band and photographers snapping shots of him. Banners proclaim, "Joe Tilney Day" and "Midville's own son Joe Tilney." There are even skywriters, spelling out "WELCOME JOE TILNEY," and the town's mayor presents him with a key to the city. Sternly, the private chastises his mother, "Are you sure you haven't been talking too much, Mother? All I did in the war was bake bread at a Midwest camp!"[21]

Perhaps since women were assumed not to have been under fire — and most, admittedly, had not been — they were also assumed not to have contributed as much to the war effort. Women who worked in factories during the war had been in far less danger than combat veterans, but servicewomen were not in reality always in less danger than servicemen, since not all servicemen had been in combat roles (but many women, nurses, for instance, had most assuredly been in harm's way). The unequal response to servicemen and women was thus unwarranted.[22]

Nevertheless, female veterans were often left out of the country's gratitude. Lack of employment was the biggest problem. Female veterans only numbered about 350,000; they could easily, under the circumstances, have fit into the job market. As veterans, furthermore, they should have received preference. But hiring officials frequently did not recognize their reemployment rights, and even some government agencies were unaware of their prior claim to federal jobs. Women were especially discouraged in their efforts to get and retain jobs commensurate with the skills and experience they had acquired during the war.[23] Whereas military experience gave male veterans an advantage in job-hunting, some employers actually counted women's service experience against them, and hence many women did not tell employers about their military service.[24] Female veterans' employment was often not even considered; women, civilian or military, were expected to step aside as a demonstration of their devotion to men and to conventionally female roles. As one former Wac put it, "[B]ack in those olden days girls were not expected to work[;] marriage would be in their future. They did not seek careers."[25]

As the end of the war grew closer, propaganda approaches shifted from getting women to work to getting them *out* of the workforce. There was a reemphasis on "traditional," idealized femininity without paid work. There was a widespread housing shortage, and meat, butter, cigarettes, and other foods and products were still scarce. By 1944, when war production was beginning to wind down, and especially in 1945, when the end of the war was in sight, attitudes toward women workers were changing, at first subtly, and then more clearly. Obviously, women production workers were being phased out — both in actuality and in the public consciousness.[26]

Two cartoon women talking over a back fence, for instance, don't discuss work but the grocery situation. One is relating a recipe, saying, " . . . and cut it into small cubes. If you can't *get* beef, then try lamb or veal. Then take butter, but if you can't get butter use oleomargarine, and if you can't get

oleomargarine then peanut oil will do. Then take the butter or the oleo-margarine or the peanut oil and put it in a large pot. Add salt and pepper and a half cup of sugar. If you can't get sugar, use a cup of corn syrup. If you can't . . ." (ellipses in original).[27] Women had been employed in much the same way as these grocery items: If you can't get butter, use oleomargarine. If you can't get men, use women. Wartime had provided a harsh measure for substitution (sometimes as strange as meat with corn syrup); now, women's absence from the workforce and from the military was expected and even desired.

Because, by design, women would not have jobs, their "natural" focus would be men—and most veterans' benefits were directed that way, too. In the volume of literature written to ease the veterans' return, women were scarcely mentioned. Although women had access to the hundreds of veterans' centers established throughout the country, most of these services were geared to helping and advising men. Servicewomen could join the American Legion as full-fledged members, but the Veterans of Foreign Wars confined them to the Ladies' Auxiliary, which was established chiefly for wives of VFW members. In spite of this lack of acknowledgment of women as "real" veterans, 65,000 women took advantage of veterans' benefits for college or graduate study—one of the few benefits of military service that actually came to fruition for women.[28]

It was against this backdrop that gender reconversion took place; as the war ended and women lost their employment, they also lost the wartime need for masculinity. A *New Yorker* cartoon demonstrates this shift in explicit terms: A short-haired woman in a cap, work pants, a man's sweater, and worker's badge, carrying a lunchbox, walks past a "Beauty Shoppe." Prominently displayed in the window is a large sign reading, "COMPLETE RECONVERSION $25" (see Figure 5–2).[29] As factories converted back to peacetime goods and male labor for available jobs, women, it was assumed, would "reconvert" to traditional femininity.

For many women, "reconversion" involved both gender renegotiation and job loss. In *Best Years*, Peggy had been a volunteer nurse. Although she is depicted as tough and capable, she (and the producers of the film) had chosen a mode of war work that was considered highly feminine.[30] Naturally, when the number of recovering male patients at the hospital declined, Peggy's war work would cease—but many women in all sorts of other jobs, in real life, wished to keep working. By force or by choice, however, by 1946, the female labor force had declined from its wartime peak of nearly

Figure 5–2: Complete gender *reconversion: removing the trappings of masculinity.* Source: *Chon Day, "Complete Reconversion, $25," August 25, 1945, in* The Complete Cartoons of the New Yorker, *edited by Robert Mankoff, Foreword by David Remick (New York: Black Dog & Leventhal, 2004). (© Chon Day/ The New Yorker Collection. Used by permission.)*

20 million to under 17 million. Women in the civilian labor force decreased from about 35 percent in 1944 to fewer than 29 percent in 1947, and the percentage of all women in the job market fell from 36.5 percent to just under 31 percent.[31]

Probably the first group to suffer mass job loss — the Women Airforce Service Pilots, with only a little over 1,000 members — was relatively small, but its fate was symbolic of what would happen to masculine women when the war ended. These women were unquestionably distinguished for their wartime service. The WASP is particularly remarkable, especially in a

study of gender reconversion, for the circumstances under which it was dis-
banded and the driving force behind disbandment.

The WASP had been created in July 1943, when two associations of fe-
male pilots (the Women's Auxiliary Ferrying Squadron, or WAFS, and the
Women's Flying Training Detachment, or WFTD) merged. The new or-
ganization was given the name WASP in August of that year. The eventual
group of 1,074 female pilots (about 600 flying at disbandment) performed
various types of missions. For example, they ferried planes from factories
and repair locations to bases, towed targets (so that gunners could prac-
tice with live ammunition) and gliders, did radar calibration flights, copi-
loted bombers, and carried out bombardier-training missions. They flew
every sort of aircraft in U.S. use during the war. WASPs also flew secret
missions, and they were used, in a turnabout of roles, to "cajole men" into
flying aircraft the men were hesitant to fly "because of a known or supposed
crash record" (including the later-famous B-29, thought to be "too big to fly
safely").[32] The most famous picture of WASP women (and one of the most
famous of any wartime women) shows four WASPs walking away from a
B 26 aircraft toward the viewer. They wear heavy flight boots and leather
jackets and carry parachutes. Although the four women are unquestionably
female and smile cheerfully, they look tough, capable, independent, and
strong—in short, "masculine."

Their masculine appearance was verified by their work. In flying the
kinds of assignments they flew, these female pilots took on roles and mis-
sions previously associated with men's roles and missions; thus WASPs chal-
lenged assumptions of male supremacy in wartime culture. Since all WASPs
were pilots or pilot trainees, they posed a threat to cultural constructions
of gender identity. Within the WASP, WASP historian Molly Merryman
noted, "There were no positions of 'women's work.'"[33] WASPs themselves
felt their masculinization, often with mixed feelings. One WASP-drawn
cartoon that appeared in a training-school book from 1944 addressed this
loss of femininity. Entitled "New Trainees," it depicts several women car-
rying suitcases as they are ordered by a WASP in flight jacket and turban
to "COME ON! FALL IN!" in front of a sign helpfully labeled, "Avenger Field"
(Texas, where WASPs were trained). At the tail of the group of trainees,
four WASPs, also in flight jackets and turbans, exclaim, "Ooooo—*Look!* A
DRESS!" as they examine with amazement the hem of one trainee's skirt.[34]

The juxtaposition of masculine and feminine here is reminiscent
of the Tangee lipstick ad discussed in Chapter Two, which featured the

construction of lipstick as "why we are fighting," a particularly interesting suggestion because of the use of so phallic a symbol to represent femininity. In the narrative that the ad writer created around the lipstick, the pilot's masculinity and her femininity coexist. The cartoon showing the WASPs noticing the dresse fulfills the same function, showing that the masculine and the feminine were intermixed in their wartime role. But, as "narratives of war capture cultural constructions more than facts," Merryman wrote, so women's roles on the home front tended to get more attention than their contributions on the battlefront. Stories of women soldiers "were mediated to fit existing and acceptable notions of gender, despite the efforts and dangers that constituted their lives." By emphasizing their retention of feminine qualities, images like these reassured people that women's femininity was in no danger of disappearing. At the same time, they also allowed readers and viewers to explore an expanded meaning of gender implied by the new roles women were proving capable of doing. Merryman summarized the gender issue succinctly: "During their years of wartime service, the WASPs flew a terrain that was very much a proving ground of masculinity." Ultimately, however, their encroachment on sacred territory proved to have painful backlash.[35]

That backlash was not just for women in the military; it was shared by women in the civilian workforce as well. A cartoon entitled "Add Post-War Adjustments" spells it out clearly (see Figure 5–3). A uniformed veteran carrying a barracks bag labeled "USA" asks a woman sitting at a desk, "Will you tell the Manager one of his old employees wants to see him[?]" The woman at the desk (which is helpfully labeled "General Manager") tells him, "I'm the General Manager," as behind her dozens of women workers peek out of doorways marked "Shipping," "Credit and Accounting," and "Production." More women look out of a doorway marked "Foundry," next to a large board labeled "Honor Roll, Heavy Hardware Manufacturing Co., Inc." The man's next stop is the employee locker room, where in "His Old Locker," to his surprise, he finds cosmetics, a handbag, a frilly dress, high-heeled shoes, and a parasol. More women, carrying sledgehammers and rivet guns, gaze at him through the doorway. Finally, he goes onto the shop floor, where the female "foreman" tells him, "Bess here will tell you all about *your old job*. She took over after you enlisted and more than doubled the production" (emphasis via underlining in original).[36] The veteran glowers and crushes his garrison cap in outrage while "Bess," about half his size and wearing coveralls and work gloves, leans confidently against her machine.

Figure 5–3: "Add Post-War Adjustments." Simultaneous "reconversion" of factories, gender, and workforce. Source: J. N. "Ding" Darling, "Add Post-War Adjustments," July 27, 1944, University of Iowa Libraries, Special Collections, http://digital.lib.uiowa.edu/cdm4/item_viewer .php?CISOROOT=/ding&CISOPTR=11475&CISOBOX=1&REC=9. (Courtesy of the Jay N. "Ding" Darling Wildlife Society. Used by permission.)

The WASP, in particular, caused this kind of indignation. WASP work was both masculine and dangerous, and although every WASP was undoubtedly "freeing a man to fight," WASPs were clearly not doing sexually stratified jobs.[37] Of all the women doing more masculine work in their wartime roles, WASPs were the ones who were encroaching the most into male territory. When, say, clerks or yeomen did their jobs, they were simply filling noncombat functions to allow men to be deployed overseas in a fighting role — an unspoken acknowledgment that only the men could take on the fighting role. WASPs were not simply replacing male pilots in jobs the males disliked, however; they were nearly doing what the male pilots were doing. This is why the WASPs, in Merryman's view, are so valuable in analyzing the threat that military women posed to wartime cultural assumptions about the construction of gender.

Other sources have disagreed with the assessment that the WASPs were not replacing men in jobs that male pilots disliked. Male pilots generally thought that if they were going to risk their lives, it should be as *combat* and not as *test* pilots, and so disliked what they viewed as needlessly imperiling their lives. As WASP historian Yvonne Pateman observed, "this was another essential task where the WASP[s] were used to relieve the men from 'dishwashing jobs.'"[38]

In any case, the replacement of men in their own milieu prompted complex responses. On the one hand, it created additional discord, because, although the missions performed by WASPs were often hazardous, they were still safer than the combat missions that the male pilots were sent overseas to perform. On the other hand, despite the relief from "dishwashing jobs," many male pilot trainees came to resent the female pilots for their replacement of men, and thus the male-pilot backlash against the WASP is unsurprising.[39]

The matter came to a head when it became apparent that the Allies were winning the war in Europe, and the pilots stationed there could come back to the United States. As they returned, many male veteran pilots joined a vociferous lobby in a campaign in the media and to Congress against the WASP. The public readily accepted their view, and the campaign expanded exponentially, supported by cultural expectations of male superiority and privilege. The WASP was threatening to constructions of men as being ideally suited to performing hazardous work. After all, if women could perform the same jobs, how hazardous could those jobs be? The pilots were insulted; women's performance of the same duties as the men demeaned

men's performance of the duties. The male pilots' point was that women should not have piloting jobs if there were men available. As Merryman recounted, the argument they advanced was that, simply by virtue of their maleness, men were more worthy and talented pilots than the WASPs. And Congress and the American public were amenable to that argument.[40]

In response, in October 1944, Hap Arnold, commanding general of the U.S. Army Air Forces, announced that he would inactivate the WASP in December of that year. "The WASPs have well met the situation for which the women pilot program was activated," his memo read. "Ably and loyally supplementing our activities during a time when a pilot shortage would have impaired the Air Forces' performance of its mission, they are no longer needed. We now have a pilot surplus. The WASP's organization was created to release male pilots for other work and not to replace them."[41] The female pilots were given two and a half months to pack up and leave the bases to which they had been assigned — and, in a surprising coda to their service, by today's standards, they even had to pay their own ways home. In the course of their duties, thirty-eight WASPs had died. But, because the WASP was not militarized, their families received no death or veterans' benefits, and their compatriots had to raise money among themselves to send the bodies home.

Despite this brusque treatment, the *Independent Woman* of May 1945 could claim without irony that, "whether a job is to be filled by a man or a woman depends on the qualifications of the individual rather than on whether the person is a male or female." And, again without irony, it noted that "key factors are the specific requirements of the job and the specific qualifications of the individual for the job."[42] The disbandment of the WASP was due not only to the demand of male veterans to make room for them when their overseas duties were finished, but also in great part to constructions of the WASPs as antithetical to the postwar ideal.

Because of the lobbying of the media and Congress, the public was entirely ready to be grateful and pay what it perceived as its debt to returning male veterans by shunting women out of the way. What wartime need had meant for women in general, and WASPs in particular, was that they were painted as heroines dedicated to the cause of freedom. Now, however, they were objects of cultural anxieties about whether the country could return to its prewar standards. Once celebrated, as Merryman put it, women in all aspects of the war effort were now assailed by the media as self-serving individuals who endangered the abilities of returning male veterans to survive

the postwar economy.[43] In this respect, the disbandment of the WASPs was very typical. It is representative of the way women's wartime contributions generally were overlooked or perceived as less valuable than those of men.

One cartoon summed up the opposition of male pilots (some of whom were not even in the regular military) to the WASP militarization bill that would have saved the WASP from disbandment. The cartoon, entitled, "HOW TO GET IN THE AAF," shows a muscular man in a wig and women's clothing (including a skirt), smoking a pipe and carrying a handbag. Displayed in the window of the store out of which he walks is a sign: "FOR SALE[:] W.T.S. [the War Training Service, a male pilots' organization] PILOT'S UNIFORM."[44] A caption underneath the cartoon gives context: "An American Legion official" had apparently written to whoever first published the image, "You will never know the amount of good [this image and the magazine publishing it] did in getting the attention of Congress in the plight of the WTS and CPT [Civilian Pilot Training Program] men. Your cartoon . . . was read and talked of like nothing done before."[45] In fact, an editorial, "WANTED— FEMALE IMPERSONATORS," which accompanied the original publication of the image, was even read into the Congressional Record as exemplifying men's "plight." With a tang of bitterness, society often cast women as being an obstacle to fair treatment of men and the oppressors of returned AAF veterans. If women, as symbolized by the WASP, were unwilling to drop their wartime masculinity, the men of the War Training Service, the Civilian Pilot Training Program, and the United States Congress would force them to do it.

In disbanding the WASP, the government removed women from the wartime workforce. This helped to fulfill its broader war's-end aims: facilitating reintegration and rehabilitation of male veterans and idealizing civilian reactions to those veterans. Civilians were encouraged in advertisements and other images not to be ungrateful or tactless in their treatment of men recently returned. *Collier's* magazine ran a government advertisement drawn by Norman Rockwell, created through OWI and the Retraining and Reemployment Administration (RRA). Entitled, "Would a Veteran find *You* Here?" it details a number of different kinds of civilians and their unpleasant, unkind, or annoying reactions to returning servicemen. The civilians include the "Motor Martyr," a fellow who admits that Okinawa "may have been tough all right," but "rationed driving" was *really* rigorous;[46] the "Lady with the needle nose," who inquires if a returned ensign "[bled] much" when wounded; the "Tsk-Tsk Sister," a dowager who peers with distaste at a disabled soldier on crutches; and the "No-nonsense type," a man who

gruffly suggests to his anxious-looking offspring, "You've been home a whole week, son. Isn't it time to look for a job? Can't pamper ourselves, you know."[47]

Americans, even very young ones, might also gauge how veterans were getting on. In one *New Yorker* cartoon, two boys sit on a living-room couch; the father of one of the boys sits in an armchair reading a newspaper. One boy asks the other, "Yours readjusted yet?"[48] Another *New Yorker* image that plays with the readjustment theme shows an officer addressing a group of soldiers at a military briefing. The officer instructs, "Now, remember. Civilians have been through a lot. Don't try to *make* them talk about their experiences, but if they want to talk, *let* them."[49] Both government-sponsored and nongovernment images propagandized the American people about readjustment in the same way they had about women's working.

Established comic strips, like the one Milt Caniff drew for camp newspapers, displayed idealized female responses to servicemen's reintegration. Caniff usually positioned his heroine, Miss Lace, as someone stating male opinions in a sexy woman's body—the serviceman's ideal. One strip has her overhearing a plump biddy in a restaurant. The older woman rails, "Well, now that the war's over I hope the hotels and restaurants will soon be cleared of those dreary people in uniforms—with all those silly ribbons!" As Miss Lace drinks her coffee, the woman continues, " . . . Really, I don't see why soldiers aren't kept in their camps when they're not fighting, rather than being allowed to overrun all the decent places . . . and their *women!*" She finishes her tirade by saying, "For the taxes we pay, one would think the government could provide a place for those unhappy looking females and their children," implying that the soldiers and those "creatures" (their wives) are not married, although the women wear wedding rings. The final panel shows Miss Lace fixing her makeup. In the background all that can be seen of the shrewish woman are her feet, as though she has been knocked cold and is lying on the floor. As she powders her nose, Lace asks the manager of the restaurant if she should "wait here for the [paddy] wagon," assuming he will call the police to report her assault. He, wearing a military discharge pin, smiles, "What wagon?"[50] The lengthy treatment both Rockwell and Caniff give the topic indicate the depth of the problem of civilians' readjustment to servicemen, as well as vice versa.

Because the images imply strongly that returned veterans faced a myriad of ungenerous responses to their service and were understandably resentful about it, veterans were appreciative of women like Miss Lace, or Peggy in *Best Years of Our Lives.* The women these characters symbolized were strong,

full of common sense, and generally modest—but they also demonstrated "feminine" care and empathy for the difficulty of men's experiences and rehabilitation. In both artists' renderings, older and/or busybody women are the most grievous offenders against veterans, and younger, attractive women represent the model response. In Rockwell's piece, the appropriate, "grateful" civilian reaction is characterized by an attractive young woman in an apron, with outstretched arms; a fatherly type with a pipe stands smiling beside her in a house doorway. Servicemen who had devoted the previous several years to their country deserved the response of these "Americans, first-class": "Welcome home, soldier!"[51] Advice to civilians followed: "Good Americans don't prod the veteran with questions if he doesn't want to talk. They don't act sorry for him. Nor tell him life has been hard here. (He's been where it *is* hard.) And they don't stare at any disability he may have."[52]

An even more (literally) desirable response to men's homecoming was women's enthusiastic sexual response. The theme is represented by another *Male Call* cartoon: A neighbor stops over to a young, attractive woman's place and observes, "Gee, I'll bet you're glad to have him back, Missus Smith," and asks if she's going to the market today. "Missus Smith," wrapped in a sexy dressing gown that reveals a dramatic décolletage, looks through a doorway at her sleeping husband, and says, "No—not today—he's liable to wake up and want something."[53] A hint to the interpretation of her response is given by the title of the strip: "Whew CQ"; *this* "Charge of Quarters"[54] could take a soldier's breath away in anticipation of waking up and wanting "something"—or someone—and having it, or her, right there, instead of in his army-camp or combat-nap dreams.

Sexual attractiveness and open, welcoming arms were augmented by other qualities of "femininity": rapt attention to men and a marked desire to concede to their wishes. In public conversations, men who had been posted overseas had harsh judgments of "unwomanly" women when they came home. Historians have noted that American men berated American women for being "unfeminine," in contrast with their European sisters, because men found American women less attentive to male desires than European women, to whom they were romantic and military heroes. Still other men who had been overseas declared that European women "really were women," while American girls tried to compete with men, insisting on an equal conversational share with their escorts. In comparison, French girls let their male companions do the talking, with their sole purpose being to be pleasant to these men.[55]

Men also judged women's femininity (or lack thereof) with perceptions of shallowness or materialism. As one ex-G.I. put it, "the English girl is direct, frank, and unassuming. . . . The American girl puts on an act and is interested in a man only for what she can get out of him." Another returned G.I. observed "with disgust" that "here the women trample one another for nylons. Over there they stand in line patiently for a crust of bread."[56] A former correspondent for the military newspaper *Stars and Stripes* continued the legwear theme. He noted that he'd "heard more complaints from American women over the lack of nylons than he had heard from European women over the destruction of their homes and the deaths of their men."[57] While American women might have been concerned with the "sexiness" critical veterans desired, men both desired it and were interpreting women's concern as trivial and small-minded in relation to what they had seen abroad.

A "feminine" woman was not sexually aggressive; strong, forceful, bossy, or physically masculinized women were seen as particularly threatening as the postwar era began. In one *Collier's* panel, a middle-aged woman and a female visitor sit on a couch, watching the very tall daughter of the first woman fling her arms around and aggressively kiss an extremely surprised, shorter young man. "Yes," the first woman says happily, "Myrtle is finally overcoming her standoffish attitude toward boys."[58] Clearly, "Myrtle" has conquered her aloofness and has taken sexual aggression to new frontiers; yet this, along with her height, marks her as the sort of "girl" deemed undesirable. A woman in another image, from *The New Yorker*, waits outside a fence at a Separation Center, from which men were demobilized. At the end of a long line of wives with small children, a young woman is responding to a question from the lady in front of her. "Oh," she's saying, "I'm not waiting for anyone in particular."[59]

This young woman, checking out the available men for their possibilities as mates, shows masculine behavior because she is assuming an aggressive sexual role. The cartoon bears a striking resemblance to a *Male Call* cartoon, published in the Camp Newspaper Service, in which a recently returned corporal is leaning blissfully on a public mailbox to watch, in successive panels, the legs, busts, and derrieres of women as they walk by. As a policeman approaches, the corporal asks him, "Am I out of order here, officer?" The officer replies, "No lad! . . . Keep at your gazin'! Since I walked off the transport in 1919, I myself have never lost pleasure in the spectacle! . . ."[60]

This strip, entitled, "No Chicken, Inspector," implies that men have a historical precedent for objectifying women; furthermore, that that option

is a right bestowed upon them by their military service. Both of these ideas are demonstrated by the police officer's comments. Where the men's attitude placed women, however, was as disembodied legs, busts, and derrieres; as such, they could be scrutinized as (or as not) ideal womanhood to which to return after the war. In her examination of wartime advertising campaigns directed at women, historian Melissa McEuen pointed out that the fetishization of hands and legs (and, one might add, busts, as seen in innumerable cartoons of women) "would encourage the sexualization of American women on a scale not seen before." McEuen further noted that the sexualization of middle-class American women through other kinds of popular graphic art that focused on particular body parts "laid the foundation for the postwar transmogrification of cheesecake into soft-core pornography."[61] The soldier in the cartoon plainly depicts this sexualizing move. Even if a man were a "Chicken Inspector," American culture expected this kind of behavior of him or looked at it fondly, despite its effect of reducing women almost literally to meat to be examined. Given the mores of the time and the acknowledged double standard, however, American culture's take on a woman observing men in a similar situation might be that she was a "camp follower," fulfilling stereotypes of both sexually autonomous and "gold-digging" women. For a man, the behavior is dismissed as predictable heterosexual appreciation of the female form; for a woman, it is maligned.

There were some ironic attempts to help men "understand" the kinds of women they were coming home to. Milt Caniff drew a *Male Call* strip for G.I.s about to be demobilized, with a guide to understanding women and the kinds of personalities (and, implicitly, their gendered behavior) that veterans might expect. Headed "WIMMIN, Civilian, Random Notes Regarding," and subtitled "Scribbled on the back of an old Draft Classification Card," the strip pulls few humorous punches when categorizing women, especially as to sexuality. The "Deep Freeze Type," a brainy-looking woman with glasses, "will tell you why you fought, but won't share the benefits of peace with you." Another "type" is represented by a woman labeled "Bad Timing," who greets her husband's homecoming train and his open arms with, "Hello! Did you have your insurance converted?" Then there is a voluptuous woman with her arms wrapped amorously around an overwhelmed G.I., with the caption, "When a stacker like this gets bold—*Beware!* (The word about Mustering Out Pay has been in all the papers!)"[62]

Caniff's articulation of frankly misogynist opinions provided a glimpse into why women were treated as they were. The "Deep Freeze Type" who wouldn't "share the benefits of peace" (i.e., have sex) with a veteran was

hardly desirable, but a highly sexualized "stacker" who got "bold" with a man was only trying to get his mustering-out pay. A woman was damned if she did and damned if she didn't; she was a "bold stacker," "more material in outlook" than men, "interested in a man only for what she can get out of him."

Ultimately, "femininity" was portrayed most often in images as a combination of sexuality, physical attractiveness, and receptiveness to returning veterans. Milt Caniff illustrated yet another *Male Call* cartoon, produced around V-J Day, as a large, single panel, rather than the strip's usual four small frames. Drawn as if the characters were standing on Earth's continents, it has a beautiful, young, slender, buxom woman in a backless gown and long gloves holding her arms out to a grizzled, unshaven soldier with a rifle in his hand. He strides over the ocean toward her; she stands on land, waiting. Smoke rises from the combat zone on the continent behind him as he walks (significantly) on the water, headed for her open arms. He grins wolfishly as he says, "NOW — WHERE WERE WE?"[63] A sort of "payment" for his almost religious wartime sacrifices, a "feminine" woman was still unquestionably one whom men desired, who was sexually welcoming but not aggressive. The large-panel format demonstrated this desire as much as it did celebration of the end of the war.

Men, perhaps unsurprisingly, were perceived as being entitled to make these judgments about femininity by virtue of their overseas experiences. "These soldiers of ours have a right to gripe about the contrast" between European and American women, wrote Agnes Meyer, the "distinguished author and leader in the battle for social progress" (see opening epigraph). "All over the world," she waxed lyrical, servicemen "made a reputation for befriending the enemy's children and feeding the hungry ones."[64] Unfortunately, with this credibility, returning servicemen publicly condemned American women, castigating their shallow materialism, their inability to rise to veterans' expectations, and the outdated, immature roles women took in courtship.[65] There was little mention of the work women had done during the war, and even as soon after war's end as May 1946, "American Women" were held responsible for "Hostility to Migrant [war] Workers," for "Crimes Against Childhood," and for leaving "A Tragic Legacy for Youth."[66] Although it's unclear what sort of "social progress" the "distinguished author" hoped to bring about, she made it clear that, in her mind, women had violated the covenants of their femininity, not only by undermining the war effort (in rejecting migrant war workers, for instance), but also by not being proper mothers.

Much as a woman war-worker could offset her wartime masculinity by maintaining her femininity through correct mothering, a proper postwar woman, especially a younger woman, could express her femininity by having children when her husband returned. Women of childbearing years had an obligation (in Agnes Meyer's view) and often a desire to procreate. It was their "inescapable responsibility for the preservation of our highest traditional values in terms of contemporary needs," Meyer wrote, and to this end, there was a steep surge in birthrate that expanded women's childrearing responsibilities during the war and thereafter.

This increased emphasis on mothering furthered the cultural separation between women and the paid workforce; many women who had taken jobs in addition to their domestic duties were eager to extricate themselves from this double burden in the postwar years. The emotional deprivations experienced by women separated from husbands during the war made women willing to concentrate their energies on rebuilding family relationships rather than on work.[67] The world had recently seen roughly 50 million people killed, and men and women who had survived the war had often, willingly or unwillingly, put off having families.[68] Hence, the "traditional values in terms of contemporary needs" meant that the very "future of our [American] civilization" depended on women producing children. This would not only satisfy the desire that individual couples had for families, it would replace the lives that had been lost. This "contemporary need" necessitated women's surrendering most work outside the home in order to devote themselves fully to motherhood—still (and always) that most "feminine" of pursuits.

Agnes Meyer was hardly alone in her attitudes. In an article that shows strong signs of Philip Wylie's 1942 diatribe against "Momism," two 1944 *Coronet* magazine authors upbraided mothers for "Maternal Overprotection." This condition, caused by "the harmfulness of mothers," not only promoted physical and psychological effects in their sons, but was responsible for what the authors termed "the large proportion of psychiatric rejections in the armed forces." "The domineering mother," they said, "creates juvenile delinquents, boys who make life miserable for the little fellow, neurotics who can't live happily with their wives." Moreover, "the situation becomes worse in wartime," they cautioned, "for with millions of fathers gone from their homes, millions of mothers become more jealously protective, more emotional, more demanding of their children."[69] In the case of one boy, whose mother tried to make him into a writer but who eventually became a soldier, "what saved [the man] was War and not his mother." The authors

made no attempt to understand or validate the needs or fears of women who worried for their husbands' safety each day; smothering mothering clearly made moms into villains—hardly ideal, with the rising postwar birthrate.

In fact, the more children a serviceman had with his wife, the greater the dependency allowance he received from the government. A *Ladies' Home Journal* advertisement demonstrated the result in a cartoon where a morose corporal sits on his bunk in the barracks, tallying up a list of monthly income sources, while his wife's picture smiles down from the wall. He is glumly regarding the total—$80—when his sergeant approaches him with a telegram. The second half of the ad shows the same corporal flinging his arms in the air in celebration; the telegram reads, "It's twins! [signed] Mary." The earlier amount of $80 has been crossed out on his tally sheet; the amount of his monthly family income has jumped to $104.[70] His wife's production of an additional baby has produced additional money, an important increase for a man about to be demobilized and wondering how much money the family will have to live on. Thus, motherhood was central not only to the scenario of normative female behavior, but also to greater economic gains.

Mothers of unmarried servicemen also played an important gendered role in the postwar world, often having a great desire to nurture the sons who had been away or in danger, in all the classic motherly ways. One *New Yorker* cartoon shows a matronly figure entering the cozy bedroom where her newly returned staff sergeant son lies smiling as he sleeps. As she brings in a tray of egg, toast, and steaming coffee, she wakes him with, "Good Morning, Mr. Civilian."[71] The cartoon highlights the importance of mothers during the war: Wounded men cried for their mothers on the battlefield, and mothers were symbols of home. As another *New Yorker* cartoon soldier walks with his father into his apartment building, his sisters, grandmother, and, centrally, his mother rain a personal ticker-tape parade on him from the apartment above. Hanging above the apartment-house door are two American flags and a placard, which reads, "WELCOME HOME HAROLD KLEIN."[72] For these women, the end of the war was less about victory in Europe or over Japan than about the return of their sons, grandsons, or brothers and the reestablishment of, one prayed, the intact family unit.

Other panels showed mothers and wives taking pride in the roles their men had played in the war, with the sense that women's own status was a function of their men's. The men's masculine status would be lauded and/or increased when it was emphasized and acknowledged; thus, by association, so would the woman's status (not unlike the woman whose general

husband hadn't been saluted by the Wac). One panel has a couple standing at the "Films" counter in a store. The woman is holding a camera, while her much-decorated husband stands behind her phlegmatically, his hands in his uniform pockets. He is modestly unconcerned about the "chest candy" (ribbons, decorations, and devices) he is wearing. As the woman negotiates with the counter clerk, however, she tells him, "No, we specially want *color* film."[73] Ribbons and decorations tell a narrative of military campaigns and exploits; black-and-white film would only show their vibrant tones as gray, she seems to say. Much like Captain Derry's wife, Marie, in *The Best Years of Our Lives*, this woman has her status increased by his accomplishments, as reflected by his uniform.

Women's postwar abdication of public power and the relinquishment of their jobs and autonomy would result in the military and labor force again being almost entirely male, and women having to accept more powerless status—ironic, given that they had been told during the war that to take up more powerful positions was patriotic. It would also allow men to assume or resume status that placed them over women. A *New Yorker* cartoon demonstrates how women negotiated this (enforced) abdication of power: A woman, watching her husband fix their broken-down car, asks, "Would it be all right if I expressed an opinion, provided the opinion were not my own?"[74] In a postwar world, with everyone acutely aware of how a disturbance of "normalcy" looked, the hierarchy was cast as involving concrete, predictable gender roles that did not overlap or cause discomfort. Ostensibly, everyone would know what she or he needed to do, because gender behaviors would be prescribed. With peacetime, women would move back to their proper place.

Their "proper place" was still primarily their homes. But women who didn't willingly accept their "feminine" lot found their masculinity doubly damning, as there was no longer a war to excuse it, and it was possible that the qualities they had acquired would be difficult to shed. One image shows a mother leaning over a fence to talk to her neighbor, who is hanging clothes on a laundry line. Both the mother and her small daughter wear white T-shirts and dark coveralls. "It's a mother and daughter outfit I picked up in the father and son department," she tells the neighbor.[75] Another woman, a clerk in a tobacconist's, displays a box of cigars to a man in a hat and tie. "They're very nice," she informs him. "I smoke them myself."[76] Images like this confront the anxiety that women have picked up masculine modes of dress and habits that will be hard to get rid of. Another anxiety fretted that men would be unable to defend themselves against the masculinized

women. A cartoon mother bends over a nearly unconscious little boy who is being jumped on by a larger, devilishly grinning female child. Wagging her finger as if to teach him a lesson, the mother scolds, "Little gentlemen don't hit little girls."[77] Men, it seems, also felt themselves in a double-damned situation: Faced with masculinized women, they were socially prevented from responding aggressively, as they might to another man.

The role reversal of the girl beating up the boy in this cartoon also speaks to the concerns about children developing skewed gender expression, discussed in Chapter One, or, as argued in Chapter Four, that a strong, assertive woman was particularly read as masculine. The image expresses a fear that people will continue to believe that "little girls" are weak and fragile, full of "sugar and spice, and everything nice," despite the fact that in this cartoon, it is the little *girl* (not the "little gentleman") who has adopted belligerently male characteristics. Perhaps because she has seen women grow strong and forceful, her gender expressions have become skewed, and she directs her hostility against the little boy. The woman instructs him on his gender-role behavior according to attitudes informed by the prewar era—but a little postwar girl might not feel the strictures on her behavior the way a prewar girl had. As a result, he is unable to defend himself.

As the war drew to a close, propaganda about domestic duties went into reverse mode from the tactics used to get women into the workforce as the war began. As housework was compared to war work during the war in order to get women into factories, it was now portrayed as worthy of their attention in order to get them out. One advertisement for Sani-Flush has a picture of a cross-looking woman in an apron, scrubbing a toilet with soap flakes and a scrub brush, with the legend, "I left an office for THIS!" over her head. The copy below reads, "Well, shame on you, the perfect secretary, for not knowing about Sani-Flush." It is difficult to see how secretarial work would have imparted knowledge about cleaning bathrooms; her secretarial courses may have covered Gregg shorthand but obviously not "the quick, easy, sanitary way to keep toilet bowls spic and span," as the ad copy enthuses.[78] Advertisements like these, however, reinforced the idea that, no matter what job a woman had done during the war, her duties following the war still required her to attend to the domestic domain, and she might apply her wartime professional pride (if not her professional skills) to completing these tasks. After all, it was a new era, and war had brought new advances—to the household sphere as well as to armaments. As a middle-aged woman from a *Collier's* panel, looking in an appliance-shop window with a sign in it reading, "Here It Is—Super Duper WASHER,"

exclaims to another, "What a wonderful age. Jet propulsion, atomic energy, and now — washing machines."[79]

Attending to the domestic domain was emphatically not supposed to include a woman's dominating her husband. Domesticity was feminine, whereas being domineering was another form of aggressive female masculinity. One *New Yorker*–cartooned gentleman, speaking from a stage to a group of women, says, "And so when the nomination was offered me, and I got my wife's permission to accept, I felt that..." (ellipses in original).[80] The cartoon plays on standard jokes about the hen-pecked husband, a common theme. In another *New Yorker* panel, a large, tough, angry-looking woman stands at an altar in front of a clergyman. Standing beside her is her thin groom, approximately half her height, with a receding hairline and eyeglasses. The reverend is saying, "I now pronounce you wife and man."[81] If what a woman wanted was marriage, this woman was certainly physically large enough to impose her will on her milquetoast husband-to-be. In a third panel, a man is tiptoeing into his home in his stocking feet, carrying his shoes and opening the door carefully. As he moves inside, he steps into a boxing ring that his wife has roped off around the doorway; she waits for him dressed in a bathrobe, with curling papers in her hair and boxing gloves on her hands.[82] He may be coming in late after a big night, but she is certainly going to make him pay for it, and in a classically masculine way. This belligerent woman, even if she does have the feminine marker of her hair in curlers, has put on masculinity as surely as she has put on boxing gloves.

If there were worries that women had become permanently masculinized, there were also worries that men might be permanently feminized as a result of the gender upheaval of the war. A surprising number of cartoons from 1945 to 1946, for instance, showed men and women pushing the envelope of gender-role behaviors. A "Welcome Home!" cartoon from *Collier's* depicts the ubiquitous balding, bespectacled man in a ruffled apron with a bow in back greeting his soldier son, who has dropped his barracks bag at the front door in homecoming. Inside the house, a service flag with two stars on it hangs in the window.[83] As they embrace, the two men smile at each other, with the father saying, "A few more days, son, and I'll have to take the flag in — your ma's on her way home, too."[84] Not only is the mother in the military; the father is in an apron, articulating one of the primary anxieties about women in the service: that masculinized women would mean feminized men. All of this underscored the need for gender reconversion after the war.

And it wasn't just women who would need gender reconversion: If masculinized women had reactively produced feminine men, then men, too, would need to alter any unusual gender behavior after the war. Two women in another *Collier's* panel sit in a living room as, through the kitchen doorway, they watch a newly returned sergeant first class in an apron wash stacks of dishes. Hanging on a chair in the living room is his jacket, marked with not only his sergeant's stripes but also multiple hashmarks and service ribbons. One woman is saying excitedly to the other, "You should hear the new note of authority in his voice when he gives in to me."[85] Even a man theoretically toughened by advanced rank and multiple years of army service could be squelched by his masculinized wife. She is not necessarily masculine in her appearance but in her aggressive insistence on having things her own way. The bossy wife had her counterpart in the passive, dishwashing, apron-clad male, and he, too, would have to reconvert—oddly enough, in this case, from a tough NCO in a position of authority *back* to the softened man who gave in to his wife.

Postwar conditions and lack of supplies also emphasized the ways that necessity had altered gender. Material for clothing of all kinds was still difficult to find after the war, though factories reconverted to making civilian cloth. One *Collier's* panel has two salesmen in a men's clothing store. They wear suit jackets, ties, socks and shoes—and grass skirts instead of pants. A customer stands beside one salesman, who sarcastically calls to the other, "George, he asks if we're getting any new suits yet."[86] In their highly feminized attire, the salesmen seem to ask, Would we be wearing *skirts* (grass ones, at that) if there were any other masculine clothing to wear? That, however, didn't mean the expansion of gendered behaviors wasn't welcomed by some. In a last image, a portly middle-aged man leans over the "Foundations and Corsets" counter in a busy department store. "Confidentially," he tells the sales girl, "it's for me personally."[87]

Chapter One began with the description of a cartoon called "Letting the Genie Out of the Bottle": the enormous woman "genie" leaving, in a puff of smoke, the home, which is presided over by her tiny feminized husband. In the woman's coverall pocket were symbols of self-support, strength, and independence. Unquestionably, World War II provided opportunities for women to move into male spheres, to take on masculinity—the jobs, clothing, behavior, and language—and the freedom those things represented. Unfortunately, most of the feminist strides the war had enabled were reversed by the necessity of caring for, employing, and showing gratefulness

to deserving male veterans who had finally come home after a long and bloody war. As gender roles reconverted, women had to surrender their wartime masculinity and resume the features of prewar femininity, as well as some constructions of postwar femininity.

But, although many women desired the (re)creation of "traditional" gender roles, there were also many for whom the end of the war meant a painful end to the liberation afforded by wartime. Women no longer were experiencing "savage elation" at their competence, skill, and patriotism.[88] What materialized instead were attempts to maneuver women out of the workforce and back into the home. Women's bravado in taking on that wartime masculinity was now silenced by the deafening click of a door closing on women's reconverted lives.

"These Girls Are Strong— Bind Them Securely!"

World War II Images of Women in the Postwar World

> The wind was an eerie whistle through the trees, long fingers of rain rapped at
> the windows like angry gremlins. But the inside of the house was warm and cozy.
> Mother darned socks. Dad was engrossed in his newspaper. And Jane was ensconced
> on the rug with the latest issue of *Wonder Woman*.
>
> —Advertisement, National Comics Group[1]

The impact of images of women that arose in World War II did not die with
the end of the war; as the ad quoted in the opening epigraph shows, tradi-
tional gender behaviors coexisted peacefully with the new role models for
girls. The ad constructs a scene in which the idealized graphic-art character
of Wonder Woman fits into a homey setting. And although some of the de-
tails of the sentiments expressed in those images have changed, the images'
appeal has not; much of the popular graphic art created during that time
still exists. Images of female production laborers and secretaries, Wonder
Woman, and Rosie the Riveter are republished and redistributed widely
today, roughly seventy years after they were created. Wartime women,
most notably Rosie, appear on lunchboxes, coffee mugs, and tote bags, on
refrigerator magnets, lapel pins, T-shirts, water bottles, and myriad other
products.[2] Other images, created for enlisting women into the workforce

and the military, have also continued to live long beyond the World War II era.

The images that brought women into the service and the workforce in the first place still have significance now—though that significance may be far different from the image-makers' original intentions. Most images of women during the war were created to convince their audiences that women could balance traditional femininity and wartime masculinity. Many depictions have been recast, since the war, to do different work—but the women are still framed as symbols of female power, physical strength, self-sufficiency, and self-determination. Through their symbolic meaning, these World War II representations have indirectly helped not only to promote feminism as a movement, but also to create communities of lesbians. In fact, these images became icons of the women's liberation era: Rosie the Riveter and Wonder Woman persisted in popular culture, adding meanings that enriched their significance after the war. Their interpretations and uses have continued to evolve through decades of complex change.

These World War II images have faced fluctuating public opinion about women's roles. As Betty Friedan put it in 1963,

> over and over again women heard in voices of tradition and of Freudian
> sophistication that they could desire no greater destiny than to glory
> in their own femininity.... They were taught to pity the neurotic,
> unfeminine, unhappy women who wanted to be poets or physicists
> or presidents. They learned that truly feminine women do not want
> careers, higher education, political rights—the independence and the
> opportunities that the old-fashioned feminists fought for.[3]

Wonder Woman and Rosie the Riveter, representing all wartime women, had pried open the bars of acceptable behavior for women; despite the fact that those bars had closed again after the war, there was no denying that they had once been open.

And those doors had opened and closed for lesbians as well as for heterosexual women. Much as the public during the war had feared it might, the services' recruitment and subsequent concentration of "masculine" women did bring together numbers of lesbians. When these women were demobilized in large urban centers, they enabled nascent communities of lesbians to form. In an ironic twist, the government that had been so ambivalent about having lesbians in its midst had contributed to the establishment of a larger

lesbian subculture when homosexual personnel were honorably (if they had managed to keep their orientation secret) or undesirably discharged. Many lesbians and gay men, thinking they could not go home again (some with what they considered a mark of Cain on their records), stayed where they had disembarked, in such cities as New York, San Francisco, Los Angeles, and Boston, joining and helping to form the enclaves of homosexuals that were growing there. In this way, according to historian Allan Bérubé, "the government sponsored a migration of the gay community."[4]

Posters like the ones created and distributed by the OWI, and collected in the National Archives and Records Administration, have been reclaimed, recaptioned, and redistributed as commercial ventures. Now those images are sold on the Internet and at World War II remembrance sites. One such site is the Liberty Ship *S.S. Jeremiah O'Brien*, open to the public at San Francisco's Pier 23. In the *O'Brien*'s gift shop, there is a refrigerator magnet for sale that is a miniaturized poster. It shows four women sitting clustered in front of an American flag, wearing company identification badges, and the title: "SECRETARIES OF WAR."[5] On another magnet appears the image of a secretary, a factory worker, and a welder. The caption reads, "SOLDIERS *without* guns."

Sold as memorabilia of wartime, more acceptable now than some of the other propaganda pieces produced at the time, such as, say, posters or cartoons slurring the Japanese, the images memorialize women's contributions to the war effort. In that setting, the miniaturized posters evoke nostalgia and are cast as quaint collectibles, reminders of a bygone time. For women and men who saw the images at the time of their publication, they no doubt evoke memories of an exciting era when everyone, including women, pulled together for victory. As the "Self-Guided Tour" pamphlet handed out with an admission ticket to the *O'Brien* reads, "You are stepping into history. The *Jeremiah O'Brien* will take you back to the days of World War II, and the times of Rosie the Riveter, ration stamps and bell bottomed trousers [emblematic of the navy and Merchant Marine]. This ship is a living symbol of that era."[6]

In fact, the wooden sign in front of the *Jeremiah O'Brien* reads, "ROSIE THE RIVETER BUILT ME," and below that are reproductions not only of the classic "Rosie the Riveter" flexing her bicep, but also two other reproduced posters emphasizing the role of women in wartime. The poster on the far left is a reproduction of a woman clutching a V-mail letter to her chest. Behind her hangs a service flag, a red-bordered banner with a blue star centered on it,

indicating her husband's service.[7] Below the wistful-looking woman are the words, *"Longing won't bring him back sooner* . . . GET A WAR JOB!" (emphasis and ellipses in original). Certainly, the OWI and the War Manpower Commission (the sources of this poster) were pulling no punches when it came to translating women's emotional responses to their men's absence into tangible workforce numbers.

But modern perceptions of women's public image in World War II influence reproduced images, updating and tweaking them, and incidentally showing an understanding of the ambivalence of the era. The images are not just of strong and capable women—Rosie the Riveter types—but also of women depicted ironically: as emotional and naïve, normative and "feminine," or turning sexuality on its head. This can be demonstrated in another pair of reproduced images. The first reproduction, from the collection of the Smithsonian Museum of American History, shows two views of an attractive brunette woman. First she is wearing the winter uniform of a cadet nurse, and then the working white duty uniform. "Be A Cadet Nurse[,] The Girl With A Future," the caption reads. Below, the poster touts, "A Lifetime Education FREE for high school graduates who qualify" (see Figure E–1).[8] The model in these views is a beautiful woman with well-coiffed hair and tasteful makeup. She connotes idealized femininity despite her military-style, gray wool winter suit with epaulettes and her beret with militarized insignia in the first view, and her stereotypical feminine image in a white duty dress and nurse's cap, in the second.

Actual cadet nurses were usually much more pragmatic (and realistic-looking) than the fashion model portrayed in the poster (see Figure E–2). Because their contracts stated that they must join the Army Nurse Corps or Navy Nurse Corps when they graduated, most cadet nurses understood that they were signing up for frequently difficult, unpleasant, tedious, and emotionally draining work, caring for war-wounded men. They might not have been fashion models, but particularly because they were going into a most "feminine" occupation, they were often viewed as the best of American patriotic womanhood.

The second image uses another cadet nurse recruiting poster in a modern recast of the traditional, care-taking woman's role to turn the fashion-model-nurse stereotype on its head (see Figure E–3). The cadet nurse model in this image, which has been turned into a greeting card, wears the same gray wool uniform and beret as the nurse in the first poster, but seems a bit younger. She is similarly attractive, however, with clear blue eyes

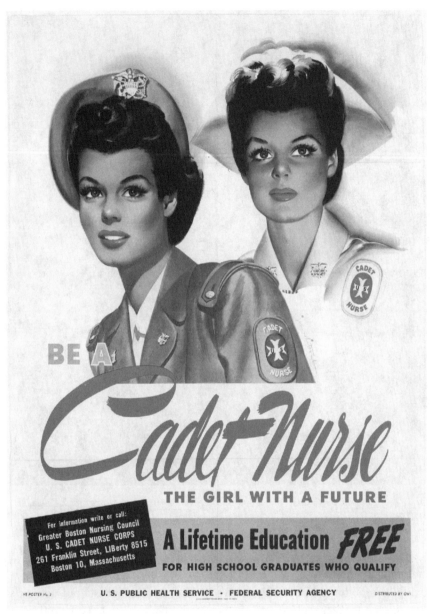

Figure E-1: Representing the cadet nurses with fashion-model style, white duty and "smart gray" winter uniforms. Source: John Whitcomb, "Be A Cadet Nurse, The Girl With A Future," National Archives and Records Administration Record Group 44: Records of the Office of Government Reports, 1932–1947, 44-PA-2567.

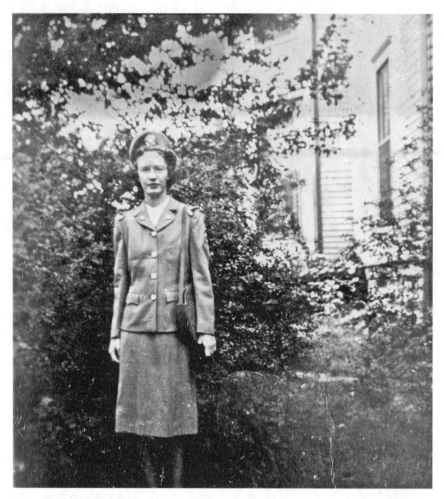

Figure E-2: The "real deal": Cadet Nurse Virginia L. Johnson (Brenner), October 1943, Columbia, Missouri. (Photo courtesy of Cynthia and Cathleen Brenner.)

under dark, mascara-heavy eyelashes. She stands, dignified, in the foreground, embodying virtuous women's service, as two high-school-age girls carrying books stare admiringly at her in the background. The caption at the top of the card reads, "You too can be a LESBIAN."[9]

In World War II, since images of women deliberately used text or other features of the cartoon to demasculinize their subjects or render that masculinity permissible, this reinterpretation of the cadet nurse image is doubly subversive. It deliberately calls on the woman's masculinity to make

Figure E-3: Reframing the cadet nurse image, circa 2004. Source: *"Talk Bubbles," NobleWorks, Hoboken, New Jersey.*

its joke, especially since female masculinity and lesbianism were so highly conflated during the war. The poster of the Wac in uniform labeled "Good Soldier," for instance, both enlarges the definition of "soldier" and renders her masculinity part of her wartime service and contributions.[10] Thus her masculinity is necessary for victory, but neatly terminates at war's end. In this modern interpretation of the cadet nurse recruiting campaign, however, the message is even more multilayered: It openly acknowledges the uniformed woman's masculinity, interprets that masculinity as lesbianism in its text, and renders that lesbianism both admirable and desirable—a very "queered" interpretation.

Wonder Woman's "masculine" qualities have been a subject of contention since her inception. A 1941 creation, she persisted after the war along with Superman and Batman. Her series was one of the only superhero comics to be published continuously during the 1950s, bridging the Golden and Silver ages of comics.[11] Wonder Woman has also appeared in a myriad of incarnations: She now has to her credit not only her own comic book series (produced by multiple writer and artist teams), but also a television movie, a television series, a "posing doll," and all manner of Wonder Woman merchandise, from roller skates to Pez dispensers. In 1999, Mattel introduced a Wonder Woman "Barbie"; there have been other Barbie releases since then, and all are collectors' items. She is also featured on a telephone, where her plastic legs straddle the keypad, and in yet another take on her character, her feet light up in a novelty pen. She even showed up in 1975 as a Wilton cake pan set (which was packaged with a plastic Wonder Woman face).[12] She has recently appeared as a "First Appearance" action figure licensed by D.C. Comics; in this she is wearing her original outfit, including a billowy blue star-spangled skirt, a red strapless top with an eagle breast-plate, and high-heeled red boots.[13] From her inception, Wonder Woman has had commercial draw because she represents a feminist vision of women's qualities, including physical strength, intelligence, beauty, and autonomy, all equal to her male counterparts.

The feminist movement adopted Wonder Woman early on: She appeared on the very first issue of *Ms.* magazine in July 1972. On the cover, a gigantic Wonder Woman in her original costume defies gunfire, armored tanks, and aircraft while striding over a tiny city at war. Behind her a billboard reads, "Peace and Justice in '72," and a banner above her head reads, "WONDER WOMAN FOR PRESIDENT." The old comic book character was being revived as a mascot for the magazine; what's more, she was plainly also

being invoked as the symbol for the women's liberation movement.[14] Inside the issue, along with various feminism-themed articles, was a two-page essay on sexism in Wonder Woman comic-book plotlines. It angrily noted the superheroine's submissiveness and loss of power in recent issues.

Ms. continued its campaign to paint Wonder Woman as emblematic of feminism with the publication of a book entitled *Wonder Woman*, a collection of classic Wonder Woman comic book stories. Most of these were written by the creator of the character, William Moulton Marston. They embodied, Gloria Steinem wrote in the introduction to the book, "the relief, the sweet vengeance, the toe-wriggling pleasure of reading about a woman who was strong, beautiful, courageous, and a fighter for social justice." This volume undeniably brought Wonder Woman a new measure of fame and respectability, offering "a story selection that was politically correct," and used her strength, beauty, and power to motivate the instructive feminist narratives that Steinem endorsed.[15]

Obviously, the idea must have worked, because in the mid-1970s, a poster of the cartoon heroine appeared as part of the women's health movement. The cartoon that the health movement used, which originally appeared in the July 1973 issue of *Sister: The Newspaper of the Los Angeles Women's Center*, shows Wonder Woman brandishing a gynecological instrument (an emblem of self-examination) at a man with a stethoscope in his jacket pocket and a button labeled "AMA," a symbol of the male-dominated medical establishment. Behind her are male representatives of Planned Parenthood and the "pro-life" movement (including a man with a rosary and large crucifix) and books entitled *Law* and *Freud*. As she lashes the instrument like a weapon, Wonder Woman trumpets, "WITH MY SPECULUM, I AM STRONG! I CAN FIGHT!" (emphasis in original).[16] This Wonder Woman is confronting the taboo of women's bodies, encouraging learning, and ending women's reliance on a predominantly male medical profession. The poster reclaims for women a character who had frequently been used to perpetuate traditional behavioral gender norms despite her masculine qualities.[17]

Wonder Woman was not the only World War II image of womanhood to be reclaimed for a more modern purpose. Rosie the Riveter, perhaps the most reclaimed World War II image of a woman, was brought into the 2004 presidential election when a nonprofit political action committee encouraging women to vote sent out a flyer. On one side was a full-page reproduction of Rosie's famous face. On the other, five women (a white executive, an Asian American baker, an African American waitress, an Asian American

surgeon, and a Latina businesswoman) stand superimposed over another, lighter reproduction of the same image of Rosie.[18] The flyer's creators seem quite aware of the racial politics inherent in a presidential election. Taken together, these diverse women, with the image of Rosie in the background, are posited as Everywoman, Rosie somehow uniting them with her "We Can Do It!" attitude.

The image of Rosie the Riveter is frequently used for political campaigns. In the 2008 presidential election, Hillary Clinton used it on a refrigerator magnet, but with a graphic art image of Clinton's smiling face under a red headscarf, with the original polka-dots turned into white stars. The American flag forms a border at the top of the magnet, and superimposed over the flag are the words, "She Can Do It!" Below the image, on a blue border, small white letters spell out "HILLARY FOR PRESIDENT 2008" (see Figure E–4). Another use of the image, on a large lapel button, celebrates another political achievement: Here, a photograph of Nancy Pelosi's face is Photoshopped onto Rosie's iconic image. Over the flexed arm, the text reads, "A Woman's Place is in the House . . . As Speaker!" Under the image, the text spells out, "Nancy Pelosi / January 4, 2007 / First Woman Speaker of the House."[19] Barack Obama evoked the image of Rosie the Riveter in his presidential campaign, and multiple refrigerator magnets and T-shirts sprang up to celebrate his potential and his achievements (demonstrating that even men want to draw on Rosie's strength and symbolism).[20] Unrelated to any particular campaign, but still evoking political sentiments, there are T-shirts and buttons on which the classic Rosie the Riveter flexes her bicep, while a text bubble asserts, "Chicks Kick Ass!"

Advertisers have often used Rosie's image as well. In a Tampax ad, for example, tattooed on Rosie's bicep, just below her rolled sleeve, is an important historical message: "TAMPAX WAS THERE."[21] Tampax was, in fact, invented in 1936, just in time to be of great use in World War II, when women's more physically demanding and less home-centered lives made tampons eminently practical. Probably for this reason, the product also carried the caché of promoting and enabling women's freedom.[22] Rosie, with her qualities of strength and independence, may have been perceived in World War II as masculine, in a positive wartime way, but she is revealed in the Tampax ad as a representative of this most female of biological processes. Rosie's iconically muscular arm becomes the billboard for the product, with Tampax triumphantly (and literally) tattooing itself onto her longevity. Her mix of gendered characteristics becomes the canvas for this product of "feminine" hygiene.

Figure E-4: Rosie's politicized postwar incarnations. Source: *Author's personal collection; "Chicks Kick Ass!"* © *1999, Ephemera, Inc.*

Figure E-5: Everything's coming up Rosie. Source: *Seattle Museum of Flight Gift Shop. (Photo courtesy of Cynthia L. Brenner, August 19, 2010.)*

It may be impossible to catalog and explain all of the ways the image of Rosie the Riveter is used today. It has been commercially exploited or employed by every possible source, from a house-cleaning service to (male) garage mechanics to historical parks and museums. Museums related in any way to women's work in World War II often have a large supply of items emblazoned with her likeness on display and in the gift shop (see Figure E–5). Reproductions not only of Rosie but of many other World War II women occur so frequently, however, that one thing is clear: It would be impossible to sort out a single meaning of their application. Powerful images of masculine women are everywhere now, used by all, for many different kinds of agendas.[23]

The many uses and reuses of Rosie and numerous other images raise the question: How does a society simultaneously empower and disempower women? The answer has to be that it shows them images that tell them they must *assume* "masculine" characteristics, but with these strictures: Those masculine characteristics must have a definite expiration date (i.e., the end of a war); women must maintain femininity, such that the amount of masculinity a woman is able to exhibit is implicitly regulated; women may not be too masculine or be masculine for too long; and at the end of their masculine tenure, they must exhibit at least *some* return to precrisis or constructed postcrisis femininity, surrendering almost entirely their "men's" jobs, clothing, behavior, and expressions.

Of course, it is illogical to expect that the masculine qualities that sustained women, and the country, for a period of several years would disappear entirely or with no lasting effect. The masculine qualities were there to some extent before the war, and they would recur after it as well. But the powerful ideology of domesticity was imprinted on everyday life after the war, and ironically, traditional gender roles became a central feature of the postwar, "modern," middle-class home.[24]

The fact remains that women at that time were actively encouraged to masculinize their gender expressions in pursuit of their country's larger goals. War posters, cartoons and comics, and advertisements plainly demonstrate and document that encouragement. What the images also reveal is the uncomfortable stripping process that occurred as women's masculinity, and thus their wartime advances, were generally replaced with idealized constructions of what and how women should be. Under the radar of most public perception, popular graphic art gracefully, subtly, and often humorously made its case, recording for future generations not only what women had accomplished, but also the fact that they were *capable* of accomplishing these things. What this art also exposes are the ways in which female masculinity was the linchpin of these changes.

NOTES

Introduction. "A Queer Mixture of Feelings"

1. Advertisement for the Women's Army Auxiliary Corps (later the Women's Army Corps), dated March 28, 1943, *Life*, April 3, 1943.

2. The interchangeability of "queer" with "odd" has in modern times been reclaimed by lesbian, gay, bisexual, transgender, and other groups. They interpret "queer" as synonymous with those terms. One author defined it as "a quality related to any expression that can be marked as contra-, non-, or anti-straight," with "straight" connoting heterosexuality, heteronormativity, or conventionality. See Alexander Doty, *Making Things Perfectly Queer: Interpreting Mass Culture* (Minneapolis: University of Minnesota Press, 1993), xv.

3. "Queer" was used informally in the (punitive) classification of lesbians and gay men as homosexual, particularly prior to military discharge. See Allan Bérubé, *Coming Out under Fire: The History of Gay Men and Women in World War Two* (New York: Free Press, 1990). Bérubé refers to "queer stockades" and "queer brigs," where "during outbreaks of antigay witch hunts and purges, suspected homosexuals were locked up [together], sometimes for months" (213). It is important to note that there is no apparent evidence that any such practice existed for lesbians, possibly because of the relatively small numbers of (1) women who served, and (2) those who were discharged for lesbianism or "homosexual practices."

4. See Monika Franzen and Nancy Ethiel, *Make Way! 200 Years of American Women in Cartoons* (Chicago: Chicago Review Press, 1988).

5. This work adheres to Leisa D. Meyer's use of the terms "WAC" and "WAAC." She noted that the WAAC existed from May 1942 to September 1943, when it was replaced by the Women's Army Corps (WAC). The acronym WAC is thus used in this work "to refer to the organization and Wac ('ac' lowercase) to refer to an individual or individuals within the corps." "Corps" and "women's corps" are used "interchangeably with WAC." See Leisa D. Meyer, *Creating G.I. Jane: Sexuality and Power in the Women's Army Corps during World War Two* (New York: Columbia University Press, 1996), Prologue, notes. I have also used WAAC when appropriate and sometimes WA(A)C when referring to both.

6. Bérubé, *Coming Out under Fire*, 29.

7. Susan M. Hartmann, *The Home Front and Beyond: American Women in the 1940s* (Boston: Twayne, 1982), 16, 18–19.

8. Laura Hapke, *Daughters of the Great Depression: Women, Work, and Fiction in the American 1930s* (Athens: University of Georgia Press, 1995), 16.

9. Hartmann, *Home Front and Beyond*, 18–19.

10. Elaine Tyler May, *Homeward Bound: American Families in the Cold War Era* (New York: Basic Books, 1988), 47–48, 50.

11. Ibid., 50–51.

12. Margot Canaday, *The Straight State: Sexuality and Citizenship in Twentieth-Century America* (Princeton, NJ: Princeton University Press, 2009), 95.

13. "Unemployment Statistics during the Great Depression," n.d., U-S-History.com, Online Highways, www.u-s-history.com/pages/h1528.html.

14. Canaday, *Straight State*, 96.

15. Hartmann, *Home Front and Beyond*, 20.

16. Ibid., 21.

17. Maureen Honey, *Creating Rosie the Riveter: Class, Gender and Propaganda during World War II* (Amherst: University of Massachusetts Press, 1984), 19.

18. Hartmann, *Home Front and Beyond*, 21.

19. "Resources: Historical Frequently Asked Questions," n.d., Women In Military Service For America Memorial Foundation, www.womensmemorial.org/H&C/Resources /hfaq.html.

20. "World War I: Women and the War," n.d., Women in Military Service for America Memorial Foundation, www.womensmemorial.org/H&C/History/wwi%28war%29 .html.

21. Judith A. Bellafaire, "The Women's Army Corps: A Commemoration of World War II Service," n.d., CMH Publication 72-15, U.S. Army, Center of Military History, www.history.army.mil/brochures/wac/wac.htm.

22. "World War II era WAVES: Overview and Special Image Selection," n.d., Naval History and Heritage Command, www.history.navy.mil/photos/prs-tpic/females/ wave-ww2.htm.

23. "Coast Guard History—SPARS," n.d., Coast Guard Compass, Official Blog of the U.S. Coast Guard, http://coastguard.dodlive.mil/index.php/2009/08/coast-guard -history-spars/.

24. "Women Marines in World War II," n.d., United States Marine Corps, History Division, www.tecom.usmc.mil/HD/Frequently_Requested/Marines%20in%20 WWII%20Sheets/Women.htm. Numbers mentioned for women's service in World War II vary. Women in Military Service for America uses 400,000 (no source is cited); Maj. Gen. Jeanne Holm, USAF (Ret.), uses 350,000. Jeanne Holm, *Women in the Military: An Unfinished Revolution*, rev. ed. (Novato, CA: Presidio Press, 1992), 100.

25. Holm, *Women in the Military*, 98.

26. Elizabeth M. Norman, *We Band of Angels: The Untold Story of American Nurses Trapped on Bataan by the Japanese* (New York: Simon and Schuster, 1999), xii.

27. Evelyn M. Monahan and Rosemary Neidel-Greenlee, *And If I Perish: Frontline U.S. Army Nurses in World War II* (New York: Anchor Books, 2003), 6.

28. Susan H. Godson, *Serving Proudly: A History of Women in the U.S. Navy* (Annapolis: Naval Institute Press, 2001), 134–136.

29. Holm, *Women in the Military*, 50. Holm herself joined the army in World War II, so she was speaking from experience. She later left the WAC and joined the newly minted U.S. Air Force, eventually becoming the first female major general in any of the services.

30. Meyer, *Creating G.I. Jane*, 149.

31. Hartmann, *The Home Front and Beyond*, 31.

32. Holm, *Women in the Military*, 51–52.

33. Meyer, *Creating G.I. Jane*, 2.

34. Karen Anderson, *Wartime Women: Sex Roles, Family Relations, and the Status of Women during World War II* (Westport, CT: Greenwood Press, 1981), 3, 60.

35. *Collier's*, October 19, 1940, 38.

36. Quoted in George H. Roeder Jr., *The Censored War: American Visual Experience during World War Two* (New Haven, CT: Yale University Press, 1993), 43.

37. Paul Fussell, "Foreword," in Diana Trilling, *Reviewing the Forties* (New York: Harcourt Brace Jovanovich, 1978), vii.

38. Sources for this work include thousands of images from the National Archives and Records Administration, the Library of Congress, the United States Army Women's Museum, and the Wisconsin Historical Society, among others. The National Archives located in College Park, Maryland, has the full collection of Office of War Information (OWI) records. The Library of Congress Prints and Photographs division, along with its many images, includes original artwork both of OWI artists and of Pulitzer Prize–winner Bill Mauldin. The Wisconsin Historical Society provides a nearly complete collection of military camp newspapers on microfilm, and the United States Army Women's Museum in Fort Lee, Virginia, contains not only files on Humor and Cartoons but also a moving connection to the reality of life as a Wac in World War II. This interesting collection of original WAC uniforms includes, rather startlingly, examples of WAC underwear. See Bibliography for more information on collections cited.

39. Honey, *Creating Rosie the Riveter*, 13, 37–38, 214.

40. "The New Yorker: Ross's Little Magazine, 1925–1951," n.d., BBC, www.bbc.co.uk/dna/h2g2/alabaster/A21723121.

41. Roger Angell, "Uniform Bliss," *New Yorker*, November 12, 2001.

42. After some wrangling, "the US government acknowledged that *The New Yorker* was as necessary for civilised [*sic*] life as *Time* and *Newsweek* and allowed them to print an ad-free 'pony edition' for the troops, which by the end of the War had higher circulation than *The New Yorker* itself." "The New Yorker: Ross's Little Magazine."

43. Fussell, "Foreword," vii–viii.

44. Academic Dictionaries and Encyclopedias, "Collier's Weekly," http://en.academic.ru/dic.nsf/enwiki/228194. Wikipedia, admittedly a questionable source, also lists a figure of 2.5 million during the war and 2.846 million in 1946, but sources are not cited. Circulation figures are difficult to obtain, as the magazine went defunct in 1957 and rights have changed hands several times since. See Wikipedia, "Collier's Weekly," http://en.wikipedia.org/wiki/Collier%27s_Weekly.

45. Guy Gilpatric, "The Queen of Tijuana," *Collier's*, December 21, 1940.

46. Racism was also common. "The Queen of Tijuana" perpetuated old, ugly stereotypes of Latinos.

47. When such photographs did appear, it was under Roosevelt's "strategy of truth." The purpose was usually to increase war production. See Roeder, *The Censored War*, 36.

48. Bill Watterson, *The Calvin and Hobbes Tenth Anniversary Book* (Kansas City, MO: Andrews and McMeel, 1995), 14.

49. For more on this topic, see Amy Kyste Nyberg, *Seal of Approval: The History of the Comics Code* (Jackson: University Press of Mississippi, 1998).

50. Hartmann, *Home Front and Beyond*, 189–190.

51. Watterson, *Calvin and Hobbes*, 7.

52. Bill Mauldin, *Up Front* (New York: Henry Holt, 1945), 4, 7, 21.

53. Roeder, *The Censored War*, 119.

54. "V-mail," or Victory mail, was used to deal with the enormous amount of correspondence going overseas because transport space was limited. As one source put it, "letters, written on specially designed 8½ by 11-inch stationery, were photographed, and the film was shipped in canisters overseas. The developed film was then distributed to the troops as a letter in the form of a 4 by 5½-inch photograph. V-Mail made it possible to transform letters with a bulk weight of 2,500 pounds into film weighing only forty-five pounds." Judy Barrett Litoff and David C. Smith, *We're In This War, Too: World War II Letters from American Women in Uniform* (New York: Oxford University Press, 1994), 126, n.5.

55. *The Patriotic Tide: 1940–1950* (Alexandria, VA: Time-Life Books, 1969), 190.

56. Don Herold, "The Battle on the Home Front," Foreword, in *It's a Funny World: Cartoons from Collier's* (New York: Robert McBride, 1942), 29.

57. Angell, "Uniform Bliss," 93.

58. Hartmann, *Home Front and Beyond*, 190.

59. William L. Bird Jr. and Harry R. Rubenstein, *Design for Victory: World War II Posters on the American Home Front* (New York: Princeton Architectural Press, 1998), 1.

60. Ibid., 1–2, 87.

61. Judith Halberstam, *Female Masculinity* (Durham, NC: Duke University Press, 1998), 2, 8.

62. Ibid., 53.

63. John W. Jeffries, *Wartime America: The World War II Home Front* (Chicago: Ivan R. Dee, 1996), 8, 9.

64. Ibid., book jacket.

65. Honey, *Creating Rosie the Riveter*, 2.

66. When I questioned my mother and her companion about whether they had read comic books as children in the 1930s and 1940s, the response from both was a very strong negative: "We had better things to do!"

67. Honey, *Creating Rosie the Riveter*, 11.

68. Roeder, *The Censored War*, 141.

69. Marione R. Derrickson, ed., *Laugh It Off: Cartoons from the Saturday Evening Post* (New York: Whittlesey House, 1944), n.p.

Chapter One. From Bathing Suits to Parachutes, or, "Don't Call Me Mac!"

1. Jay N. ("Ding") Darling, *Des Moines Register and Tribune*, 1943, in Monika Franzen and Nancy Ethiel, *Make Way! 200 Years of American Women in Cartoons* (Chicago: Chicago Review Press, 1988), 131. This cartoon also appears in the collection *Ding's Half Century*, by Jay N. Darling, edited by John M. Henry (New York: Duell, Sloan & Pearce, 1962).

2. See Robert Westbrook, "'I Want a Girl, Just Like the Girl Who Married Harry James': American Women and the Problem of Political Obligation in World War II," *American Quarterly* 42, no. 4 (1990): 590.

3. For more on women in the workforce in World War II in their own words, see Sherna Berger Gluck, *Rosie the Riveter Revisited: Women, the War, and Social Change* (New York: Meridian/Penguin, 1987).

4. Karen Anderson, *Wartime Women: Sex Roles, Family Relations, and the Status of Women during World War II* (Westport, CT: Greenwood Press, 1981), 3.

5. Anna Eleanor Roosevelt, *It's Up to the Women* (New York: Frederick A. Stokes, 1933), vii–ix, 64. Roosevelt also included a week's worth of Depression-era menus in the book. It is replete with economizing repasts such as "Hot Stuffed Eggs with Tomato Sauce," "Creamed Spaghetti with Carrots," and "Prune Pudding."

6. Ibid., 145.

7. The cartoon is by Robert J. Day, 1933, and was originally published in *The New Yorker*. It later appeared in "Cartoons of the Century," *Newsweek*, December 20, 1999, 60. See also *The New Yorker's* collection of cartoons at Cartoonbank.com. Eleanor's work as First Lady was legendary; a pamphlet from the Eleanor Roosevelt National Historic Site claims that "Eleanor toured the country extensively, observing poverty-stricken rural areas, city slums, prisons, and even the inside of coal mines" (pamphlet, "First Lady of the World," U.S. National Park Service, U.S. Department of the Interior, GPO 2009-224/80349).

8. Roosevelt, *It's Up to the Women*, ix.

9. For more on women in the military during World War II in their own words, see Judy Barrett Littoff and David C. Smith, *We're in This War, Too: WWII Letters from American Women in Uniform* (New York: Oxford University Press, 1994). Wacs were the only female service members allowed to go overseas, and many served in the European, Pacific, and China-Burma-India theaters of operation.

10. For more about the notion of men fighting for women, see Westbrook, "'I Want a Girl.'"

11. Mattie E. Treadwell, *The Women's Army Corps* (Washington, DC: Office of the Chief of Military History, U.S. Department of the Army, 1954), 206. Read also Chapter 11 for a full history of the slander campaign.

12. Nelson Lichtenstein, Susan Strasser, and Roy Rosenzweig, *Who Built America? Working People and the Nation's Economy, Politics, Culture and Society*, Stephen Brier, executive editor, vol. 2, American Social History Project (New York: Bedford/St. Martin's, 2000), 510.

13. Ibid., 510.

14. R. Taylor (for OWI), National Archives and Records Administration, College Park, Maryland (NARA hereafter), Records of the Office of War Information (OWI), Record Group 208, 1926–1951 (bulk 1942–1945) (RG 208 hereafter), Records of the Bureau of Graphics, E-219, Box 1.

15. [Saul] Steinberg, *New Yorker*, December 4, 1943, 30.

16. Gregory D'Alessio, "These Women!" (feature), "Humor/Cartoons" Folder, United States Army Women's Museum, Fort Lee, Virginia.

17. Evelyn M. Monahan and Rosemary Neidel-Greenlee, *A Few Good Women: America's Military Women from World War I to the Wars in Iraq and Afghanistan* (New York: Alfred A. Knopf, 2010), 132.

18. Maj. Gen. Jeanne Holm, *Women in the Military: An Unfinished Revolution*, rev. ed. (Novato, CA: Presidio Press, 1992), 72.

19. "Scope and Content," NARA, RG 208.

20. "Foreward [*sic*]: The Purpose of the Domestic Branch of the Office of War Information," NARA, Records of the Domestic Operations Branch, RG 208, NC-148, E-215, Box 1063.

21. "The Information Program Operation," NARA, RG 208, NC-148, E-215, Box 1063.

22. NARA, RG 208, NC-148, E-90, "Women in the War Presentation" Folder.

23. "WOMANPOWER/ 1 minute spot announcements/FOR LOCAL STATIONS/

#4," by the J. Walter Thompson Company (advertising company), NARA, RG 208, NC-148, E-90, "Women in the War Presentation" Folder.

24. Ibid.

25. See Gluck, *Rosie the Riveter Revisited*, especially the story of Juanita Loveless, p. 135, for how women were sometimes offered several jobs a day.

26. Bureau of Publications and Graphics, "Office Chief and Section Descriptions and Functions," NARA, Records of the Domestic Operations Branch, RG 208, Box 4, Entry 6-A, "OWI History—General" Folder.

27. Quoted in William L. Bird Jr. and Harry R. Rubenstein, *Design for Victory: World War II Posters on the American Home Front* (New York: Princeton Architectural Press, 1998), 11.

28. George H. Roeder, *The Censored War: American Visual Experience during World War Two* (New Haven, CT: Yale University Press, 1993), 82.

29. NARA, RG 208, NC-148, E-218, Box 1066, "Graphics Letter 1943" Folder.

30. *Graphics Artists' Newsletter*, September 29, 1943, NARA, RG 208, NC-148, E-218, Box 1066, "Graphics Letter—1943" Folder.

31. NARA, RG 208, NC-148, E-218, Box 1066, "Graphics Letter—1943" Folder.

32. "Graphic Possibilities," no recorded author, NARA, Records of the Bureau of Graphics, V-742, RG 208, E-219, Box 1.

33. Henry Boltinoff (for OWI), dated "7/14," NARA, V-628, RG 208, NC-148, E-218, Box 1.

34. NARA, RG 208, NC-148, E-218, Box 1066, "Graphics Letter—1943" Folder.

35. Jefferson Machamer (?) "+ OWI," NARA, Records of the Bureau of Graphics, RG 208, E-219, Box 1. A "certificate of availability" was given by management to an individual who left a company's labor force—essentially dictating whether or not that individual was free to work again. Carl J. Schneider and Dorothy Schneider, *Eyewitness History: World War II* (New York: Facts on File, 2003), 61.

36. Henry Boltinoff, ASMC (for OWI), NARA, Records of the Bureau of Graphics, RG 208, E-219, Box 1. ASMC stands for American Society of Magazine Cartoonists.

37. Machamer, "+ OWI."

38. Letter, September 15, 1943, NARA, RG 208, NC-148, E-218, Box 1066, "Graphics Letter—1943" Folder.

39. Susan M. Hartmann, *The Home Front and Beyond: American Women in the 1940s* (Boston: Twayne, 1982), 23.

40. Letter, September 1, 1943, NARA, RG 208, NC-148, E-218, Box 1066, "Graphics Letter—1943" Folder.

41. Leila Rupp, quoted in Maureen Honey, *Creating Rosie the Riveter: Class, Gender and Propaganda during World War II* (Amherst: University of Massachusetts Press, 1984), 114.

42. A—R—— [signature illegible] (for OWI), *News Copy from OWI*, NARA, RG 208, M-92.

43. "Christmas Gift for Him," advertisement, Cole of California, *New Yorker*, December 11, 1943, 87.

44. Ford [first name illegible], POS WWII, US, J49, J71, 1944, Library of Congress, Prints and Photographs Division.

45. For a much more in-depth discussion of pin-ups, see Maria Elena Buszek, *Pin-Up Grrrls: Feminism, Sexuality, Popular Culture* (Durham, NC: Duke University Press, 2006).

46. Coakley (for OWI), NARA, Records of the Bureau of Graphics, RG 208, E-219, Box 1.

47. [Artist's name illegible] (for OWI), NARA, Records of the Bureau of Graphics, RG 208, E-219, Box 1.

48. Letter, September 15, 1943, NARA, RG 208, NC-148, E-218, Box 1066, "Graphics Letter—1943" Folder.

49. Printing Requisition for U.S. Employment Service Pamphlet, *The More Women at War the Sooner We'll Win*, June 8, 1944. The pamphlet printing requisition was canceled on September 1, 1944, "because of the rapidly changing needs for women war workers and a discontinuance of War Manpower Commission to recruit women workers nationally." NARA, RG 208, NC-148, E-90, "Women in the War" Folder.

50. *Graphics Artists' Newsletter*, August 25, 1943, NARA, RG 208, NC-148, E-218, Box 1066, "Graphics Letter—1943" Folder.

51. Ibid. The letter further cites a Bureau of the Census survey showing "that of five million persons who were not employed but were willing to take a full-time job, more than a million were women over 45 years of age."

52. Honey also noted, "This was an especially big step for women because the work on display was traditionally defined as appropriate for men, requiring, as it did, physical strength, technological expertise, ease in handling tools, or male cooperation. Apart from the nearly total exclusion of non-white Americans, there is an egalitarian thrust to wartime images in terms of class and gender." Maureen Honey, "Remembering Rosie: Advertising Images of Women in World War II," in *The Home-Front War: World War II and American Society*, edited by Kenneth Paul O'Brien and Lynn Hudson Parsons (Westport, CT: Greenwood Press, 1995), 83.

53. Colin Allen, ASMC (for OWI), Slide series 197-WP, NARA.

54. Honey, "Remembering Rosie," 83.

55. In another relevant discussion on working women, Melissa Dubakis examined Norman Rockwell's "Rosie the Riveter," observing that the image "was a new construction, a mythic regime, which attempted to control and direct the changing possibilities that the home front presented to women. It formed part of a discourse, a constellation of beliefs, images, and representations . . . [which] sought to shape [women's] experience. Women responded quite diversely to such mythic constructions . . . according to the intersecting axes of class, ethnicity, marital status, and number of children." Melissa Dubakis, "Gendered Labor: Norman Rockwell's *Rosie the Riveter* and the Discourses of Wartime Womanhood," in *Gender and American History since 1890*, edited by Barbara Melosh (New York: Routledge, 1993), 182.

56. Cover, *New Yorker*, September 4, 1943.

57. Bo Brown (for OWI), NARA, RG 208, NC-148, E-218, Box 1.

58. Notably, a preponderance of sources cite numbers of working- and middle-class women who took war-related work, but few, if any, address how many upper-class women did so. As Dubakis noted, "In posters and advertisements . . . white middle-class women served always as the norm." Dubakis, "Gendered Labor."

59. Chas. Strauss (for OWI), NARA, Records of the Bureau of Graphics, RG 208, E-219, Box 1. The forty-eight-hour week (eight hours a day, six days a week) was the wartime standard.

60. NARA, RG 208, NC-148, E-218, Box 1066, "Graphics Letter—1943" Folder.

61. Pat Dwyer (for OWI), NARA, Records of the Bureau of Graphics, RG 208, E-219, Box 1.

62. The definition of "mannish," according to *Webster's Encyclopedic Unabridged Dictionary of the English Language* (New York: Portland House, 1989).

63. Advertisement, Cole of California, *New Yorker*, February 12, 1944, 13.

64. "Priscilla" (for OWI), NARA, RG 208, NC-148, E-218, Box 1.

65. Gregory D'Alessio (for OWI), 1943, NARA, Records of the Bureau of Graphics, RG 208, E-219, Box 1.

66. Henry Boltinoff, ASMC (for OWI), NARA, RG 208, NC-148, E-218, Box 1.

67. Bob Barnes (for OWI), Records of the Graphics Unit—Cartoons, RG 208, E-219, Box #2 (original in the Caroline and Erwin Swann Collection of Cartoon and Caricature, Library of Congress, Division of Prints and Photographs, Washington, D.C.).

68. All of the cartoons cited in this section were gathered from OWI records at the NARA, RG 208. Many have been collected and hand-glued by OWI employees into a large, now yellowed, scrapbook.

69. Grundy (for OWI), Slide series 179-WP, NARA.

70. Sam Norkin (for OWI), Slide series 179-WP, NARA.

71. Garrett Price (for OWI), "V-128, 8/31," NARA, Records of the Bureau of Graphics, RG 208, E-219, Box 1. "Dingbat" was a term used as "thingamabob" or "whatsis" might have been.

72. Bo Brown (for OWI), NARA, Records of the Bureau of Graphics, RG 208, E-219, Box 1.

73. Otto Soglow (for OWI), NARA, Records of the Bureau of Graphics, RG 208, E-219, Box 1, no. v-190–1016.

74. "C.A." [Colin Allen] (for OWI), NARA, Records of the Bureau of Graphics, RG 208, E-219, Box 1.

75. Whitney Darrow Jr., *New Yorker*, January 15, 1944, 22.

76. "Minje" (for OWI), *News Copy from OWI*, August 3, 1944, NARA, RG 208, M-68.

77. "Christmas Gift for Him," advertisement, Cole of California, *New Yorker*, December 11, 1943, 87.

Chapter Two. "America Will Be as Strong as Her Women"

1. Quoted in Susan Hartmann, *The Home Front and Beyond: American Women in the 1940s* (Boston: Twayne, 1982), 199.

2. "War, Women and Lipstick," Tangee Lipstick advertisement, courtesy of Texas Woman's University collection of the Women Airforce Service Pilots (WASP). The pilot in the ad is not dressed in WASP uniform; she was probably a member of one of the two organizations merged to create the WASP: the Women's Flying Training Detachment (WFTD) or the Women's Auxiliary Ferrying Squadron (WAFS). The publication source of the ad is unknown, but the ad almost certainly ran in popular women's magazines of the day.

3. Penny Summerfield and Nicole Crockett, "'You Weren't Taught That with the Welding': Lessons in Sexuality in the Second World War," *Women's History Review* 1, no. 3 (1992): 437.

4. Beth L. Bailey, *From Front Porch to Back Seat: Courtship in Twentieth-Century America* (Baltimore: Johns Hopkins University Press, 1989), 97–98. The chapter is entitled "The Etiquette of Masculinity and Femininity."

5. Howard Chandler Christy, "I Wish I Were a Man," NARA, *Posters and Facsimiles* (hereafter "NARA poster catalog"), no. 6014.

6. "Feminine Patriotism," NARA poster catalog, no. 6005.

7. "Right Shoulder Arms" is a command from the U.S. military's "Manual of Arms."

8. Laura Behling, *The Masculine Woman in America, 1890–1935* (Urbana: University of Illinois Press, 2001), 2.

9. "Suffragists on the Warpath," Callan's Sketchblog, http://callanmolinari.blogspot.com/2009/08/well-done-sister-suffragettes.html.

10. "Election Day!" c. 1909, Library of Congress Prints and Photographs Division, http://memory.loc.gov/cgi-bin/query/D?suffrg:1:./temp/~ammem_xG02.

11. Bailey, *From Front Porch to Back Seat*, 114.

12. "Performance of gender" is Judith Butler's concept from *Gender Trouble: Feminism and the Subversion of Identity* (New York: Routledge, 1990). It essentially says that we learn to perform our genders—that they are not as fixed as previously suspected; in other words, "masculine" and "feminine" are qualities that are behavioral, rather than essential.

13. Hartmann, *The Home Front and Beyond*, 163.

14. Private Barney Tobey (for OWI), *Copy from OWI*, NARA, RG 208.

15. Bo Brown (for OWI), NARA, Records of the Bureau of Graphics, RG 208, E-219, Box 1.

16. George Clark, "The Neighbors," February 22, 1942, News Syndicate.

17. Maureen Honey, *Creating Rosie the Riveter: Class, Gender and Propaganda during World War II* (Amherst: University of Massachusetts Press, 1984), 110.

18. Amy Bentley, *Eating for Victory: Food Rationing and the Politics of Domesticity* (Urbana: University of Illinois Press, 1998), 5.

19. Bailey, *From Front Porch to Back Seat*, 114.

20. Slide 179-WP-1510, NARA (published by the Joint Labor Management Committee of Goodyear Aircraft Corporation).

21. Slides 179-WP-1486 ("Jewelry Is Dangerous"), 1487 ("Wear Headdress Properly"), and 1493 ("Antics of Axey Dent the Cartlin . . . Wear a Head Covering for Your Own Safety"), NARA.

22. Nancy Baker Wise and Christy Wise, *A Mouthful of Rivets: Women at Work in World War II* (San Francisco: Jossey-Bass, 1994), 139.

23. Slides 179-WP-1510 and WP-1429, NARA.

24. Honey, *Creating Rosie the Riveter*, 78.

25. Melissa Dubakis, "Gendered Labor: Norman Rockwell's *Rosie the Riveter* and the Discourses of Wartime Womanhood," in *Gender and American History since 1890*, edited by Barbara Melosh (New York: Routledge, 1993), 193.

26. "Dunkel," uncaptioned welding mask cartoon from OWI, NARA, RG 208, from slides of cartoons. "It's hard to be beautiful" and "The WAAC's reveille" are both from the "Humor/Cartoons" Folder, United States Army Women's Museum, Fort Lee, Virginia.

27. Pallas Athene was the official WAC goddess. Insignia for enlisted women had her likeness on a brass disk; the officers' insignia was a cut-out of her helmeted head and shoulders.

28. Cover from *Nifty: Gags—Cartoons—Humor*, January (no year), "Humor/Cartoons" Folder, United States Army Women's Museum, Fort Lee, Virginia. This mask,

with a protuberant "nose," on which the Wac is applying lipstick, is inaccurate. Most gas masks of the time are depicted with a rubber hose of perhaps a foot or more leading to a purification/filtration system on the wearer's chest or slung over her or his shoulder.

29. C. A. [Colin Allen], ASMC (for OWI), Slide series 179-WP, NARA.

30. Peter Arno, *Peter Arno's* Man in the Shower (New York: Simon & Schuster, 1944), n.p.

31. Leisa D. Meyer, *Creating G.I. Jane: Sexuality and Power in the Women's Army Corps during World War Two* (New York: Columbia University Press, 1996), 3, 6, 11; "Marching to Victory," songbook of the U.S. Navy WAVES (Northampton, MA: Naval Reserve Midshipmen's School, Women's Reserve, 1943); Slide 44-PA-433, NARA. The WAAC's system of rank was different from the later WAC's. The lowest rank in the WAAC was known as an "Auxiliary." The WAC used standard army rank.

32. Slide series 44-PA-259-F, NARA.

33. "Make a date with Uncle Sam . . . ," Slide series 44-PA-222, NARA.

34. Meyer, *Creating G.I. Jane*, 3. Meyer drew upon the work of George Chauncey, among others, in discussing homosexuality as "inappropriate" gender manifestation, saying that although "Chauncey argued in early articles that the issue of sexual object choice came to dominate over gender inversion as a primary criterion for diagnosing a woman as homosexual, it is clear that the mannish woman continued as the popular lesbian archetype for most people" (p. 243, n. 9).

35. Emily Yellin, *Our Mothers' War: American Women at Home and at the Front during World War II* (New York: Free Press, 2004), 326. Yellin used the term "perversion" in her chapter "The 'Wrong Kind' of Woman," under the subheading "Homosexuals and Sex Maniacs."

36. Mattie E. Treadwell, *The Women's Army Corps* (Washington, DC: Office of the Chief of Military History, U.S. Department of the Army, 1954), 624.

37. Honey, *Creating Rosie the Riveter*, 113.

38. The services at that time included the U.S. Army, U.S. Navy, U.S. Coast Guard, and U.S. Marine Corps. The U.S. Air Force was not created until 1947, and the Air Corps and then the Air Forces were still part of the U.S. Army at that time.

39. "For your country's sake today . . . ," Slide series 44-PA-820, NARA.

40. "The WAC/Women's Army Corps," recruiting poster, Slide 44-PA-235, NARA.

41. Going overseas was a privilege given only to Wacs, and even then usually only to white Wacs. An exception to this was the (Negro) 6888th Central Postal Directory Battalion sent to the ETO in 1944. According to the psychiatric study quoted in Treadwell, *Women's Army Corps*, "those who wished to share war's sufferings with the men were termed 'masochists'" (p. 624).

42. Meyer, *Creating G.I. Jane*, 25.

43. Internal government information, NARA, RG 208, NC-148, E-90, Box 588, "WAVES" Folder.

44. "Webster + Ensign M.E.W. of the WAVES," in "Life's Darkest Moment," *New York Tribune*, 1943 (day and month not available). From the Mary Margaret Schisler Salm Collection, Institute on World War II and the Human Experience, Florida State University, Tallahassee, Florida.

45. "Good Soldier," Slide 44-PA-254, NARA.

46. Advertisement for the Women's Army Auxiliary Corps [later WAC], dated March 28, 1943, *Life*, April 3, 1943.

47. "Priscilla" (for OWI), Slide series 179-WP, NARA.

48. Sherna Berger Gluck, *Rosie the Riveter Revisited: Women, the War, and Social Change* (New York: Meridian/Penguin, 1987), 12. This attitude was mirrored in the lack of acceptance — and a surplus of hostility — accorded to women in the service. See Chapter Three for discussion of rumor campaigns conducted against servicewomen as behavior modification. See also Meyer, *Creating G.I. Jane*, and Summerfield and Crockett, "'You Weren't Taught That.'"

49. Wise and Wise, *A Mouthful of Rivets*, 105.

50. Color film copy transparency, Library of Congress Reproduction Number LC-USZC4–5603, Library of Congress, Prints and Photographs Division, Washington, D.C.

51. Richard Dickson (for OWI), n.d., NARA.

52. "Hercules Powder Co.," Slide 179-WP-1566, NARA. The poster is "signed" "Sophie S. Jablonski, Apprentice Machinist."

53. NARA, RG 208.

54. William L. O'Neill, *World War II: A Student Companion* (New York: Oxford University Press, 1999), 359.

55. Bentley, *Eating for Victory*, 2.

56. Report of the Women's Advisory Committee, War Manpower Commission, March 1944, RG 208, NC-148, E-90, "Women in the War" Folder 2.

57. Colin Allen (for OWI), NARA, Records of the Bureau of Graphics, V-148–9/5, RG 208, E-219, Box 1.

58. James Gibson (for OWI), NARA, Records of the Bureau of Graphics, RG 208, E-219, Box 1.

59. Yellin, *Our Mothers' War*, 102–103; Robert Westbrook, "'I Want a Girl, Just Like the Girl Who Married Harry James': American Women and the Problem of Political Obligation in World War II," *American Quarterly* 42, no. 4 (1990).

60. Postcard, no author, n.d., n.p., Mary Margaret Schisler Salm Collection, Institute on World War II and the Human Experience, Florida State University, Tallahassee, Florida.

61. Clyde Lewis, "Private Buck," April 13, 1943, King Features Syndicate.

62. Report of the Women's Advisory Committee, 3.

63. Garrett Price (for OWI), NARA, Records of the Bureau of Graphics, RG 208, E-219, Box 1.

64. "Cpl Newcombe, Armored Force, Ft. Knox, KY" (for OWI), NARA, RG 208, NC-148, E-218, Box 1.

65. *The Columbia Documentary History of American Women since 1941*, edited by Harriet Sigerman (New York: Columbia University Press, 2007).

66. "Alain," *New Yorker*, bound volume of issues from August 21 to October 31, 1943.

67. Author illegible, n.d., "Humor/Cartoons" Folder, United States Army Women's Museum, Fort Lee, Virginia. A "deuce-and-a-half" (usually pronounced "deuce-and-half" or "deuceanhalf") is a two-and-a-half-ton truck.

68. Will Johnson (for OWI), NARA, RG 208, E-219, Box 1.

69. "Stamams" [?], NARA, Records of the Bureau of Graphics, V-714, RG 208, E-219, Box 1.

70. George Clark, "The Neighbors," 1942, News Syndicate.

71. Wise and Wise, *Mouthful of Rivets*, 44.

72. "You Are Going to a Strange Country," *Male Call*, September 2, 1945. Translated (with apologies for inaccuracies): "Yessir, you'da thought the Commanding General wrote most of the Army Regulations himself! He had us all pissed off most of the time.... Well, this day he stuck us out ahead of our operational perimeter and the mission operational support went blooie! We had every soldier [G.I.] on a Browning Automatic Rifle or Model One Garand rifle.... The entire Table of Organization from the commanding officer to the lowest Private First Class got a Purple Heart, thanks to that one loose cannon!" An "88" was a German artillery gun, much loathed and feared by Allied troops. See also Bill Mauldin's *Up Front* (New York: Henry Holt, 1945). An "8-ball" was a crazy person, and that characterization could apply here; a person discharged for mental instability was processed under "Section 8," which could also apply.

73. "Strange Country."

74. "It's a Tradition with Us, Mister!" Slide 179-WP-1564, NARA. This poster is labeled "War Production Coordinating Committee." It bears the "Westinghouse" logo at the bottom.

75. "At the battle of Monmouth in 1778, Molly 'Pitcher' (so-named because she brought pitchers of water to soldiers on the field) became the second known woman to man a gun when her husband fell in battle. For her heroic role, GEN Washington awarded her a warrant as a noncommissioned officer," according to the Women in Military Service for America Memorial website, www.womensmemorial.org/H&C/History/earlyyears%28amrev%29.html.

76. "It's Our Fight Too!" Slide 179-WP-1565, NARA.

77. Household fats were used in the manufacture of glycerin (as in nitroglycerin) for explosives; civilians were encouraged to save it and sell it to their butchers at four cents a pound. This image is labeled "Post Apr. 11 to May 1," but does not include the year it was distributed. The poster may well have come out fairly early in the war, as women's participation in the workforce was generally well accepted even barely a year into the war. For more information, see Honey, *Creating Rosie the Riveter*, 111. Honey catalogued a number of advertisements by major manufacturers, such as Eureka's proclamation, "You're a Good Soldier, Mrs. America" (January 9, 1943), and Arvin Manufacturing's declaration that "women are doing their part to help win the war . . . working shoulder to shoulder with men" (June 5, 1943).

78. Phyllis McGinley, poem accompanying cartoon by "Leo" (for OWI), NARA, V-413, Records of the Bureau of Graphics, RG 208, E-219, Box 1.

79. "Soldiers without Guns," Slide 44-PA-229, NARA.

80. "It's a Tradition with Us, Mister!" Slide 179-WP-1564, NARA.

81. "It's Our Fight Too!" Slide 179-WP-1565, NARA.

82. "'For the Love of _____ HURRY!': He Needs Our Best—*Now*. The INLAND [Company] Way for U.S.A.," Slide 179-WP-1052, NARA. The image shows an American soldier in combat, looking anxiously over the shoulder of a woman assembling the rifle he so urgently needs.

83. "It's a Tradition with Us, Mister!" Slide 179-WP-1564, NARA

84. "More Nurses Are Needed," Slide 44-PA-205, NARA. In this advertisement for the U.S. Army Nurse Corps, an exhausted nurse in fatigues and a helmet wipes her brow and slumps against a field-expedient blood plasma stand (an inverted rifle with fixed bayonet stuck into the ground so that the bottle of plasma may be hung on it). Her right hand wipes sweat from her brow, while her left reaches in supplication into

the text area, toward the reader. In red below the picture is written, "*More* nurses are needed!" and in smaller letters below that, "All women can help . . ."

85. Slide 44-PA-205, NARA. See also Leisa D. Meyer's discussion of Wacs in combat, and their training for, but lack of permission to use, firearms (which meant they could not receive combat pay, regardless of the conditions under which they served). Meyer, *Creating G.I. Jane*, 89.

86. Oddly, this was not the case with women of other Allied nations. The OWI ran a cartoonlike feature called "United Nations Facts," in the style of "Ripley's Believe It or Not," that routinely featured brief stories and small drawings on this topic. For example, it reported on "Czechoslovak women fighters" and two "Soviet Russian Girl Pilots," "Girl Heroes" who had shot down eleven German planes between them. NARA, RG 208, NC-148, E-218, Box 1.

87. Slide 179-WP-1569, NARA.

88. "Drawn for Philco by Sammy McKim," Slide 179-WP-1017, NARA.

89. Bailey, *From Front Porch to Back Seat*, 114.

90. Tom Brokaw, *The Greatest Generation* (New York: Random House, 1998), 331.

91. U.S. National Park Service, Manzanar National Historic Site web page, www.nps .gov/manz/index.htm. Although attitudes were slowly — very slowly — evolving toward African Americans, I do not wish to indicate that African Americans, nor, indeed, members of any nonwhite or even non-Christian group, were met without considerable and often insidious prejudice, particularly in terms of official policies of segregation, in World War II. Charity Adams Earley's memoir *One Woman's Army*, by the commander of the only African American WAC company sent overseas during the war, includes several excellent examples. Charity Adams Earley, *One Woman's Army: A Black Officer Remembers the WAC* (College Station: Texas A&M University Press, 1989). Further, people commonly called all Asians "Japs," and many Japanese Americans (even those not interned) and non-Japanese Asians suffered discrimination during the war.

92. Gluck, *Rosie the Riveter Revisited*, 10. The posters that addressed this topic were often surprisingly direct, taking the American public to task for gender, racial, and/ or religious discrimination. Posters often addressed issues directly. One pictures two people of color, their "shaded" faces under the omnipresent welding masks, which are tipped up. "OUR MANPOWER," the text blares in large black capitals. It continues, "1/5 of our strength must not be lost through discrimination." "OWI Posters — Released (Photos)," NARA, Records of the Domestic Operations Branch, RG 208, Box 4, Entry 6-A. The poster then notes, in still smaller letters under the previous lines of text, the statistics that inform the cited fraction: "12,900,000 Negroes, 4,800,000 Jews, 11,400,000 Foreign born." Sexism often fared little better. As President Roosevelt declared in a Columbus Day speech in 1942, "in some communities employers dislike to hire women. In others they are reluctant to hire Negroes. We can no longer afford to indulge such prejudice." Michael S. Sherry, *In the Shadow of War: The United States since the 1930s* (New Haven, CT: Yale University Press, 1995), 74.

Chapter Three. "Does Your Sergeant Know You're Out?"

1. From *B.B.C.* [Bermuda Base Command] *News*, June 26, 1943, vol. 2, no. 25, 6. The verse is preceded by the note, "Originating from the A.E.F. in Africa, this short piece has floated around far and wide, finally hitting the B.B.C. News."

2. Melissa A. McEuen, *Making War, Making Women: Femininity and Duty on the American Home Front, 1941–1945* (Athens: University of Georgia Press, 2011), 203.

3. Beth Bailey, personal communication, August 15, 2005.

4. Beth Bailey, personal communication, April 12, 2011.

5. Maureen Honey, *Creating Rosie the Riveter: Class, Gender and Propaganda during World War II* (Amherst: University of Massachusetts Press, 1984), 114.

6. "Thrill That Comes Once in a Lifetime," *New York Tribune.* Author signature illegible. Handwritten at the top is "Aug 29th 1942." From "Humor/Cartoons" Folder, United States Army Women's Museum, Fort Lee, Virginia.

7. Leisa D. Meyer, *Creating G.I. Jane: Sexuality and Power in the Women's Army Corps during World War Two* (New York: Columbia University Press, 1996), 50.

8. Major General Orlando Ward, chief of military history, "Foreword," in Mattie E. Treadwell, *The Women's Army Corps* (Washington, DC: Office of the Chief of Military History, U.S. Department of the Army, 1954).

9. "The WAC Officer: A Guide to Successful Leadership," War Department Pamphlet No. 35-2, February 1945 (Washington, DC: U.S. Government Printing Office, 1944), 50.

10. Ethel A. Starbird, *When Women First Wore Army Shoes: A First-Person Account of Service as a Member of the Women's Army Corps during WWII* (Bloomington, IN: iUniverse, 2010), 65.

11. "The WAC Officer," 50. It is not clear whether the phrase "sex conduct" is used as current scholars might use the term "gender role."

12. Treadwell, *Women's Army Corps*, 204–205.

13. For a far more detailed description and analysis of the slander campaign against the WAC, see Treadwell, *Women's Army Corps*, Chapter 11, entitled "The Slander Campaign," and Leisa Meyer, *Creating G.I. Jane*, Chapter 2, entitled "Ain't Misbehavin'? The Slander Campaign against the WAC."

14. Mindy Pomper, *Free a Man to Fight! Women Soldiers of World War II* (film), Two Girls From Back East Productions, 1999; Cadet Nurse Corps Recruiting Poster, NARA, RG 208.

15. Treadwell, *Women's Army Corps*, 166.

16. However, it seemed there was such a thing as being *too* womanly, and that went for women in the other Allied countries as well. The standardization of military garb aside, there were official worries in the British Auxiliary Territorial Service (ATS—the women's army branch, equivalent to the American WAC) that a military "uniform could be worn in such a way as to make women too glamorous and alluring, in other words too feminine." The initial official wartime response to what has been referred to as "the slatternly image of the ATS" (an image paralleled in the United States with the slander campaign against the WAC) was to try to "smarten up" the uniform. The reaction then was also negative, even prompting "protests in parliament" that the new uniform would inspire women in the service to pick up men or even encourage women to join the British Army for this purpose. In the United Kingdom as well as in the United States, the issue was whether women's uniforms were too "masculine" or too "feminine." For if a woman was not feminine enough, it was thought that she might be using the uniform to express masculinity—or, equally undesirable, that she was one of the "unnatural" lesbians populating the women's branches of the service.

17. In response to multiple complaints that Wacs/Waacs were misbehaving, investigators acting at Col. Hobby's request discovered that civilian women were able to purchase "WAAC uniforms, or close copies of the uniform ... [at] department stores around the country." Evelyn M. Monahan and Rosemary Neidel-Greenlee, *A Few Good Women: America's Military Women from World War I to the Wars in Iraq and Afghanistan* (New York: Alfred A. Knopf, 2010), 107. It seems intuitive that if material were available enough in color, quality, and amount to sell to civilian sources, that material should equally have been available to the army, which theoretically had priority.

18. Mary Margaret Salm, personal communication via e-mail, July 31, 2004. For full details of Col. Hobby's difficulties in obtaining uniforms of sufficient number, quality, style, and fit for the WAC, see Treadwell, *Women's Army Corps*, Chapter 9, "Stresses of Rapid Build-Up: Supply and the WAAC Uniform."

19. Charity Adams Earley, *One Woman's Army: A Black Officer Remembers the WAC* (College Station: Texas A&M University Press, 1989), 27–30.

20. Starbird, *When Women First Wore Army Shoes*, 10.

21. *It's a Funny World: Cartoons from Collier's* (New York: Robert McBride, 1942), 36.

22. Treadwell, *Women's Army Corps*, 38.

23. Quartermaster Supply Catalog, Wacs' and Nurses' Clothing and Equipment List, United States Army Women's Museum, Fort Lee, Virginia.

24. Mary Margaret Salm, personal communication via e-mail, August 10, 2004.

25. Earley, *One Woman's Army*, 38.

26. Treadwell, *Women's Army Corps*, 195.

27. O. L. Dudley, "Camp Wallace, Tex," in Treadwell, *Women's Army Corps*, 196.

28. Carole Landis, "Foreword," in Corporal Vic Herman, *Winnie the Wac: The Return of a World War II Favorite,* new enlarged ed., edited by Virginia Herman (Carlsbad, CA: T. G. Graphics, 2002), no page.

29. Herman, *Winnie the Wac*, no page.

30. Jeanne Holm, *Women in the Military: An Unfinished Revolution*, rev. ed. (Novato, CA: Presidio Press, 1992), 51.

31. *It's a Funny World*, 23.

32. Sam Brier, *Judge*, December 1942, 1207 (United States Army Women's Museum, Fort Lee, Virginia).

33. Herman, *Winnie the Wac*, no page.

34. Barney Tobey, no publication information, n.p., n.d., from "Humor/Cartoons" Folder, United States Army Women's Museum, Fort Lee, Virginia.

35. Eveready batteries advertisement, on display at the United States Army Women's Museum, Fort Lee, Virginia.

36. The cartoon is by George Wolfe, King Features Syndicate, 1944, "Humor/Cartoons" Folder, United States Army Women's Museum, Fort Lee, Virginia.

37. Herman, *Winnie the Wac*, no page.

38. Irwin Rea, in *Laugh Parade: A Collection of the Funniest Cartoons of the Day* (New York: Grosset and Dunlap, 1945), no page.

39. Jo Fischer(?), in "Laff-a-Day," cartoon feature, King Features Syndicate, 1942, "Humor/Cartoons" Folder, United States Army Women's Museum, Fort Lee, Virginia.

40. Chon Day, from the collection of Mary Margaret Schisler Salm, Institute on World War II and the Human Experience, Florida State University. The "weather bow"

is defined as "on or at the side or part towards the wind; windward; to expose or be exposed to the action of the weather," or, one supposes, in this case, to scrutiny from the street or sidewalk (Dictionary.reference.com, http://dictionary.reference.com/browse/weather?fromAsk=true&o=100074).

41. Quartermaster Supply Catalog, Wacs' and Nurses' Clothing and Equipment List, United States Army Women's Museum, Fort Lee, Virginia.

42. Treadwell, *Women's Army Corps*, 38–39. The women themselves had to ask for window shades in their barracks and not infrequently had to deter would-be suitors and/or molesters.

43. Lieutenant David Breger, *"G.I. Joe" ("Private Breger"): From the Pages of Yank and Stars and Stripes* (Garden City, NY: Blue Ribbon Books, 1945). The cartoon is from a series on the Articles of War; the cartoon is for Article 82, which deals with "any person who in time of war shall be found lurking . . . about any . . . quarters . . ."

44. Treadwell, *Women's Army Corps*, 38.

45. Meyer, *Creating G.I. Jane*, 155.

46. Wac (name withheld by request), personal interview, March 17, 2003, Fort Lee, Virginia. The informant told me that the pants, of herringbone twill, were sufficiently sturdy in material and manufacture that she owned and used them for many years after she left the service.

47. Meyer, *Creating G.I. Jane*, 155.

48. On Wacs obtaining trousers from British tailors, see "WAC & WAAC World War II Uniforms," Olive-Drab, www.olive-drab.com/od_soldiers_clothing_combat_ww2_waac.php. On trousers in the ETO, see Meyer, *Creating G.I. Jane*, 155.

49. Starbird, *When Women First Wore Army Shoes*, 12.

50. Meyer, *Creating G.I. Jane*, 155. Advice given to British servicewomen in women's magazines sternly reiterated American concerns about masculinization: "Don't go all out for hair cropped like an escaped convict, nails clipped to nothing and a ploughman's stride," said one piece. A doctor, Edith Summerskill (one of the few wartime women Members of Parliament and a credible equivalent to U.S. Congresswoman Edith Nourse Rogers, who introduced the WAAC creation bill), provided a response to worries over unfeminine uniformed women: "One Eton crop combined with a long stride," she railed, provided opponents "with a case from which to generalize [that] . . . a uniform, however severely cut," could somehow influence inherent, biological femininity. Penny Summerfield and Nicole Crockett, "'You Weren't Taught That with the Welding': Lessons in Sexuality in the Second World War," *Women's History Review* 1, no. 3 (1992): 437.

51. Treadwell, *Women's Army Corps*, 140.

52. Ibid., 197. The intelligence director found instead that the huge influx of Waacs into the town "at such times as they are free, particularly Saturday and Sunday . . . causes some amount of inconvenience."

53. Summerfield and Crockett, "'You Weren't Taught That with the Welding,'" 437.

54. Treadwell, *Women's Army Corps*, 447.

55. This applied to other services, but only the WAC was subject to a smear campaign. See Treadwell, *Women's Army Corps*, Chapter 11, "The Slander Campaign," and Meyer, *Creating G.I. Jane*, Chapter 2, "Ain't Misbehavin'."

56. *It's a Funny World*, 5.

57. Starbird, *When Women First Wore Army Shoes*, 65. Starbird also sardonically noted, "To those of us still around when charges of sexual harassment at Aberdeen Proving Grounds hit the headlines in 1996, this was very old news."

58. Treadwell, *Women's Army Corps*, 608, 615. The monthly genital exam in men was known by the highly descriptive nickname "the pecker check" (or "short arm inspection"), and the medical officer who performed this function was identified, of course, as "the pecker checker." Urban Dictionary online, www.urbandictionary.com/define .php?term=pecker-checker. It is unknown whether there were equally graphic terms used by the women for their examinations.

59. Treadwell, *Women's Army Corps*, 608.

60. "Dogface" was a term used by G.I.s to describe themselves, especially if they were infantry troops.

61. Sergeant Leonard Sansone, "The Wolf," 1945, United Publishers, New York, no page.

62. Breger, n.p. The cartoon is from a series on the Articles of War; the cartoon is for Article 67, dealing with "Any . . . soldier who, being present at any mutiny . . . does not use his utmost endeavor to suppress the same . . ."

63. E. Simms Campbell, *More Cuties in Arms* (Philadelphia: David McKay, 1943), no page.

64. Treadwell, *Women's Army Corps*, 445.

65. Ibid., 625.

66. *Male Call* (bound book of all strips) (Princeton, WI: Kitchen Sink Press, 1987), no page, strip dated "1944." The strip was never published or even inked in, and in fact has a circled "NO" handwritten above it. See also Meyer, *Creating G.I. Jane*, 154.

67. Meyer, *Creating G.I. Jane*, 154.

68. Admittedly, Miss Lace is in a negligee, which would indeed suggest a sexual encounter.

69. I am indebted to Randy Carol Goguen (formerly Balano) for bringing the article to my attention. Personal communication, November 2008.

70. Herman, *Winnie the Wac*, no page.

71. Campbell, *More Cuties in Arms*, no page.

72. "The WAC Officer," 50.

73. Ibid., 50–51.

74. Ibid., 51.

75. Ibid., 54.

76. Ibid., 54.

77. Emily Yellin, *Our Mothers' War: American Women at Home and at the Front during World War II* (New York: Free Press, 2004), 326.

78. "The WAC Officer," 55.

79. Karl Menninger was the older brother of Dr. William Menninger, who was director of the Psychiatry Consultants division of the Surgeon General's Office during World War II, and cofounder with William and their father of the Menninger (psychiatric) Clinic in Topeka, Kansas. "Menninger Family Archives," Kansas Historical Society, www.kshs.org/p/menninger-family-archives/13786#william.

80. Howard J. Faulkner and Virginia D. Pruitt, *Dear Dr. Menninger: Women's Voices from the Thirties* (Columbia: University of Missouri Press, 1997), 11.

81. Ibid., 19.

82. Ibid., 19–20.

83. Ibid.

84. Herman, *Winnie the Wac*, no page.

85. *It's a Funny World*, no page.

86. "Spaar," in "Laff-a-Day," comic feature, King Features Syndicate, 1942, from scrapbooks of Mrs. Warren Resh, kept at the Wisconsin Historical Society.

87. "They're Either Too Young or Too Old," sung by Kitty Kallen with Jimmy Dorsey and His Orchestra, music by Arthur Shertzinger, lyrics by Frank Loesser, recording date 1943, WB Music Corporation.

88. "Kit" E. Leggett, "USS La Porte (APA-151) / Manila, P.I. to Los Angeles, U.S.A. / A salute to the Army and Navy officers and crew for the consideration and courtesy extended to the Enlisted Women of this shipment," "Humor/Cartoons" Folder, United States Army Women's Museum, Fort Lee, Virginia.

89. Howard Baer, *Collier's*, n.d., "Humor/Cartoons" Folder, United States Army Women's Museum, Fort Lee, Virginia.

90. See Paul Fussell, *Wartime: Understanding and Behavior in the Second World War* (New York: Oxford University Press, 1989), Chapter 8, "Drinking Far Too Much, Copulating Too Little."

91. *Life*, April 12, 1943, 83.

92. *Yank: The Army Weekly*, September 5, 1943, 23.

93. Treadwell, *Women's Army Corps*, 421.

94. Ibid.

95. There were African American nurses in the army in World War II. Trained at Fort Huachuca, Arizona, they were permitted to nurse only African American G.I.s or German POWs, which many of them bitterly resented. See Michael C.C. Adams, *The Best War Ever: America and World War II* (Baltimore: Johns Hopkins University Press, 1994), concerning the "Double-V" campaign for "Victory at home (against racism and segregation) and abroad (against fascism)."

96. *Yank: The Army Weekly* was entirely produced by and directed to enlisted men, not officers.

97. *Yank: The Army Weekly*, September 5, 1943, 3.

98. Adams, *Best War Ever*, 128.

99. Campbell, *More Cuties in Arms*, no page.

100. Adams, *Best War Ever*, 124–125.

101. Allan M. Brandt, *No Magic Bullet: A Social History of Venereal Disease in the United States since 1880* (New York: Oxford University Press, 1987), 163.

102. Ibid., 164.

103. "There's No Medicine for Regret," Slide 44-PA-293, NARA.

104. "VD Bulletin No. 95," n.d., Federal Security Agency, United States Public Health Service, Washington, D.C.

105. "Play Safe/Beat V.D.," pamphlet, n.d., Louisiana Venereal Disease Control Program, in Cooperation with the United States Public Health Service, NARA, RG 208, Box 5, E-84, "V.D. Pamphlets" Folder. The pamphlet, small enough perhaps to be included in a condom packet, details in pictures how to roll up a condom for wear, how to apply and remove the condom, and what "parts" (of the wearer's body) it protects and does not protect. Interestingly, the removal of the condom calls for turning it inside out, thus probably reflecting the then-current attention to contact with possibly syphilitic

and/or gonorrheal material on the outside of the condom. This is opposed, of course, to the post-AIDS era, when the greater concern would be HIV-infected semen released by an inverted condom.

106. Brandt, *No Magic Bullet*, 163.

107. Sergeant George Baker, *The New Sad Sack* (New York: Simon & Schuster, 1946), no page. "Sad Sack," thus named for his ill-fitting uniform and lack of spit and polish, was army slang for "rotten soldier." It was used roughly in the same way as the terms "G.I." and "dogface"—as in "a sad sack of shit."

108. Ibid., no page. The strip is entitled "Dream" (read "wet dream"). Immediately after sex, men "were supposed to go posthaste to the prophylaxis stations set up by the Army and Navy. . . . Inside the stations, they were asked to urinate, wash 'exposed parts,' 'instill colloidal silver solution into the anterior urethra,' and apply ointment to 'all exposed parts.'" Beth Bailey and David Farber: *The First Strange Place: The Alchemy of Race and Sex in World War II Hawaii* (New York: Free Press, 1992), 106. Hundreds of these "pro" stations were established in all theaters of operation during the war. Brandt, *No Magic Bullet*, 164.

109. "Sneaky and the Professor," NARA, Records of the Domestic Operations Branch, RG 208, Box 4, E-6A, "OWI Posters—Released (Photos)." This painfully realistic description of the disease and ways to prevent it seems at odds with the cartoon method of delivery, but the example speaks credibly to the accessibility of the cartoon form. While servicemen were given or sold books at much reduced cost, many, for reasons of education, age, or humor, still clung to the comic as their main source of reading material. Sad Sack stars in another cartoon where he is pressured into going to live entertainment, but resorts instead to reading comic books.

110. "Sneaky and the Professor."

111. "Off to a Good Start," Pamphlet 16–32247–1 (Washington, DC: Government Printing Office, n.d. [1930s]).

112. *Male Call*, 9.

113. Ibid.

114. Bill Mauldin, "Foreword," *Male Call*, 6, 7.

115. *Male Call*, 11.

116. Ibid.

117. The homoeroticism of a man writing sexual material for other men is not discussed in the collection.

118. *Male Call*, 12.

119. "Solid Sender," February 14, 1943, in *Male Call*, 28.

120. "I Dream of Genii," January 30, 1944, in *Male Call*, 53.

121. "R.H.I.P. (Rank Hinders Impromptu Propositions)," February 13, 1944, in *Male Call*, 54. Most of Caniff's titles are themselves gags or puns of some kind and provide additional entertainment. The term "R.H.I.P.," in military parlance, stands for "Rank Has [or Hath] Its Privileges," a nice way of saying that officers, or anybody whose rank is greater than yours, generally have a better life than you do.

122. "Charge without Reconnaissance," June 18, 1944, in *Male Call*, 63.

123. "Support for Exposed Flank," February 20, 1944, in *Male Call*, 55; there are other examples.

124. Strip dated April 22, 1945, in *Male Call*, 85. "The MM-M-M One" is a take-off on the name of the Model One (M1) Garand Rifle.

Chapter Four. "Now, Let's See Your Pass," or, Wonder Woman and the "Giant Women Army Officers"

1. *Wonder Woman*, November 1944, no. 35, J. R. Publishing, NARA, RG 208, Box 1, E-84, "Back to School Campaign Reports" Folder.

2. Some modern critics have observed parallels between the two, observing that Wonder Woman has "the Rosie the Riveter arms, the long skirt . . . that entire picture is basically distillated [*sic*] 'CAN DO!'" "Wonder Woman's Costume Change," June 30, 2010, ComicsAlliance Roundtable, www.comicsalliance.com/2010/06/30/review-won der-woman-costume-change/#ixzz1GXGP2bM4. It bears noting, however, that Wonder Woman first appeared in December 1941, while Rosie the Riveter was not created until 1942, by Westinghouse artist J. Howard Miller. "Rosie the Riveter: Real Women Workers in World War II," transcript of video presentation by Sheridan Harvey, Library of Congress, July 20, 2010, www.loc.gov./rr/program/journey/rosie-transcript.html.

3. Maureen Honey, *Creating Rosie the Riveter: Class, Gender and Propaganda during World War II* (Amherst: University of Massachusetts Press, 1984), 15.

4. Leisa D. Meyer, *Creating G.I. Jane: Sexuality and Power in the Women's Army Corps during World War Two* (New York: Columbia University Press, 1996), 27.

5. [Lawrence] Lariar (for OWI), NARA, Records of the Bureau of Graphics, RG 208, E-219, Box 2.

6. LeBaron Coakley (for OWI), NARA, Records of the Bureau of Graphics, RG 208, E-219, Box 1.

7. "Alain" (for OWI), Slide series 179-WP, NARA, V-229-11/3.

8. E. Simms Campbell, *More Cuties in Arms* (Philadelphia: David McKay, 1943), no page.

9. Barbara Shermund, "Humor/Cartoons" Folder, United States Army Women's Museum, Fort Lee, Virginia.

10. George Clark, "The Neighbors" (feature), 1942, News Syndicate, Wisconsin Historical Society, Madison.

11. Corporal Vic Herman, *Winnie the Wac: The Return of a World War II Favorite*, new enlarged ed., edited by Virginia Herman (Carlsbad, CA: T. G. Graphics, 2002), no page.

12. Ibid., no page.

13. "Phillip's—," n.p., n.d., "Humor/Cartoons" Folder, United States Army Women's Museum, Fort Lee, Virginia.

14. Gregory D'Alessio, *Collier's*, n.d., "Humor/Cartoons" Folder, United States Army Women's Museum, Fort Lee, Virginia, no page.

15. [Author illegible], *New Yorker*, October 9, 1943, 52.

16. Lillian Faderman, *Odd Girls and Twilight Lovers: A History of Lesbian Life in Twentieth-Century America* (New York: Penguin, 1991), 123.

17. Major Charity Adams (Earley), commander of the 6888th Central Postal Directory Battalion, the only African American WAC battalion to go overseas during the war, was in charge of "thirty-one officers and almost nine hundred enlisted women" when the battalion was stationed in the European Theater. Charity Adams Earley, *One Woman's Army: A Black Officer Remembers the WAC* (College Station: Texas A&M University Press, 1989), 144. Those under Colonel Oveta Culp Hobby's command in the WAC (the largest women's service) numbered 100,000 when the WAC was "at its peak strength."

Mattie E. Treadwell, *The Women's Army Corps* (Washington, DC: Office of the Chief of Military History, U.S. Department of the Army, 1954), xi.

18. Lieutenant Dave Breger, *"G.I. Joe" ("Private Breger"): From the Pages of Yank and Stars and Stripes* (Garden City, NY: Blue Ribbon Books, 1945), no page.

19. David Breger, *Private Breger's War: His Adventures in Britain and at the Front* (New York: Random House, 1944), no page.

20. Meyer, *Creating G.I. Jane*, 28.

21. Herman, *Winnie the Wac*, no page.

22. Mischa Richter, in *Funny Business: A New Collection of Cartoons from the* Saturday Evening Post, edited by Marione P. Derrickson and John Bailey (New York: Whittlesey House, McGraw-Hill, 1945), no page.

23. Lundberg, in *Best Cartoons of the Year, 1942*, edited by Lawrence Lariar (New York: Crown, 1942), no page.

24. "It Depends, It Depends," in *Yank: The Army Weekly*, August 22, 1943, 8.

25. Meyer, *Creating G.I. Jane*, 30. Also "Humor/Cartoons" Folder, United States Army Women's Museum, Fort Lee, Virginia.

26. Michael C. C. Adams, *The Best War Ever: America and World War II* (Baltimore: Johns Hopkins University Press, 1994), 85.

27. Breger, *"G.I. Joe,"* no page.

28. Ibid.

29. Adams, *Best War Ever*, 85.

30. Earley, *One Woman's Army*, 198–200. In fact, this behavior, particularly by a white male officer toward a black female one, was so unusual that Adams felt fairly suspicious of such obsequious actions and wondered what the young officer's ulterior motives might be. The situation was apparently so serious, however, that the black medical officer traveling with Adams's outfit was sent to examine the injured (white) man.

31. "SALO" [Salo Roth], in *Laugh It Off: Cartoons from the* Saturday Evening Post, edited by Marione R. Derrickson (New York: McGraw-Hill, 1944), no page.

32. "Strong-Armed WAVE K.O.'s Civilian Souse," in *B.B.C.* [Bermuda Base Command] *News* 3, no. 23, June 12, 1943, 6, Wisconsin Historical Society, Madison.

33. Milt Caniff, *Male Call* (Princeton, WI: Kitchen Sink Press, 1987), 38. The strip is dated June 27, 1943. Waacs were called "Auxiliaries" when the name of the Corps was still Women's Army Auxiliary Corps.

34. "The American Experience" page of the PBS website provides a timeline of events surrounding the "Zoot Suit Riots." See www.pbs.org/wgbh/amex/zoot/eng_timeline/index.html. According to the site, there was concern that "Mexican boy gangs" were growing as a result of wartime juvenile delinquency. Inflammatory newspaper coverage helped to spark race riots, including an incident in which as many as 500 servicemen and civilians attacked Mexican American young people as they exited a dance at a Los Angeles high school. The police arrested Mexican American youth "for their own protection."

35. Trina Robbins, *The Great Women Superheroes* (Northhampton, MA: Kitchen Sink Press, 1996), 3, 4, 6; Les Daniels, *The Life and Times of the Amazon Princess Wonder Woman: The Complete History* (San Francisco: Chronicle Books, 2000), 48, 52; Susan Hartmann, *The Home Front and Beyond: American Women in the 1940s* (Boston: Twayne, 1982), 190–191.

36. Faderman, *Odd Girls and Twilight Lovers*, 122.

37. William Moulton Marston, *The American Scholar*, 1943, quoted in Robbins, *Great Women Superheroes*, 7.

38. Robbins, *Great Women Superheroes*, 7.

39. In the first edition of *Wonder Woman*, she was described as having "the speed of Mercury and the strength of Hercules." Hartmann, *Home Front and Beyond*, 190. Apparently her powers were later upgraded.

40. The flowing short skirt became skin-tight shorts because evidently all those fabric folds were difficult to draw. The skirt—which some sources have claimed was a sort of skort, or "billowy" shorts, rather than an actual skirt—has taken some criticism from modern comic website editors, with the observation that Wonder Woman's skirt was "not very awe-inspiring," the reason being that it was "one poodle away from a sock hop." "Wonder Woman's Costume Change," ComicsAlliance Roundtable.

41. Maureen Leonard, personal communication, August 18, 2005.

42. Unfortunately, Trevor's crash and Wonder Woman's subsequent loyalty to him and the United States are also derided (good-naturedly) on comics websites as an example of American exceptionalism: "It always bugged me," one website editor wrote, "since she just pledged her allegiance to the first nation that dropped a dude on her island." "Wonder Woman's Costume Change," ComicsAlliance Roundtable.

43. Hartmann, *Home Front and Beyond*, 23.

44. Leonard, August 18, 2005.

45. Robbins, *Great Women Superheroes*, 7.

46. *Wonder Woman*, November 1944, no. 35, p. 1.

47. Hartmann, *Home Front and Beyond*, 191.

48. Robbins, *Great Women Superheroes*, 7.

49. *Wonder Woman*, November 1944, no. 35, 13.

50. Robbins, *Great Women Superheroes*, 7.

51. As Trina Robbins put it, "The mythic hero is usually born from the union of a virgin and a god, and when the virginal Amazon queen Hippolyta desires a child, the goddess Aphrodite instructs her to mold one out of clay, and then breathes life into the statue. Thus, Wonder Woman's divine parent is, in this case, a female deity, and little Diana has two mommies." Robbins, *Great Women Superheroes*, 7.

52. Ibid., 8, 12, 14.

53. *Wonder Woman*, November 1944, no. 35. The quotation is the opening epigraph to this chapter.

54. Ibid., no page.

55. Judith Butler, *Bodies That Matter: On the Discursive Limits of "Sex"* (New York: Routledge, 1993), "Introduction." Butler discussed "performativity" in this book and throughout much of her other work. The most notable use of that term was in regard to "the performance of gender," in which she essentially claimed that women and men learn to act out the supposedly inherent features of their femininity and masculinity—the ways we sit, talk, express ourselves, and so on.

56. Although the term "girl" was perfectly acceptable in wartime America to describe adult females, the use of the term here marks Atlanteans as childlike and even childish in their attempts to gain power.

57. Beth Bailey, personal communication, August 9, 2005.

58. For a complete discussion of bondage and storylines involving it, see Daniels, *Life and Times of the Amazon Princess*.

59. *Wonder Woman*, November 1944, no. 35.

60. John Cawelti, quoted in Honey, *Creating Rosie the Riveter*, 15.

61. May 8, 1940, cited on Greg Bjerg, "The Man Who Changed Comic Books Forever," March 26, 2006, Damn Interesting, www.damninteresting.com/the-man-who -changed-comic-books-forever.

62. See Amy Kiste Nyberg, *Seal of Approval: The History of the Comics Code* (Jackson: University Press of Mississippi, 1998).

63. Patricke Johns-Heine and Hans Gerth, in Honey, *Creating Rosie the Riveter*, 15.

Chapter Five. "Here's One Job You Men Won't Be Asking Back"

1. Benjamin J. Atlas, "What Future for the Servicewoman?" *Independent Woman*, May 1945, 128.

2. Agnes E. Meyer, "A Challenge to American Women," *Collier's*, May 11, 1946, 77.

3. "C.A." [Colin Allen] (for OWI), NARA, Records of the Bureau of Graphics, RG 208, E-219, Box 1.

4. Beth L. Bailey, *From Front Porch to Back Seat: Courtship in Twentieth-Century America* (Baltimore: Johns Hopkins University Press, 1989), 115.

5. Meyer, "A Challenge," 77.

6. Elaine Tyler May, *Homeward Bound: American Families in the Cold War Era* (New York: Basic Books, 1988), 77–78.

7. "Alain," "Men and Women Wanted," September 8, 1945, in *The Complete Cartoons of the New Yorker*, edited by Robert Mankoff, Foreword by David Remnick (New York: Black Dog & Leventhal, 2004) (*Complete Cartoons* hereafter).

8. Atlas, "What Future for the Servicewoman?" 128.

9. Hartmann, *The Home Front and Beyond: American Women in the 1940s* (Boston: Twayne, 1982), 25.

10. "Hello, Gang!" poster, 44-PA-949, NARA online, http://arcweb.archives.gov/ arc/.

11. *The Best Years of Our Lives*, from a novel by Mackinlay Kantor, directed by William Wyler, screenplay by Robert E. Sherwood, 1946, MGM Studios. Fred Derry is played by Dana Andrews; the sailor who has lost his hands is played by Harold Russell, who received two Oscars that year, one for Best Supporting Actor and one for being an inspiration to all returning veterans. He is the only actor to have received two Oscars for the same role. The third man, the banker-turned-sergeant-and-back-again, is played by Frederick March. Internet Movie Database, www.imdb.com/name/nm0751174/bio.

12. The flashback scene is one of the most subtly interesting and powerful in the film: Derry walks into a field where hundreds of junked aircraft are parked and pulls himself into the dusty hulk of a B-17, brushing away dirt from what would have been his bombardier's seat. The scene is entirely without words or sound effects (but backgrounded by rising music). The viewer watches him through the dirty, scratched Plexiglas as he obviously relives the experience he has been seeing in his nightmares. The foreman finds him still sitting in his old "workplace," with a haunted look on his face, sweating profusely.

13. Advertisement, Jacobs Aircraft Engine Company, Pottstown, Pennsylvania, in *Collier's*, October 20, 1945, 93.

14. Ibid.

15. Bailey, *From Front Porch to Back Seat*, 41.

16. Gregory D'Allessio, "Welcome Home!" *Collier's*, April 22, 1946.

17. May, *Homeward Bound*, 76.

18. Jeanne Holm, *Women in the Military: An Unfinished Revolution*, rev. ed. (Novato, CA: Presidio Press, 1992), 119–120. A "line officer" is an officer not in the Army Nurse Corps or Navy Nurse Corps; a "full colonel" is also known as a "bird colonel," a term referring to the eagle rank insignia — in other words, he or she is *not* a lieutenant colonel, who wears silver oak leaves.

19. May, *Homeward Bound*, 76.

20. Michael C.C. Adams, *The Best War Ever: America and World War II* (Baltimore: Johns Hopkins University Press, 1994), 11.

21. Jeff Keate, in *Collier's*, November 24, 1945.

22. Please see Chapter Two for a discussion of women *without* guns. See also Leisa D. Meyer, *Creating G.I. Jane: Sexuality and Power in the Women's Army Corps during World War Two* (New York: Columbia University Press, 1996), for more on women who served under combat conditions and their lack of combat pay.

23. Hartmann, *Home Front and Beyond*, 44.

24. WAC veteran, name withheld by request, personal interview, March 17, 2003, United States Army Women's Museum, Fort Lee, Virginia.

25. Mary Margaret Salm, personal communication via e-mail, January 1, 2006.

26. Sherna Berger Gluck, *Rosie the Riveter Revisited: Women, the War, and Social Change* (New York: Meridian/Penguin, 1987), 15.

27. Robert J. Day, August 18, 1945, in *Complete Cartoons*.

28. Hartmann, *Home Front and Beyond*, 44, 47.

29. Chon Day, "Complete Reconversion, $25," August 25, 1945, in *Complete Cartoons*.

30. Melissa A. McEuen, *Making War, Making Women: Femininity and Duty on the American Home Front, 1941–1945* (Athens: University of Georgia Press, 2011), 21. McEuen cited D'Ann Campbell's assertion that, "of all working women, nurses received the highest sociopolitical approval ratings in the United States"; they were "viewed as 'heroines,' achieving distinction while maintaining a feminine image."

31. Hartmann, *Home Front and Beyond*, 24.

32. Molly Merryman, *Clipped Wings: The Rise and Fall of the Women Airforce Service Pilots (WASPs) of World War II* (New York: New York University Press, 1998), 3, 20, 26. The anecdote that usually circulates relates that Colonel Paul Tibbets, who later piloted the *Enola Gay* to drop the atomic bomb on Hiroshima, was having difficulty locating male pilots to fly the large aircraft (all large, difficult-to-fly aircraft were known as "widow-makers"). The story goes that he trained WASPs to fly the B-29, then took the aircraft and its female pilots to bases around the country. At each stop, when WASPs exited the aircraft, male pilots seemed to change their minds about the effort and danger inherent in flying that plane.

33. Merryman, *Clipped Wings*, 3.

34. "WASP trainees wore [turbans] to keep their hair 'up,'" according to Wasp on the Web, a website focusing on WASP history. The site points out that the turbans "were also called 'Urban's Turbans' after an Avenger Field Base Commander." "WASP Glossary," n.d., Wings Across America, entry for "turbans,' www.wingsacrossamerica.us/wasp/resources/glossary.htm.

35. Merryman, *Clipped Wings*, 3, 4.

36. J. N. "Ding" Darling, "Add Post-War Adjustments," July 27, 1944, University of Iowa Libraries, Special Collections, http://digital.lib.uiowa.edu/cdm4/item_viewer .php?CISOROOT=/ding&CISOPTR=11475&CISOBOX=1&REC=9.

37. Merryman, *Clipped Wings*, 4.

38. Lieutenant Colonel Yvonne C. Pateman, USAF (Ret.), "Women Airforce Service Pilots: WASP," in *In Defense of a Nation: Servicewomen in World War II*, edited by Jeanne M. Holm, USAF (Ret.) (Arlington, VA: Vandamere Press, 1998), 118.

39. Merryman, *Clipped Wings*, 4.

40. Ibid., 7, 44. The WASP was retroactively militarized by President Jimmy Carter.

41. "Memorandum for Chief of Staff, Subject, Inactivation of the WASP," October 2, 1944, Records of the War Department General and Special Staffs, Office of the Chief of Staff, Security-Classified Correspondence, 1942–47, NARA, RG 165, Box 205, NM 84, E-13.

42. Atlas, "What Future for the Servicewoman?"

43. Merryman, *Clipped Wings*, 45.

44. "Pierotti," Woman's Collection, Texas Woman's University Archives, Denton, Texas.

45. Essay accompanying Pierotti cartoon, Woman's Collection, Texas Woman's University Archives, Denton, Texas.

46. Gasoline and tires, among many other things, were rationed in the United States and other Allied countries.

47. Norman Rockwell, *Collier's*, October 20, 1945, 3.

48. Sidney Hoff, October 6, 1945, in *Complete Cartoons*.

49. Mischa Richter, December 8, 1945, in *Complete Cartoons*.

50. "Combat Point," September 23, 1945, in *Male Call* (bound book of all strips) (Princeton, WI: Kitchen Sink Press, 1987).

51. The official time frame at men's conscription was given as "the duration of the war, plus six months."

52. Rockwell, *Collier's*, 3.

53. "Whew CQ," September 30, 1945, in *Male Call*, 99.

54. "CQ" referred to "Charge of Quarters," the army's term for the person standing watch.

55. Bailey, *From Front Porch to Back Seat*, 41, 115.

56. Meyer, "A Challenge," 77.

57. Bailey, *From Front Porch to Back Seat*, 41.

58. Mary Gibson, *Collier's*, November 24, 1945.

59. Sam Cobean, November 17, 1945, in *Complete Cartoons*.

60. "No Chicken, Inspector," September 1945, in *Male Call*, 98.

61. McEuen, *Making War, Making Women*, 55, 58, 63. McEuen examined Rosalind Coward's "contention that once fragmented, a separate body part can then 'come under the scrutiny of the ideal.'" Coward identified these fragments, McEuen explained, as "new areas constructed as sensitive and sexual, capable of stimulation and excitement, capable of attracting attention."

62. "Home Front Hodgepodge," January 1946, in *Male Call*, 106.

63. Untitled strip, August 1945, in *Male Call*, 93.

64. Meyer, "A Challenge," 77.

65. Bailey, *From Front Porch to Back Seat*, 40–41.

66. Meyer, "A Challenge," 77.

67. Hartmann, *Home Front and Beyond*, 25.

68. "Estimated War Dead, World War II," War Chronicle, http://warchronicle.com/numbers/WWII/deaths.htm. It is important to note that casualty figures differ, sometimes widely, from source to source.

69. Molly Castle and Aiken Welch, "Too Much Mother," *Coronet*, August 1944, 31–34.

70. "It's Twins!" *Ladies' Home Journal* advertisement, *The New Yorker*, July 28, 1945.

71. Sidney Hoff, September 8, 1945, in *Complete Cartoons*.

72. Sidney Hoff, December 1, 1945, in *Complete Cartoons*.

73. Alan Dunn, October 13, 1945, in *Complete Cartoons*.

74. Chon Day, June 22, 1946, in *Complete Cartoons*.

75. Howard Sparber, *Collier's*, June 15, 1946.

76. Mischa Richter, March 17, 1945, in *Complete Cartoons*.

77. Howard Sparber, *Collier's*, June 8, 1946.

78. Sani-Flush advertisement, *Collier's*, October 20, 1945, 96.

79. Grant C. Huband, *Collier's*, June 29, 1946.

80. Richard Decker, October 20, 1945, in *Complete Cartoons*.

81. Sam Cobean, September 29, 1945, in *Complete Cartoons*.

82. Irwin Caplan, *Collier's*, November 24, 1945.

83. Service flags were permitted to be hung in the windows of families with members in the service. Blue stars indicated service; gold stars indicated a death of a family member who had been in the armed services.

84. Gregory D'Allessio, "Welcome Home!" *Collier's*, April 13, 1946, 76.

85. Sergeant Barney Tobey, *Collier's*, October 20, 1945.

86. Charles Pearson, *Collier's*, May 25, 1946.

87. Mischa Richter, November 3, 1945, in *Complete Cartoons*.

88. "Priscilla" (for OWI), Slide series 179-WP, NARA.

Epilogue. "These Girls are Strong—Bind Them Securely!"

1. Advertisement, National Comics Group, c. 1948, reproduced in Les Daniels, *Wonder Woman: The Complete History* (San Francisco: Chronicle Books, 2000), 92.

2. Images of Rosie the Riveter are more prevalent than those of Wonder Woman in large part because Rosie the Riveter's image is in the public domain. D.C. Comics holds the copyright for Wonder Woman and her image.

3. Betty Friedan, *The Feminine Mystique* (New York: Dell, 1963), 11.

4. Lillian Faderman, *Odd Girls and Twilight Lovers: A History of Lesbian Life in Twentieth-Century America* (New York: Penguin, 1991), 126.

5. "American Classics," reproduction of a poster in the collection of the National Archives, Watermind.com, Berkeley, California.

6. S.S. *Jeremiah O'Brien* Self-Guided Tour pamphlet, National Liberty Ship Memorial, Pier 23, San Francisco.

7. Lawrence Wilbur, "Longing Won't Bring Him Back Sooner," poster created for the War Manpower Commission, 1944, www.olive-drab.com/gallery/description_0054.php. A gold star indicated the death of a family member.

8. John Whitcomb, "Be A Cadet Nurse, The Girl With A Future," U.S. Public

Health Service, Federal Security Agency, poster, 1944, National Museum of American History, Smithsonian Institution.

9. "Talk Bubbles," NobleWorks, Hoboken, New Jersey. I've interpreted the two young women in the background as high-school girls because they are carrying schoolbooks and look only slightly younger than the cadet nurse in the foreground.

10. Slide 44-PA-254, NARA.

11. Dan C. Shoemaker, personal communication via e-mail, February 12, 2006. The "Golden Age" of comics is generally thought of as lasting from roughly the mid-1930s through the early 1950s. During this time, comic books were intensely popular among both children and adults. The archetype of the superhero was created and defined during these years, and it was at this time that many of the most famous superheroes, such as Batman, Superman, Wonder Woman, and Captain America, debuted. Subsequent to the Golden Age, the "Atomic Age," named for obvious reasons, debuted, followed by the "Silver Age" of comic books. The Silver Age is dated from roughly the mid-1950s through the early 1970s. "Golden Age of Comics," Comic Vine, www.comicvine.com/golden-age-of-comics/12–55820/.

12. Daniels, Wonder Woman, 134, 197.

13. "First Appearance" Wonder Woman action figure, D.C. Direct™, D.C. Comics.

14. Daniels, *Wonder Woman*, 130–131.

15. Ibid., 132.

16. Cartoon by C. Clement, mid-1970s, in *Suffragettes to She-Devils: Women's Liberation and Beyond*, edited by Liz McQuiston (London: Phaidon Press, 1997), 108–109. McQuiston noted that, "self-examination was first demonstrated in the U.S.A. in 1971, and by 1975 the Women's Health Movement had carried it to a dozen other countries." See also Adele E. Clarke and Virginia L. Olesen, *Revisioning Women, Health, and Healing* (New York: Routledge, 1999), 68.

17. McQuiston, *Suffragettes to She-Devils*, 108.

18. Flyer, "Just Go Vote 2004," JustGoVote.org, Washington, D.C.

19. Tiger Eye Design, Ohio.

20. During the 2008 presidential campaign, Obama's use of the slogan "Yes, We Can," was also reminiscent of Rosie's "We Can Do It!" "Si, se puede," a similar phrase in Spanish (it can be loosely translated as "Yes, it's possible," or "It can be done"), was the motto of the United Farm Workers under the leadership of Cesar Chavez and has been used by immigration rights protestors.

21. Tampax advertisement, *Fitness* magazine, April 2000.

22. Karen Houppert, "Pulling the Plug on the Sanitary Protection Industry," *Village Voice*, February 1995, 31.

23. Kara Vuic, personal communication by e-mail, May 6, 2011.

24. Elaine Tyler May, *Homeward Bound: American Families in the Cold War Era* (New York: Basic Books, 1988), 20.

BIBLIOGRAPHY

Adams, Michael C. C. *The Best War Ever: America and World War II.* Baltimore: Johns Hopkins University Press, 1994.

American Art Archives, www.americanartarchives.com/campbell,es.htm.

Anderson, Karen. *Wartime Women: Sex Roles, Family Relations, and the Status of Women during World War II.* Westport, CT: Greenwood Press, 1981.

Angell, Roger. "Uniform Bliss." *New Yorker,* November 12, 2001.

Arno, Peter. *Peter Arno's* Man in the Shower. New York: Simon & Schuster, 1944.

Atlas, Benjamin J. "What Future for the Servicewoman?" *Independent Woman,* May 1945.

Bailey, Beth L. *From Front Porch to Back Seat: Courtship in Twentieth-Century America.* Baltimore: Johns Hopkins University Press, 1988.

Bailey, Beth, and David Farber. *The First Strange Place: The Alchemy of Race and Sex in World War II Hawaii.* New York: Free Press, 1992.

Baker, Sgt. George. *The New Sad Sack.* New York: Simon & Schuster, 1946.

Behling, Laura. *The Masculine Woman in America, 1890–1935.* Urbana: University of Illinois Press, 2001.

Bellafaire, Judith A. "The Women's Army Corps: A Commemoration of World War II Service." N.d. U.S. Army Center of Military History, www.history.army.mil/brochures/wac/wac.htm.

Bentley, Amy. *Eating for Victory: Food Rationing and the Politics of Domesticity.* Urbana: University of Illinois Press, 1998.

Bérubé, Allan. *Coming Out under Fire: The History of Gay Men and Women in World War Two.* New York: Free Press, 1990.

The Best Years of Our Lives. From a novel by Mackinlay Kantor. Directed by William Wyler. Screenplay by Robert E. Sherwood. 1946. MGM Studios.

Better Homes and Gardens, various issues, 1941–1945.

Bird, William L., Jr., and Harry R. Rubenstein. *Design for Victory: World War II Posters on the American Home Front.* New York: Princeton Architectural Press, 1998.

Bjerg, Greg. "The Man Who Changed Comic Books Forever." N.d., www.damninteresting.com/the-man-who-changed-comic-books-forever.

Brandt, Allan M. *No Magic Bullet: A Social History of Venereal Disease in the United States since 1880.* New York: Oxford University Press, 1987.

Breger, Lt. David. *"G.I. Joe" ("Private Breger"): From the Pages of* Yank *and* Stars and Stripes. Garden City, NY: Blue Ribbon Books, 1945.

Brier, Sam. *Judge.* December 1942. United States Army Women's Museum, Fort Lee, Virginia.

Buszek, Maria Elena. *Pin-Up Grrrls: Feminism, Sexuality, Popular Culture.* Durham, NC: Duke University Press, 2006.

Butler, Judith. *Bodies That Matter: On the Discursive Limits of "Sex."* New York: Routledge, 1993.

———. *Gender Trouble: Feminism and the Subversion of Identity.* New York: Routledge, 1990.

Campbell, E. Simms. *More Cuties in Arms.* Philadelphia: David McKay, 1943.

Canaday Margot. *The Straight State: Sexuality and Citizenship in Twentieth-Century America.* Princeton, NJ: Princeton University Press, 2009.

Caniff, Milt. *Male Call.* Princeton, WI: Kitchen Sink Press, 1987.

CartoonBank.com, *New Yorker.*

Castle, Molly, and Aiken Welch. "Too Much Mother." *Coronet,* August 1944, 31–34.

Coast Guard Compass, Official Blog of the U.S. Coast Guard, http://coastguard.dod live.mil.

Collier's, various issues, 1941–1945.

Comic Vine, www.comicvine.com.

Comics Alliance, www.comicsalliance.com.

Daniels, Les. *The Life and Times of the Amazon Princess Wonder Woman: The Complete History.* San Francisco: Chronicle Books, 2000.

Derrickson, Marione R., ed. *Laugh It Off: Cartoons from the* Saturday Evening Post. New York: McGraw-Hill, 1944.

Derrickson, Marione P., and John Bailey, eds. *Funny Business: A New Collection of Cartoons from the* Saturday Evening Post. New York: Whittlesey House, c. 1945.

Doty, Alexander. *Making Things Perfectly Queer: Interpreting Mass Culture.* Minneapolis: University of Minnesota Press, 1993.

Dubakis, Melissa. "Gendered Labor: Norman Rockwell's *Rosie the Riveter* and the Discourses of Wartime Womanhood." In *Gender and American History since 1890,* edited by Barbara Melosh. New York: Routledge, 1993.

Earley, Charity Adams. *One Woman's Army: A Black Officer Remembers the WAC.* College Station: Texas A&M University Press, 1989.

Faderman, Lillian. *Odd Girls and Twilight Lovers: A History of Lesbian Life in Twentieth-Century America.* New York: Penguin, 1991.

Faulkner, Howard J., and Virginia D. Pruitt. *Dear Dr. Menninger: Women's Voices from the Thirties.* Columbia: University of Missouri Press, 1997.

Federal Security Agency, U.S. Public Health Service. "VD Bulletin No. 95." N.d.

Franzen, Monika, and Nancy Ethiel. *Make Way! 200 Years of American Women in Cartoons.* Chicago: Chicago Review Press, 1988.

Free a Man to Fight! Women Soldiers of World War II (film). Directed by Mindy Pomper. Two Girls From Back East Productions, 1999.

Friedan, Betty. *The Feminine Mystique.* New York: Dell, 1963.

Fussell, Paul. "Introduction." In Diana Trilling, *Reviewing the Forties.* New York: Harcourt Brace Jovanovich, 1978.

———. *Wartime: Understanding and Behavior in the Second World War.* New York: Oxford University Press, 1989.

Gluck, Sherna Berger. *Rosie the Riveter Revisited: Women, the War, and Social Change.* New York: Meridian, 1987.

Godson, Susan H. *Serving Proudly: A History of Women in the U.S. Navy.* Annapolis, MD: Naval Institute Press, 2001.

Halberstam, Judith. *Female Masculinity.* Durham, NC: Duke University Press, 1998.

Hartmann, Susan. *The Home Front and Beyond: American Women in the 1940s.* Boston: Twayne, 1982.

Harvey, Sheridan. "Rosie the Riveter: Real Women Workers in World War II." Transcript of video presentation, July 20, 2010. Library of Congress, Journeys and Crossings, www.loc.gov./rr/program/journey/rosie-transcript.html.

Herman, Corporal Vic. *Winnie the Wac: The Return of a World War II Favorite,* new enlarged ed. Edited by Virginia Herman. Carlsbad, CA: T. G. Graphics, 2002.

Herold, Don. "Foreword." In *It's a Funny World: Cartoons from Collier's.* New York: Robert McBride, 1942.

Hokinson, Helen. *There Are Ladies Present.* New York: E. P. Dutton, 1952.

Holm, Jeanne. *Women in the Military: An Unfinished Revolution.* Novato, CA: Presidio Press, 1992 [1982].

Honey, Maureen. *Creating Rosie the Riveter: Class, Gender, and Propaganda during World War II.* Amherst: University of Massachusetts Press, 1984.

———. "Remembering Rosie: Advertising Images of Women in World War II." In *The Home-Front War: World War II and American Society,* edited by Kenneth Paul O'Brien and Lynn Hudson Parsons. Westport, CT: Greenwood Press, 1995.

Houppert, Karen. "Pulling the Plug on the Sanitary Protection Industry." *Village Voice,* February 7, 1995.

It's a Funny World: Cartoons from Collier's. New York: Robert McBride, 1942.

Jeffries, John W. *Wartime America: The World War II Home Front.* Chicago: Ivan R. Dee, 1996.

Ladies' Home Journal, various issues, 1942–1945.

Landis, Carole. "Foreword." In *Winnie the Wac: The Return of a World War II Favorite,* new enlarged ed., by Corporal Vic Herman, edited by Virginia Herman. Carlsbad, CA: T. G. Graphics, 2002.

Lariar, Lawrence, ed. *Best Cartoons of the Year, 1942.* New York: Crown, 1942.

———. *Best Cartoons of the Year, 1944.* New York: Crown, 1944.

Laugh Parade: A Collection of the Funniest Cartoons of the Day. New York: Grosset & Dunlap, 1945.

Library of Congress, Caroline and Erwin Swann Collection of Caricature and Cartoon. Prints and Photographs Division, Washington, D.C.

Lichtenstein, Nelson, Susan Strasser, Roy Rosenzweig, Stephen Brier, and Joshua Brown. *Who Built America? Working People and the Nation's Economy, Politics, Culture and Society.* Vol. 2, *1877 to the Present,* 2nd ed. Stephen Brier, executive editor. New York: Bedford/St. Martin's, 2000.

Life, various issues, 1941–1945.

Litoff, Judy Barrett, and David C. Smith. *American Women in a World at War: Contemporary Accounts from World War II.* Wilmington, DE: SR Books, 1997.

———. *Since You Went Away: World War II Letters from American Women on the Home Front.* New York: Oxford University Press, 1991.

———. *We're In This War, Too: World War II Letters from American Women in Uniform.* New York: Oxford University Press, 1994.

Mankoff, Robert, ed. Foreword by David Remick. *Complete Cartoons of the New Yorker.* New York: Black Dog & Leventhal, 2004.

Manzanar National Historic Site, U.S. National Park Service, www.nps.gov/manz.

"Marching to Victory." Songbook of the Navy WAVES (pamphlet). Northampton, MA: Naval Reserve Midshipmen's School, Women's Reserve, 1943.

Mauldin, Bill. *Up Front.* Text and pictures by Bill Mauldin. New York: Henry Holt, 1945.

May, Elaine Tyler. *Homeward Bound: American Families in the Cold War Era.* New York: Basic Books, 1988.

McCall's, various issues, 1942–1945.

McEuen, Melissa A. *Making War, Making Women: Femininity and Duty on the American Home Front, 1941–1945.* Athens: University of Georgia Press, 2011.

McQuiston, Liz, ed. *Suffragettes to She-Devils: Women's Liberation and Beyond.* London: Phaidon Press, 1997.

Menninger Family Archives (online). Kansas Historical Society, www.kshs.org/p/menninger-family-archives/13786#william.

Merryman, Molly. *Clipped Wings: The Rise and Fall of the Women Airforce Service Pilots (WASPs) of World War II.* New York: New York University Press, 1998.

Meyer, Agnes E. "A Challenge to American Women." *Collier's,* May 11, 1946.

Meyer, Leisa D. *Creating G.I. Jane: Sexuality and Power in the Women's Army Corps during World War Two.* New York: Columbia University Press, 1996.

Molinari, Callan. "Well Done, Sister Suffragettes," August 26, 2009. Callan's Sketchbook, http://callanmolinari.blogspot.com/2009/08/well-done-sister-suffragettes.html.

Monahan, Evelyn M., and Rosemary Neidel-Greenlee. *And If I Perish: Frontline U.S. Army Nurses in World War II.* New York: Anchor Books, 2003.

National Archives and Records Administration (NARA), Washington, D.C., and College Park, Maryland. Records of the Office of War Information (OWI). Record Group 208, 1926–1951 (bulk 1942–1945). Records of the Bureau of Graphics, Records of the Domestic Operations Branch, and Records of the News Bureau.

———. Records of the War Department General and Special Staffs, Record Group 165, 1860–1952 (bulk 1888–1948). Records of the Office of the Chief of Staff.

New Yorker, The, various issues, 1941–1945.

Norman, Elizabeth. *We Band of Angels: The Untold Story of American Nurses Trapped on Bataan by the Japanese.* New York: Simon and Schuster, 1999.

Nyberg, Amy Kiste. *Seal of Approval: The History of the Comics Code.* Jackson: University Press of Mississippi, 1998.

"Off to a Good Start." Pamphlet 16-32247-1. Washington, DC: Government Printing Office, n.d.

O'Neill, William L. *World War II: A Student Companion.* New York: Oxford University Press, 1999.

Pateman, Lt. Col. Yvonne C., USAF (Ret.). "Women Airforce Service Pilots: WASP," in *In Defense of a Nation: Servicewomen in World War II,* edited by Maj. Gen. Jeanne M. Holm, USAF (Ret.). Judith Bellafaire, executive ed. Arlington, VA: Vandamere Press, 1998.

The Patriotic Tide: 1940–1950. Alexandria, VA: Time-Life Books, 1969.

Pollard, Clarice. *Laugh, Cry, and Remember: The Journal of a G.I. Lady.* Phoenix, AZ: Journeys Press, 1991.

Robbins, Trina. *The Great Women Superheroes.* Northampton, MA: Kitchen Sink Press, 1996.

Roeder, George H., Jr. *The Censored War: American Visual Experience during World War Two.* New Haven, CT: Yale University Press, 1993.

Roosevelt, Anna Eleanor. *It's Up to the Women.* New York: Frederick A. Stokes, 1933.

Salm, Mary Margaret Schisler. World War II Collection. Institute on World War II and the Human Experience. Florida State University, Tallahassee, Florida.

Sansone, Sgt. Leonard. *The Wolf.* New York: United Publishers, 1945.

Sigerman, Harriet, ed. *Columbia Documentary History of American Women since 1941.* New York: Columbia University Press, 2007.

"S.S. *Jeremiah O'Brien* Self-Guided Tour." Pamphlet. National Liberty Ship Memorial, Pier 23, San Francisco.

Starbird, Ethel A. *When Women First Wore Army Shoes: A First-Person Account of Service as a Member of the Women's Army Corps during WWII.* New York: iUniverse, 2010.

Summerfield, Penny, and Nicole Crockett. "'You Weren't Taught That with the Welding': Lessons in Sexuality in the Second World War." *Women's History Review* 1, no. 3 (1992).

"Time Line: Zoot Suit Riots." PBS. American Experience: The Most-Watched History Series, www.pbs.org/wgbh/amex/zoot/eng_timeline/index.html.

Treadwell, Mattie. *The Women's Army Corps.* Washington, DC: Office of the Chief of Military History, Department of the Army, 1954.

United States Army Women's Museum, Fort Lee, Virginia. Archives and collections (Charlotte McGraw Collection, King-Fournelle Collection).

U.S. Marine Corps, History Division. "Women in the Marine Corps. Frequently Requested," July 2006, www.tecom.usmc.mil/HD/Frequently_Requested/.

U.S. National Park Service, U.S. Department of the Interior. "First Lady of the World" (pamphlet), GPO 2009-224/80349.

U.S. War Department. "The WAC Officer: A Guide to Successful Leadership." Pamphlet No. 35-2. Washington, D.C.: U.S. Government Printing Office, 1944.

"WAC and WAAC World War II Uniforms." N.d. Olive-Drab, www.olivedrab.com/od_soldiers_clothing_combat_ww2_waac.php.

"WASP Glossary." N.d. Wings Across America, www.wingsacrossamerica.us/wasp/resources/glossary.htm.

Watterson, Bill. *The Calvin and Hobbes Tenth Anniversary Book.* Kansas City, MO: Andrews & McMeel, 1995.

Westbrook, Robert. "'I Want a Girl, Just Like the Girl Who Married Harry James': American Women and the Problem of Political Obligation in World War II." *American Quarterly* 42, no. 4 (1990).

"Winnie the Welder": Winnie the Welder Oral History Project. February 16, 2005. Schlesinger Library, Radcliffe College, Cambridge, Massachusetts.

Wisconsin Historical Society. Mrs. Warren Resh Collection. Scrapbooks, 1925–1946. Madison.

Wise, Nancy Baker, and Christy Wise. *A Mouthful of Rivets: Women at Work in World War II.* San Francisco: Jossey-Bass, c. 1994.

Woman's Collection, Texas Woman's University Archives, Denton, Texas.

Women In Military Service For America Memorial Foundation, www.womensmemorial.org.

Wonder Woman, November 1944, no. 35. Originally published by J. R. Publishing Co. Copyright D.C. Comics. On file at National Archives and Records Administration

(NARA), Records of the Office of War Information (OWI), College Park, Maryland. Record Group 208, 1926–1951 (bulk 1942–1945), Box 1, Entry 84, "Back to School Campaign Reports" Folder.

"World War II Era WAVES: Overview and Special Image Selection." N.d. Naval History and Heritage Command, www.history.navy.mil/photos/prs-tpic/females/wave -ww2.htm.

"World War II Women 'Get a War Job!' Poster." N.d. Olive-Drab, www.olive-drab.com/ gallery/description_0054.php.

Yank: The Army Weekly, various issues, 1942–1945.

Yellin, Emily. *Our Mothers' War: American Women at Home and at the Front during World War II*. New York: Free Press, 2004.

INDEX